1976

Far Eastern Antiquities

A Book for Collectors

Far Eastern Antiquities

Michael Ridley

Henry Regnery Company
Chicago

Published in Great Britain by
JOHN GIFFORD LTD.

Published in the United States, 1972,
by Henry Regnery Company.

Library of Congress Catalog Card Number:
75-189801

Printed in Great Britain

Contents

Acknowledgements

ACKNOWLEDGEMENTS
The author and publishers gratefully acknowledge the following for permission to reproduce illustrations.

The Smithsonian Institution, Freer Gallery of Art, Washington D.C.
The British Museum.
The Victoria & Albert Museum, London.
The Cleveland Museum of Art.
The Russell-Cotes Art Gallery & Museum, Bournemouth, U.K.
Sydney L. Moss Ltd., London.
John Sparks Ltd., London.
Collection of W. G. Ridley.
S. Marchant and Son, London.

List of colour illustrations

List of colour illustrations continued

List of colour illustrations continued

List of colour illustrations continued

List of colour illustrations continued

List of black and white illustrations

List of line drawings

Author's note

This book is an attempt to fill a long-felt need for a concise but comprehensiv work on the art of the Far East, which will not only be an introduction to th history of that art but also a useful manual for the collector.

Although many books have been written on Far Eastern art, most are aime at providing either a general or historical appreciation. They give the collecto little practical guidance in his contact with actual objects, little advice o identification, and still less on buying and distinguishing the genuine from th fake. It is my hope that this book will help to clarify some of the many questio that collectors continually find themselves asking.

It is not easy to include all the numerous aspects of Far Eastern art in a boo of this size, and it has therefore been necessary to select only certain categorie Porcelain, such a specialised subject in itself, has been omitted. It would hav been unwise to try to cover it in the space available, for even a book entirel devoted to it could only scratch the surface.

This book is meant only as a general introduction to the subject, and th reader is advised to extend his knowledge by reading the specialist works liste in the bibliography on the particular aspect that interests him most. It is hope that the arrangement of the book in chapters dealing with specific art forms wi enable the reader to appreciate their development separately, but when rea together will provide an artistic appreciation of the Far Eastern art as a whol

No attempt has been made to include notes on prices, as they quickly becom out of date. I have tried to keep the technical terms to a minimum, but hav found it necessary to include some, and it is hoped the glossary at the back o the book will help in this respect.

I would like to thank the many people who through their help and advic have contributed to the completion of this work. In particular, I would like t thank my wife. My thanks also go to those who have allowed photographs o objects in their possession to be reproduced.

Introduction

Outside Greece and Rome one of the greatest artistic centres the world has ever known must have been the Far East, with China, Korea and Japan at the hub.

To some the art forms of the Orient are strange and something to be left alone, but many find enjoyment and great aesthetic satisfaction from collecting and handling the wonderful and beautiful works of art that were created in that area. It is for them that this book is written, while it is hoped that at the same time others will feel sufficiently curious to read it and perhaps become one of the thousands that have opened the door to find the pleasure within. For the art of the West is just a small part of human artistic endeavour, and to rely on this would be like looking at the text without the pictures, or only one side of a coin.

China was the fountain of artistic ideas, the spray from which drenched Korea and sprinkled Japan. Thus geography plays an important part in the diffusion of ideas in the Far East. Korea is so close to China that it was strongly influenced by the artistic ideals of the latter. Japan, on the other hand, received influence mainly indirectly through Korea, though during certain periods the influence was through direct contact.

The history of the art of China extends back to neolithic times, but one of the main stimuli, Buddhism, was only introduced during the first centuries A.D. from India. Thus in later Chinese art we have a strong foreign religious influence, joined to an already well-defined indigenous artistic identity. It was this artistic style that inspired the later art of Korea and Japan, whose histories began much later than China's. The great civilising force of Chinese culture was felt throughout the Far East, and it is interesting to note that though China was invaded a number of times by 'barbarians' from surrounding lands, they quickly assimilated the indigenous Chinese culture and became completely Chinese.

China, Korea and Japan, however, all owe a great deal to India for artistic inspiration as well as religious stimulus.

Philosophy and religion played an important part in the art of all three countries. Apart from Buddhism, the philosophies of Taoism and Confucianism, both indigenous creations, played an important part in China. In Korea and Japan, Buddhism played a major role, especially the later Zen sect. In Japan, Shinto, the indigenous cult of natural forces, ancestors, and the State, also

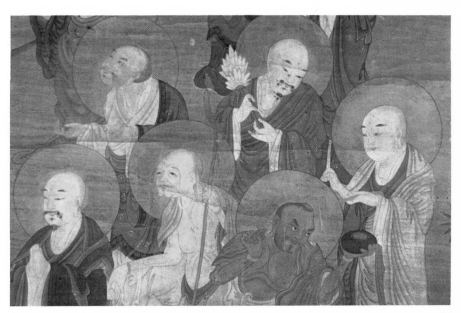

tail of Chinese Buddhist painting of hans (Saints). *Private Collection*.

15

played a part. Confucian ideas strongly influenced Japanese thought, evident even today.

Buddhism is basically an iconographic religion; it therefore acted as a major stimulus to art, the main body of which was religious. It was introduced into Japan in A.D. 560. Although it had uncertain beginnings, it took a firm hold with the result there are six forms in Japan today, Zen being the most important. The others are Jodo, Tendai and Shingon, which together with Zen (Chinese Ch'an) are of Chinese descent; and Nichiren and Shin which are indigenous.

The Shingon sect of mystic Buddhism was introduced into Japan at an early date. Its origins can be traced back to the Vajrayana sect, The Vehicle of the Thunderbolt, a combination of primitive cults and Buddhism, which had established itself in Eastern India, and later in Tibet and China.

Although in its earliest and simplest forms Hinayana Buddhism did not entail the worship of images, later forms developed, Mahayana, which produced large numbers of Buddhas, Bodhisattvas, and other deities. They were made in different positions either standing or seated, symbolising religious ideas.

Shingon Buddhism, which is related to the Indian Tantric cults, required images with a number of heads or arms in either horrific or pacific attitudes.

To this body of Buddhist art must be added the vast number of paintings of figures of mythological personages and Taoist and Shinto deities.

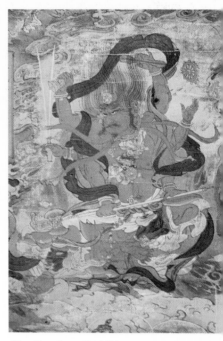

Detail of a Buddhist tantric painting, showing a multi-armed deity. *Private Collection.*

The artistic skill gained in executing religious subjects was employed to great effect in the production of non-sectarian objects. Indigenous art forms and mythology played an important part in Chinese art, often recurring at later times, due to the deep respect the Chinese had for their past. This conservative attitude is also reflected in their practice of ancestor worship.

Ghosts and supernatural creatures were often depicted in Japanese art. Perhaps the most popular of the animals was the dragon. Several varieties are known. The common or ordinary Japanese dragon is similar to the Chinese, but usually has only three claws, while the Chinese or Imperial has five. Another popular chimerical animal was the minogame, a supernatural tortoise with a long bushy tail, that does not appear until the animal has reached the age of 500 years. The collector is advised to become thoroughly acquainted with Far Eastern mythology and also with Buddhist iconography, for only in this way will he obtain the maximum pleasure from collecting.

The average Westerner, who is unacquainted with Japanese art, is unlikely to be able to distinguish it from the Chinese. If, however, he studies carefully he will see that it contrasts strongly with the Chinese. The overall 'Chinese' appearance of some Japanese pieces is perhaps due to the fact that the major stimuli have come across from China by way of Korea. However, the Japanese artist has not simply copied, but has adapted and altered the ideas with typical Japanese ingenuity, often adding original ideas of his own.

To the Japanese, the Chinese preference for sticking to a tried and successful formula, whether it be for painting, pottery or sculpture, would be failure. The Japanese artist always preferred to experiment and allow his creative genius licence. This, of course did not always result in success. It is this imaginative experimentation which makes Japanese art so different. This does not mean that Chinese art is dull and unimaginative; on the contrary, it often shows a genius of skill and artistry, confined to the limitations of accepted artistic canons, yet resulting in masterpieces which themselves provided the inspiration and stimulation for the Japanese artist.

Compared with China and Japan, Korea is almost an unknown quantity. The Japanese have made the most thorough study of Korean art, and have published a number of fine works on the subject. In the West we have only recently become acquainted with the many wonderful works of art which Korea produced. Connoisseurs were treated to a rare experience recently, when the first major exhibition of Korean works of art was held at the Victoria and Albert Museum, London. The collector's interest in Korean works must be on the whole peripheral, as he will have few opportunities to acquire specimens.

Apart from the aesthetic pleasure many have found in collecting the art of the Far East, some have been pleasantly surprised to find that their acquisitions are also good investments. However, beginner's luck, as it sometimes is, cannot always continue. Knowledge is necessary and it is hoped that the collector will find the information contained within these pages both informative and profitable.

The collector, however, should not buy works of art simply as investments. Collecting art is not the stock market and should not be pursued for monetary reasons. Collecting should be a pleasure and an aesthetic experience. If the value of one's collection rises, any profit must be considered as incidental.

Jade vase. China 18th century. *John Spark Ltd., London.*

This does not mean that one should not buy wisely; this is essential, for if one does not the result will almost certainly be a loss and not a gain. All this being said, it must be emphasised that Far Eastern art makes a very good investment.

It is important to develop taste. The collector should never buy with the idea of making money, for if this is the motive, most times he will not. Collecting is very much an aesthetic pursuit, followed by many who, not being among the fortunate few of us who are surrounded by beautiful objects, and whose job it is to handle and preserve them professionally in museums, wish to experience this by acquiring specimens themselves.

As mentioned above, knowing how to buy is very important, but it is also important to know what to buy. There is a danger in indiscriminate collecting. The result could be a group of disconnected and possibly mediocre objects. The collector should endeavour to acquire the best possible specimens that his purse will allow. His motto should be: quality rather than quantity. Money invested in good quality pieces will not only give the owner years of pleasure but will also be a sound investment. The collector should not make the mistake of buying damaged specimens, unless the objects are sufficiently rare, and never if the damage is detrimental to the artistic quality of the object, i.e. facial damage. Some pieces can be repaired, but often the damage is best left alone. The collector should never attempt to repair or clean an object without first obtaining expert advice. It is always best to have it attended to by a qualified restorer.

17

There are many ways of acquiring specimens, through antique shops, junk shops, private advertisement, street markets, provincial auctions etc. In all of these he will have to rely on his knowledge, and back it with money. On the other hand, if he buys from specialist dealers, he will benefit from the dealer's expert knowledge, and usually have a guarantee of authenticity. He will also be able to buy with confidence at the major national salerooms. Occasionally the collector will be able to acquire a bargain from a new or inexperienced dealer, but more often he will find objects overpriced in such shops.

When buying at auctions the collector should always attend the view day in order to examine the objects carefully. In this way he will be able to gain valuable experience and ensure that the object of his interest is not damaged or have any faults. All the points on forgeries mentioned in the various chapters should be borne in mind. The collector should never bid more than the price he decided upon when he examined the piece. He should fix his price and keep to it. Although he may be disappointed occasionally, he will find he has better buys. It is always a temptation to go higher than one intended.

The collector should always bear in mind that book knowledge is not everything. He must see and handle as many objects as possible. Regular visits to museums are extremely valuable and most curators or keepers will always be pleased to see objects and give advice, but they will not give valuations. There is one motto which the collector should bear in mind, it is the motto of the British Antique Dealers Association: 'Art has no enemy except ignorance'.

Finally the following story illustrates an important lesson.

A tycoon who had spent most of his life in pursuit of wealth, at last decided that he had enough to live comfortably, and so retired from business. After some time he felt bored and as he had always been interested in antiques, in particular jade, he decided to start collecting.

Always used to doing things thoroughly, he enrolled in an expensive course of six lessons on jade at a fashionable school of antiques.

At his first lesson, he was shown into a room empty except for a chair, table and a piece of jade, together with a label identifying the piece, and left there. After an hour, he was shown out and told that was all for the day.

This went on each time he attended. He was infuriated, the course was extremely expensive, and this was all that happened. Thinking things would change, he attended five sessions, but they were all the same, each time he was left with a different piece of jade and a label.

He was so dissatisfied that on the last day he took a friend along with him to show him how he was being treated.

After being shown into the room, he showed his friend the jade and the label marked: 'Jade Kuan Yin. Ming Dynasty'. Then he exploded.

'This is too much, now they can't even give me a genuine piece, but a fake!'

This little story illustrates one important fact, that no matter how much one reads, book knowledge in itself is of little value, but must be put into practice with actual experience gained in handling and seeing objects. As seen in the story above it is the handling of objects that is important. Only in this way will the collector really know his subject.

T'ao-t'ieh mask from a Chinese ritual bronze vessel. 10th century B.C.

Painting

East is East and West is West, and never the twain shall meet. This is certainly true in respect of painting. Chinese painting differs from the European not only in technique but also in philosophy.

In Europe art tended to be heavy and was essentially realistic. Conditioned by his materials, oil and canvas, the painter built up the picture layer by layer. His object was to capture, as much as possible, the shape of the article and convey it using perspective and shadow, so that the viewer might be tempted into thinking that the objects or persons portrayed were real.

In the East, painting was light, again conditioned by materials – ink and water colour on paper or silk – and the object was to convey more of an impression of the painter's thoughts as a pictorial composition, leaving out all irrelevant details. Real subjects were portrayed, but they were observed and assimilated in the artist's mind as a whole composition before he put his brush to paper. Only essentials were included; perspective through shadow was not used, the artist relied on brushwork and purity of line, and through a bird's eye view invited the viewer to travel through the picture from plain to plain. The complete scene is not recorded, but is more a theme from a scene. The appearance of simplicity is deceiving; it required the utmost concentration and skill. The brushwork had to be alive and not laboured, and the whole composition clear in the painter's mind before he put his brush to work, for the absorbent nature of the paper or silk did not allow mistakes or second thoughts. Chinese painting perhaps can best be summed up as a philosophical art.

The European medium of oil painting was displeasing to the Chinese, who found the paintings heavy and difficult to understand. There is a story which relates that during the Ch'ing dynasty a Jesuit showed an oil portrait to a Chinese, who, puzzled by the shadows painted on the face, asked: 'Do you only wash one side of your face?' This illustrates the difference in attitude between Occidental and Oriental appreciation of art. To the Chinese shadows were unnecessary, and it seemed almost as if they did not exist.

The above are very general and sweeping statements of the differences between the two art forms. There were, of course, exceptions, but they will become clearer as we examine the development of painting in the East as a whole.

The Chinese are a conservative race and to understand the elements and principles that govern their art of painting we must go back to the early days when it was in its infancy. Painting in China, Korea and Japan is essentially a development of calligraphy. Painting and calligraphy are two branches of the same art, the common denominator being the brush. It is interesting to note that an art so simple in appearance should have grown from so complex a discipline, for Chinese writing is formed from hundreds, even thousands, of ideographic characters, all of which must be memorised by the scholar. Originally semi-pictorial, the characters have lost all pictorial shape and are simply composed of various combinations of lines, which when written with a brush vary in thickness and curvature to produce a flowing script which conveys ideas or images to the mind. To the Chinese the art of calligraphy was just as important as painting; possibly even more important. The subtleties of calligraphic appreciation are often lost to the Western connoisseur, but if the collector studies both the paintings and the calligraphy often to be found on them he may with practice obtain some of the pleasure which a Chinese would feel from characters well written. The strokes of the brush are all-important; they should have beauty of form and express the personality of the writer. As in painting, calligraphy should be spontaneous and not laboured. The image and strokes being already in the mind of the writer before he starts. In good calligraphy the strokes which form the character should be crisp, clean and full of spontaneous energy like the leaves of bamboo.

Little was known in the West about Chinese painting until the second half of of the 19th century. Studies were hampered by the lack of public collections.

Painting of a male figure from a tile. China 2nd-3rd century A.D.

19

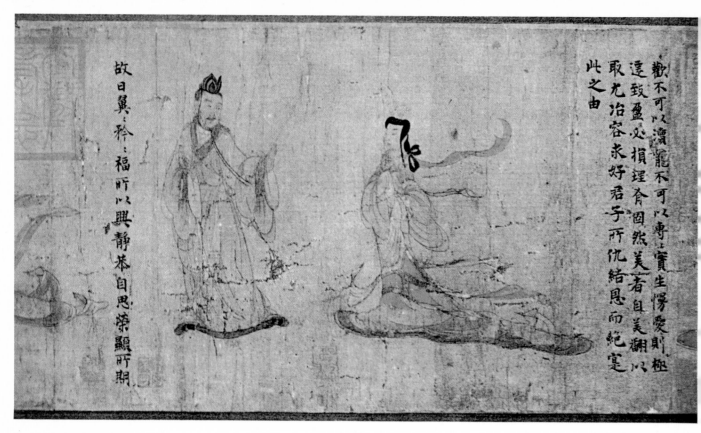

故曰翼翼矜矜　福所以興　靜恭自思　榮顯所期

歡不可以瀆寵不可以專　實生驕愛則極　遠致盈必損理有固然　美者自美翩以取尤冶容求好君子所仇　結恩而絕寔　此之曲

In 1881 the British Museum purchased the collection of Chinese paintings made by Dr William Anderson in Japan. In his brief history of Chinese painting in the catalogue of the collection Dr Anderson showed an unusual appreciation of the subject for the time. Another pioneer in the field was Fenolosa, who also made his study in Japan.

Even in China scholarship in the field was left to the traditional literary criticisms of art, which, unfortunately, were often more interested in the ideologies of the painter than his work. Well-documented and authenticated masterpieces were few and far between, and those that existed were usually in private collections, so restricting comparisons that could be made between works. There was, however, no lack of collectors who it seems were ever ready to add their attributions to paintings. It was the custom for collectors to add their own seal to a painting, much as collectors added their marks to old master prints in Europe. But in China famous connoisseurs and critics would often add an inscription recording their approval of the painting or their conviction that it was by a particular artist or of a certain period. Dealers were also not adverse to adding the seals and signatures of popular artists even to works obviously of later periods and styles. Testimonials and vermilion seals of critics and former owners are found on most old pictures, however forgeries exist of these as well as of the paintings themselves. Sometimes a genuine inscription is found attached to a painting to which it does not refer.

Attributions that can be relied on are very rare indeed and it could be said of the earlier periods of Chinese painting that none of the attributions to particular artists, let alone periods, are absolutely certain.

The inability to attribute paintings with absolute certainty distinguishes the historian of Oriental art from the Western art historian. He is handicapped by the lack of early paintings which can with certainty be attributed to known artists and periods with which comparisons can be made, and so build up a reliable mental picture of styles which can be referred to with confidence. With later works we are on firmer ground and attributions can be made with much greater confidence. A full discourse on the difficulties and problems of attributions and art scholarship, especially of the Sung and Yuan periods, is given in *Chinese Art* by William Willetts.

Having said this, let us now review what we know of the early periods of painting and artists, and of the few paintings that are in existence that have been attributed to them. It is remarkable that some scholars have said that Chinese painting died with the Sung period, and yet the majority of paintings on which our knowledge is based are post Sung. In fact the painting of each period has its own particular merit which must be looked for and appreciated.

'The Admonitions of the Imperial Instructress'. Detail of a handscroll by Ku-K'ai-chih. China, 4th century A.D. *British Museum*.

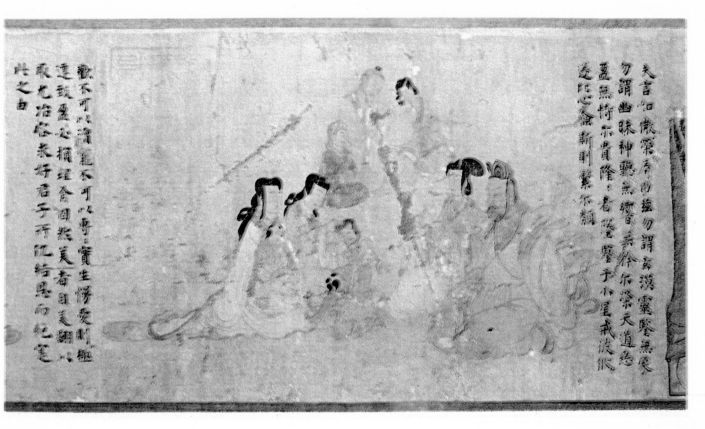

'The Admonitions of the Imperial Instructress'. Detail of a handscroll by Ku-K'ai-chih. China, 4th century A.D. *British Museum.*

Very few paintings of the Han dynasty have survived, however we are fortunate to have a few, mainly from tombs. There is a particularly fine painted tomb tile, now in the Museum of Fine Arts, Boston, showing human figures watching an animal fight. The picture has a highly developed sense of movement, showing that painting had already progressed along lines which were to be further developed in later times to become incorporated in the so-called 'Six Canons'. There are a few other tomb paintings, but we must look to painted lacquer (see chapter on lacquer) and the stone slabs carved in low relief, also from tombs, to give us a better understanding of the art. The stone reliefs seem in some cases to be transcriptions of paintings, and give a reasonable idea of the lost art of the period.

Except for frescoes, Oriental paintings are not rigid, but are mounted on rollers either vertically as hanging scrolls, Chou, (Japanese: Kakemono) or horizontally as hand scrolls, Shou Chuan (Japanese: Makimono) which could be viewed on the floor or table, and unrolled from right to left, allowing small areas to be viewed at a time, as a sort of moving picture. There were probably hand scroll paintings in the Han period, but the earliest example which has survived, 'The Admonitions of the Imperial Instructress' (Nu Shih Chen), dates to the Six Dynasties period, and is now a prize exhibit in the British Museum. Ascribed to a famous artist of the 4th century A.D., Ku K'ai-chih, it depicts scenes from the Imperial household, instructing the ladies in virtues such as self-sacrifice and sincerity, as exemplified by ladies of the past. The figures are painted with grace, elegance and dignity and the style can be seen to be a development of the earlier Han art, especially of the stone reliefs. The painting shows a developed sense of brush work, the flowing outline of the figures recalling the smooth outlines of calligraphy. A hint of external influence from Central Asia can be seen in the use of light shading. There are other paintings attributed to Ku K'ai-chih, but they are almost certainly later copies. Even the scroll in the British Museum may in fact be a copy made during the early Sung dynasty. Perhaps the earliest attempt at landscape may also be seen on the scroll, where a hunter is shown in a mountain landscape. The painting here takes on a somewhat experimental air, as if the painter was battling with proportions and perspective. The hunter and the mountain are almost of similar proportion. Other early attempts at landscape painting have not survived, and we have to look at works in other mediums for an insight into the style. A fine engraved stone sarcophagus of the early 6th century A.D. is now in the William Rockhill Nelson Gallery of Art, Kansas City. The engraving on the sarcophagus seems to be a transcript of an early painting. The subject is a compact composition of trees, figures, buildings and mountains, illustrating

21

scenes of filial piety. The stylised rendering of the foliage and other devices contrasts strongly with a realistic treatment of a seated dog. Another fine engraving, the 'Sacrificial Stone House', is in the Museum of Fine Arts, Boston.

The famous and controversial text, Ku Hua P'in Lu, 'Notes on the Classification of Old Paintings', sometimes known as the 'Six Canons' or 'Six Techniques of Painting', was written during this period by Hsieh Ho, an artist and critic, about the year A.D. 490. Considered one of the most influential paragraphs written on Chinese art, it is referred to in many books on the subject. Translations often differ, especially on the first 'technique', but the following, translated by Lin Yutang, is probably the closest to its correct meaning.

'What are the six techniques? First, creating a lifelike tone and atmosphere; second, building structure through brushwork; third, depicting the forms of things as they are; fourth, appropriate colouring; fifth, composition; and sixth, transcribing and copying.'

The first canon, the most important, has been translated differently by different authorities. The word ch'i-yun is bisyllabic, meaning 'tone and atmosphere' and sheng-tung, another bisyllabic word meaning 'fully alive, lifelike, moving'. Many mistakes have occurred by treating the translation as each separate meaning of the characters, instead of the overall descriptive meaning. Two other translations which convey the appropriate meaning are 'rhythmic vitality' used by H. A. Giles in his *Introduction to History of Chinese Pictorial Art*, and 'spiritual tone and life movement' translated by the Japanese Taki Seiichi.

For a further insight into the art of the period we must refer to the frescoes in the 'Caves of the Thousand Buddhas' at Tun Huang, on the western frontier of China. The work here, dating from the 4th century, is Buddhist, and it is here that we can examine for the first time the impact of the religion on the art of China. As in India and Tibet, Buddhism was to have a profound effect on art in Korea and Japan, but to a lesser degree in China, where the religion had to compete against the well-established philosophies of Taoism and Confucianism. In Korea and Japan there was no such opposition, and Buddhism quickly became firmly established. As a stimulant to art, Buddhism was extremely effective, though as a master it was somewhat canonical.

The caves at Tun Huang are extremely important to our knowledge of painting in China. Situated on the border of China with Central Asia, the area received influences from outside at an early date. From the Han period Tun Huang grew in importance as a military, political and commercial centre. Thus situated with its trade links with the west, it is not surprising that the influence of Buddhism was felt early in its history. The caves are supposed to have been started in the year A.D. 366, after a monk called Lo Tsun had a vision of the 'Thousand Buddhas' appearing over the mountain tops of Tun Huang. Numerous caves were carved out of the soft limestone over the centuries and decorated with paintings, and as the rock did not allow carvings to be made statues of painted clay were included.

In the 7th century it is said that there were more than 1,000 caves, but present-day surveys have shown that this was an exaggeration, the number being only 486. However these caves are tremendously important to us as they preserve numerous paintings. Historical events had their effect on Tun Huang, and all of them have left their mark in some way or other on the art preserved there. In A.D. 777 until 848 Tun Huang came under the protection of Tibet. After the cessation of the persecution of the Buddhists in A.D. 845 it again became an important centre, and religious works were produced until the 14th century.

Apart from the wonderful frescoes and sculpture preserved in the caves, a vast quantity of scrolls, drawings and woodcuts were discovered by Sir Aurel Stein, sealed in a room that had been closed for security reasons during the early part of the 11th century A.D.

Returning to the art of the Six Dynasties, we find a fine set of paintings dating to the early 6th century A.D., preserved in the 22 caves of the Wei dynasty at Tun Huang. These paintings illustrate the continuation of the early traditions of figurative and landscape painting. Ku-K'ai-chih is recorded to have painted a number of Buddhist temple frescoes, but although the paintings at Tun Huang are in the tradition of the period, they must be regarded as provincial work, of somewhat lower standard, and could not be compared with works by Ku-K'ai-chih.

By the T'ang period advances in technique had been made. At Tun Huang we see influences from India and Iran mixed with Chinese tradition to form an integrated and harmonious pictorial art form. The idea of space became more pronounced and compositions larger and more involved. The motifs were

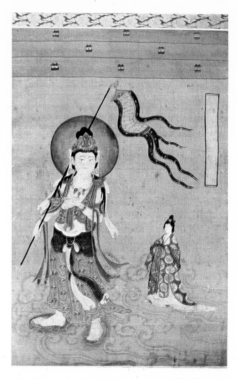

'Bodhisattva Avalokitesvara as Guide of Souls'. Painting in the T'ang style from Tun Huang. Stein Collection, No. 46. *British Museum.*

22

influenced by the Tibetan and Indian ideals of Mahayana Buddhism.

Apart from the fragmentary paintings preserved at Tun Huang, we have few other examples, as the paintings in the temples of the provincial centres have not survived. For a clearer idea of the style of the period we must look to Japan, where until 1949, when they were destroyed by fire, fine wall paintings were preserved near Nara, in the Horyu-ji Monastery. Although it is not possible to determine whether the paintings are by Chinese, Japanese or Korean hands, they convey the full majesty of the T'ang style of the 7th century. Figures of celestial beings were painted in quiet and reserved colours on the four walls, giving an overall effect not only of grandeur but also of serenity and peace of mind.

We are fortunate that some silk paintings of the period still exist, though not all that are so attributed were executed during the period. Some may be later copies.

Two great painters of the early T'ang dynasty whose names have been handed down to us in literary criticisms are Li Ssu-hsun (A.D. 651–716) and Yen Li-pen (d. A.D. 673). A superb handscroll by the latter entitled 'Portraits of the Emperors' is now in the Museum of Fine Arts, Boston. The scroll portrays 13 emperors with their attendants, each one characterised and isolated on a plain background, giving an archaic effect. The illusion of space serves to accentuate each figure with its rich colouring. Another scroll, 'Scholars of the Northern Ch'i Dynasty collating Texts', also in the museum at Boston, is signed with the name of Yen Li-pen but it is probably a later copy. Both paintings belong to the Confucian tradition or philosophy of art. Li Ssu-hsun, was a master of the landscape painting and is said to have founded the so-called Northern School.

The middle T'ang produced perhaps the greatest artist of the period, Wu Tao-tzu. One of the first professional painters of merit, he worked during the 8th century at the court of the Emperor Ming Huang, a patron of the arts and a passionate lover of beauty. A clear idea of his style may be had by observing stone engravings after his works, and the few paintings which are attributed to him which are in museums in various parts of the world. A fine stone rubbing of Kuan Yin after Wu is in the Louvre in Paris, while the British Museum possesses an interesting stone rubbing, of a Tortoise with Serpent. Most of the paintings attributed to Wu are in Japan, the best known of which is 'The Buddha Trinity' of the Tofukuji, Nara. A handscroll, 'The Birth of the Buddha', is in a private collection, while two landscapes are in the Daitoku-ji, Kyoto. The use of space to add a sense of depth to the modelling of figures is an important aspect of his style.

Besides his scroll paintings he was known as a master of frescoes, and is said to have painted over 300 Buddhist murals in the temples of Lo-lang and Ch'ang An, all of which have perished.

Another notable artist of the period was Wang Wei (A.D. 698–759). A versatile man, he was both poet and painter. As a painter he excelled at landscapes and figure work and also painted frescoes.

The father of the so-called 'Southern School', he developed a new style poetical and personal, which contrasted with the more formal and rigid style hitherto employed for landscapes. Unfortunately, we have to base most of our knowledge of him on stone engravings, for little of his work has survived. A fine handscroll now in the British Museum, of a paraphrase of Wang Ch'uan T'u by Wang Wei, attributed to Chao Meng-fu (active 1226–1290), perhaps gives us an insight into his style.

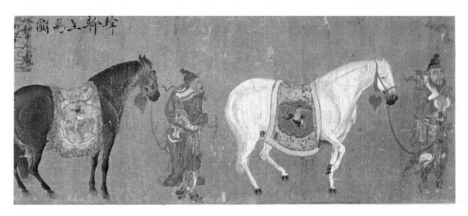

Detail of 'Horses and Grooms'. Handscroll attributed to Han Kan (A.D. 720–780). China, T'ang dynasty. *Freer Gallery of Art, Washington D.C.*

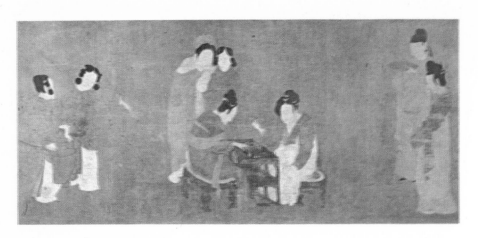

The so-called 'Southern' and 'Northern' schools of painting have no geographical significance whatsoever. Critics of the Ming period used these terms in describing the art of the Sung period, but the terms as we shall see are most confusing and misleading. As William Willetts so rightly observes in his book *Chinese Art* 'This surely was the most misleading and arbitrary division ever invented by art history'. When looked at closely, while there is some degree of conformity of style in the 'Southern School', in the 'Northern School' we have none.

When describing the art of the T'ang period, we must mention the work of the artist Han Kan (A.D. 720–780), an exponent of animal painting, especially horses. Horses were very popular in T'ang China, and it is said that the Imperial stables held 40,000. There is a handscroll in the Freer Gallery, Washington, after Han Kan, showing horses led by grooms. Another painting of a horse is in the Sir Percival David Collection, London. This time the animal is bound to a stake, showing all his restlessness and pent-up energy. Although some experts believe this to be the hand of Han Kan it is more likely to be a copy in his early style.

Before leaving the art of the T'ang dynasty, we must mention Chou Fang, active A.D. 780–816, famous for his paintings of ladies. Several works attributed to him are in the United States. A handscroll, 'Palace Lady playing Ch'in and Listeners' is in the William Nelson Gallery of Art, Kansas City, while a painting of the Sung dynasty, based on a composition by him, is in the Freer Gallery, Washington D.C.

The work of Li Chen, a contemporary of Chou Fang, is among the few authentic originals of the period that exist. Works commissioned by Kobo Daishi, a Japanese priest, and taken to Japan in the year A.D. 806 are still to be seen.

Finally, a word or two about the fragments of paintings on silk discovered at Tun Huang. Mainly Buddhist in theme, they are by minor artists, mostly monks. The fragments collected by Sir Aurel Stein were divided between the British Museum and the Delhi Museum, now the National Museum, Delhi, while fragments left in the cave were brought back to Paris by M. Pelliot, the majority of which are now in the Louvre.

After the fall of the T'ang dynasty in A.D. 907, until the establishment of the Sung dynasty in A.D. 960, there was a period of unrest known as the Five Dynasties, during which various attempts were made to establish a ruling family. Few paintings can be attributed to this period.

During the Sung dynasty the art of landscape painting reached its zenith, providing the perfect medium of expression for the neo Confucianism, which, combining elements of both Taoism and Buddhism, used the medium for expressing the natural law of action and reaction. Landscape paintings of mountains and streams were used as settings in which figures were sometimes placed showing the position and importance of man on nature and vice versa and expressing the relationship and unity between them. Likewise the landscape was similarly popular with the followers of a form of Buddhism known to the Chinese as Ch'an and the Japanese as Zen.

Ch'an paintings expressed an enigmatic view of life through misty scenes of mountains and lakes or similar subjects, echoing, through a vision almost of emptiness, the majestic power of nature. Landscapes were supreme during the Sung dynasty, and some of the greatest of Chinese painters were to find expression in that field of art.

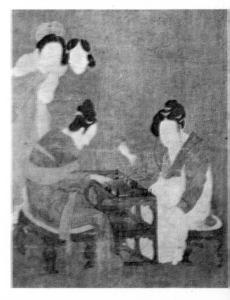

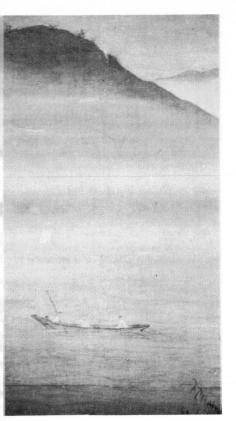

'Boating by Moonlight'. Scroll painting attributed to Ma Yuan (1190–1225). China, Sung dynasty. *British Museum.*

'Tiger'. Ink painting on paper by Mu Ch'i (1180–1250). China, Sung dynasty. *British Museum.*

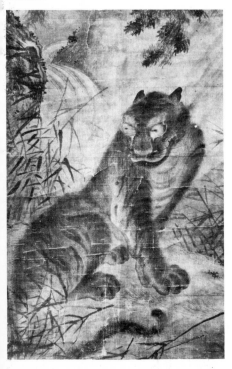

'A Goat and a Sheep'. Handscroll by Chao Meng-fu (active 1226–1290). China, Yuan dynasty. *Freer Gallery of Art, Washington D.C.*

This popularity of landscape painting was the result of a national change of philosophy and outlook. Whereas T'ang China devoted itself to the enjoyment of the pleasures of the world, the philosophy of Sung China was introvert, searching for the spiritual self.

In addition to landscapes, paintings of nature were popular mainly on album leaves, and subjects such as flowers, birds and insects were painted by a number of artists. Many of these paintings are deceptively simple. There is an attractive little painting, 'Bird on a Bough' in the British Museum, which illustrates the quality of these works. A number of paintings, mainly of similar subjects, attributed to this period are in Japan.

The full range of painting of the period is indicated by the list of categories given in the catalogue of the collection of the Emperor Hui Tsung. Ten classes are listed. (1) Taoist and Buddhist (2) Human affairs (3) Palaces (4) Foreign peoples, tribes (5) Dragons and fishes (6) Landscapes (7) Animals (8) Flowers and birds (9) Bamboos in ink (10) Vegetables and fruits. The order of listing was not necessarily the order of popularity. The majority of paintings fall into class eight.

The Sung period must be divided into two, the early Sung with its capital in the north, and the later Sung or Southern Sung with its capital in the south at Hang Chou. During the period Imperial patronage of the arts rose to a grand level. The academy attached to the Imperial court drew together a number of artists of note, though some who preferred their independence worked away from court where they developed their style free from Imperial interference.

The last Emperor of the Northern Sung period was Hui Tsung (1082–1135) himself a painter of note. There is a superb painting of 'Five-coloured Parakeet on the Branch of a Blossoming Apricot Tree' attributed to the Emperor in the Boston Museum of Fine Arts. Hui Tsung, a great lover of the arts, had amassed a considerable collection of paintings which were captured together with the Emperor himself when the Chin invaded the capital in 1126. Few specimens from this collection are still in existence.

After the invasion the court moved to Hang Chou where after a short time it re-established its former way of life, patronising the arts and indulging in philosophic dreams of life, apparently unconcerned with the state of the country, which was soon to be dominated by the Mongols, already making their presence felt on the borders. The beauties of the lake scenery of Hang Chou profoundly influenced artists who practised there.

The Ma-Hsia school of painting was created by the artists Ma Yuan (active 1190–1225) and Hsia Kuei (1180–1230).

Ma Yuan's lyrical and romantic interpretations of landscapes became the model for later painters, who often, accentuating the moods, produced paintings of extreme sentimentality, losing all the elegance and strength of Ma Yuan's ideals. He was a master of 'one cornered painting' placing his point of interest and emphasis in one corner of the painting. His pictures have little colour, lines are angular, and great importance is placed on space.

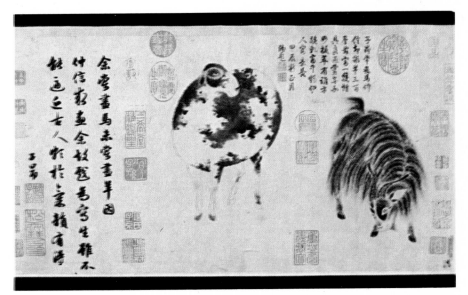

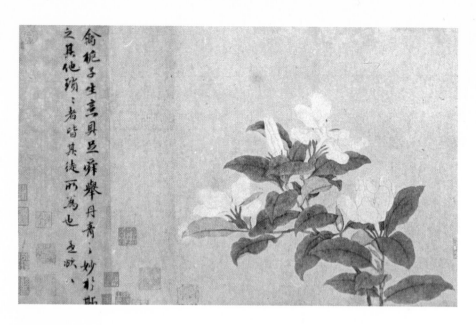

The work of his contemporary Hsia Kuei is less sentimental and much bolder than Ma Yuan's. His landscapes are full of atmosphere and convey a sense of urgency. His style is characterised by short, sharp, angular strokes conveying a speed of execution. A masterpiece by him, a long landscape handscroll in ink, is in the Palace Museum, Taiwan.

As mentioned earlier, Ch'an Buddhism had a profound effect on the art of the Sung dynasty. Unlike Mahayana Buddhism, it did not rely on icons or in gradual steps to enlightenment, but taught that enlightenment was spontaneous, and that all religious trappings were useless. This had an effect on subjects chosen for paintings, which could be almost anything; iconography was discarded. The essential element in the style was outward simplicity and speed of execution. This produced outlines of spontaneous ingenuity, depicting subjects chosen from all aspects of nature. The concept that truth of enlightenment could be found in even the most humble subject produced paintings of unusual simplicity, emitting an air of spiritual truth.

The appearance of simplicity is misleading, for it is the result of much thought and meditation. The majority of Ch'an paintings were done outside the court. The greatest exponent of the art was a monk called Mu Ch'i (1180–1250). His painting of 'Six Persimmons' is in the Daitoku-ji, Kyoto. Most of the Ch'an pictures are in Japan, where they were more appreciated and where the philosophy of Zen Buddhism is still practised.

Other painters of merit of the period are Ying Yu-chien, famous for his abstract and impressionistic treatment of landscapes; Liang K'ai, famous for his painting of the Poet Li Tai-no, now in the National Museum, Tokyo; and Kung K'ai, painter in the Taoist tradition.

Paintings of the Sung dynasty are rare and the collector should be cautious if offered one for sale. Unless from a reliable source with a guarantee it should be assumed to be a later copy.

In 1276, the Sung dynasty collapsed under the weight of the Mongol invasion, and the Yuan dynasty was established.

During this short period there was a reversal of styles to those of the Five Dynasties and T'ang period. The Mongols were fond of horses, and a number of equestrian paintings in the T'ang style were painted by the artist Chao Meng-fu (active 1226–1290); while Ch'ien Hsuan (1235–1297) painted pictures of flowers and insects in the Sung style.

Some artists refused to work at the Mongol court, but towards the end of the period things had settled down. It is in this period that we must place the art of the masters Huang Kung-wang (1269–1354), Wu Chen (1280–1354), Ni Tsan (1301–1374) and Wang Meng (c. 1309–1385). Their painting rejected the romanticism of the Sung dynasty in favour of a detached and objective treatment of nature. Their techniques also differed. No longer do we see the spontaneous line, but instead a picture built up from a series of short strokes and dots, sometimes overlapping each other. The picture was thus gradually built up as it developed in the artist's mind, until complete. The famous landscape scroll by Huang Kung-wang, now in the Palace Museum, Taiwan, is said to have taken three years to complete.

A famous painting by Wu Chen, 'Bamboo in the Wind', now in the Museum

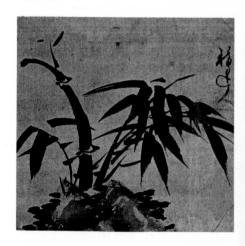

26

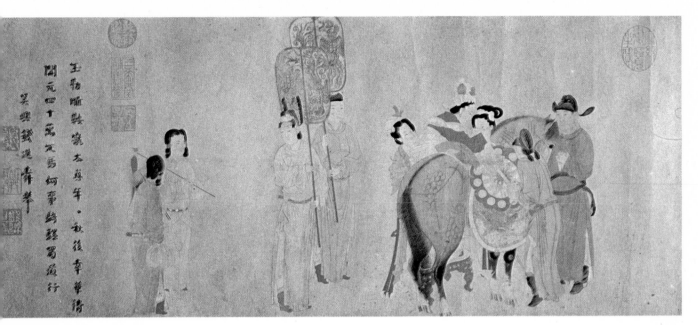

Yang Kuei-fei Mounting a Horse'. Hand-scroll by Ch'ien Hsuan (1235–1297). China, Yuan dynasty. *Freer Gallery of Art, Washing-*

of Fine Arts, Boston, is a superb example of observation and brushwork. Wang Meng is famous for his imaginary landscapes, while the paintings of Ni Tsan are easily recognised, though they were often imitated. His simple composition, delicate colours, and superb brushwork created landscapes of serene beauty.

Paintings of the Ming dynasty are more plentiful than those of earlier periods, and can be attributed with far more confidence. The art can perhaps be best described as Baroque. Paintings are larger and grander, and the colouring richer. Painting during this period was essentially the pursuit of the literati, and was the respectable pursuit not only of the scholar administrator class but also of the great landowners. It was this scholarly interest coupled with the Baroque spirit that was responsible for the growing theoretical interest in art, and the production of numerous treatises and other art literature, which have left their mark on Chinese art criticism and appreciation even to the present day. As mentioned earlier, different schools with their hypothetical differences were recognised. The paintings of the literati, non professionals, the Wen Jen Hua (Painting of the Literati) were identified with the Southern School. One might say the arbitrary division between the Southern and Northern Schools was one of snobbery. The literati considered painting as one of the true cultural pursuits, and wished to delineate between their painting and those of the professionals. In actual fact it is often difficult to distinguish between the two schools. However, it was said that the Northern School relied to a greater extent on colour and detail, whereas the Southern School carried on the tradition of the four great landscapists of the Yuan period, relying on the use of ink and atmospheric effects. The same divisions were adopted by the Japanese.

Two other schools that have their origin in the Ming period are the Che, taking its name from the province of Chekiang where its originator Tai Chin (active 1446) was born; and the school of Wu, founded by Shen Chou (1427–1509) and named after the province of Wu.

Tai Chin, originally a painter at the court of the Emperor Hsuan Te (1426–35), left the court to develop his own style, greatly influenced by the work of Ma Yuan of the Sung dynasty. A famous handscroll 'Fishermen on the River', ink on paper, is in the Freer Gallery of Art, Washington.

Whereas Tai Chin was a professional, Shen Chou, founder of the Wu School was an amateur. His successor, Wen Cheng-ming (1470–1559), was also a scholar/poet painter. The school established at Su Chou became the centre of the non-professionals. The Schools of Che and Wu often merge with the Northern and Southern Schools, and it is difficult to distinguish between them.

A great number of painters are known to have produced works during the Ming dynasty, many of which can be seen in museums throughout the world.

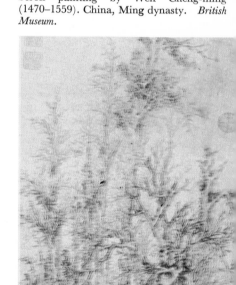

Shih Chung's (1437–1517) emotional and spontaneous work can be seen in a snow landscape in the Museum of Fine Arts, Boston; also in the museum is a scroll of a hermit contemplating nature, attributed to another master of the period Wu Wei (1458–1508). Another work attributed to him 'River Landscape', is in the National Museum, Stockholm. Lin Liang (*c*.1500) was an adept at bird and flower painting in wash, covering large areas with ease, while Lu Chi, active at the same period, concentrated on more decorative and colourful treatment of the same subjects. A fine painting by the former, 'Wild Geese in Bushes', is in the British Museum.

The four great masters of the early part of the 16th century were active during the reign of the Emperor, Chia Ching (1522–1566). They were Wen Cheng-ming (1470–1559), pupil of Shen Chou and famous for his paintings of landscapes and bamboo; T'ang Yin (1470–1523) and Ch'iu Ying (1510–1551) both pupils of Chou Ch'en. They painted mountainous landscapes often including figures, to which great attention was paid, The Museum of Fine Arts, Boston, possesses a fine landscape of 'Houses in a Bamboo Grove' by Ch'iu Ying. They also painted genre scenes and women. The British Museum has an interesting painting of the Emperor Ch'en Shu-pao listening to the music of his concubine, attributed to Ch'iu Ying. The last of the four was Hsieh Shih-chen (1488–1547) whose large and detailed landscapes perhaps illustrate best of all the effect of the art of the Ming period on a subject that during the Yuan dynasty was simplicity itself.

In contrast to the work of Hsieh Shih-chen, we must mention the paintings by Hsu Wei (1521–1593) whose explosive ink paintings of bamboo do much to restore our faith in the spontaneity and originality of Chinese painting.

The collector is strongly advised to view as many paintings as possible in museums and galleries, and to study books on the subject, so that he may become thoroughly familiar with the peculiarities of the different styles and periods. In this way he will build up a valuable mental picture with which to make comparisons and attributions.

The painting of the Ch'ing dynasty is well represented, and it will be mostly with this period that the collector will find he has to deal, but to understand

'Hsi Wang-mu, Legendary Queen of the West, with a Phoenix'. Painting on silk by Wu Wei (1458–1508). China, Ming dynasty. *British Museum.*

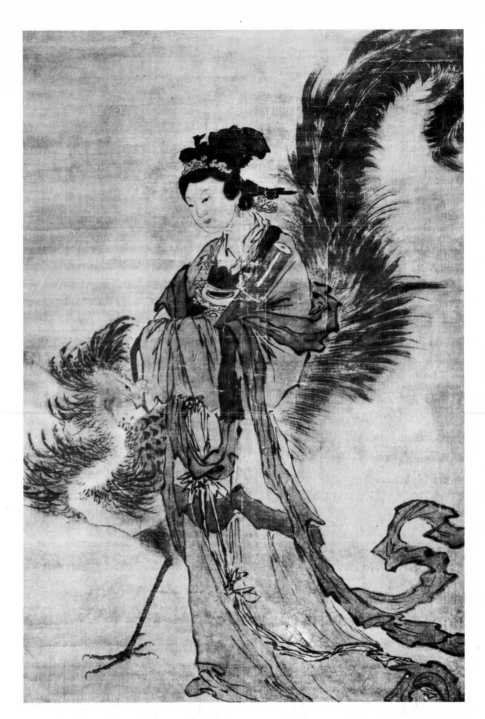

'Autumn Colours at Hsun-yang'. Detail of a handscroll by Lu Chi (*c*. 1500). China, Ming dynasty. *Freer Gallery of Art, Washington D.C.*

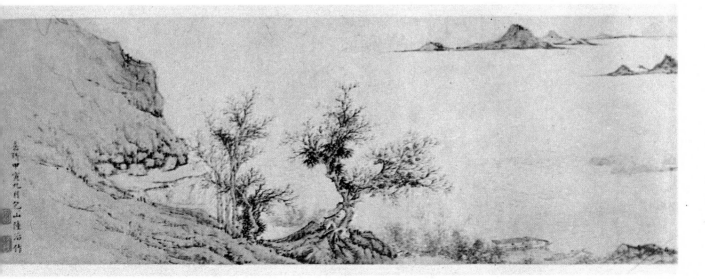

and appreciate Ch'ing art it is essential that a basic knowledge of the foregoing has been obtained.

Ch'ing painting is by no means the poor relation of Chinese art. Undervalued by some, it can hold its own with the painting of the earlier periods, but of course, only if judged within the confines of its own stylistic limitations.

The Manchus tried to assimilate as much Chinese culture as possible, and succeeded so well that they became almost more Chinese than the Chinese! In this environment painting became more retrospective, artists looking to the great masters of the past for inspiration. Another factor that appears during this period is the influence of Europe on the art and culture of China. China opened her borders to foreign ambassadors and trading missions, and made concerted efforts to expand her trade. The price she paid for this is especially noticeable towards the later part of the period, when Western influences appear in the art.

The Ch'ing court indulged in luxury, Imperial patronage was lavished on the arts and scholarship encouraged. The nobility and wealthy merchants followed the court, patronising scholars and painters alike. During the period a number of learned works were produced, among which may be mentioned the *Imperial Encyclopedia of Calligraphy and Painting*, in 100 volumes. Painting, however, as already mentioned, was retrospective. Textbooks on painting advocating set compositions threatened to stifle the imaginative genius of the Chinese artist. *The Album of the Ten Bamboo Halls* was published in 1630 and the *Mustard Seed Garden Compendium* in 1689, both illustrated with wood cuts.

The masters of the early Ch'ing Dynasty painted in the traditional style, influenced by the work of the Sung and Yuan dynasties. Their work was mainly confined to landscapes, but although very skilfully executed they lacked the originality and quality of the earlier works.

Painting during this period was primarily the pursuit of the literati, and with the exception of painters such as Yun Shou-p'ing artists were all literati and amateur. Among the early masters of the Ch'ing Dynasty were the Four Wang;

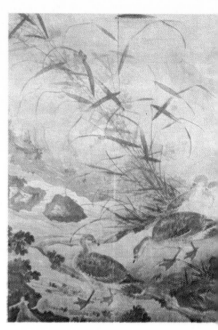

'Wild Geese in Bushes by a Mountain Stream'. Scroll painting by Lin Liang (c. 1500). China, Ming dynasty. *British Museum.*

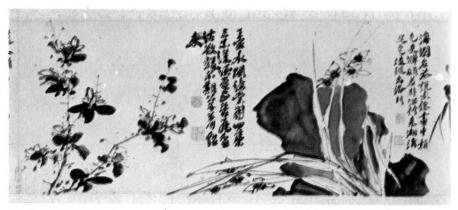

'Nature Studies'. Detail of a handscroll by Hsu Wei (1521–1593). China, Ming dynasty. *Freer Gallery of Art, Washington D.C.*

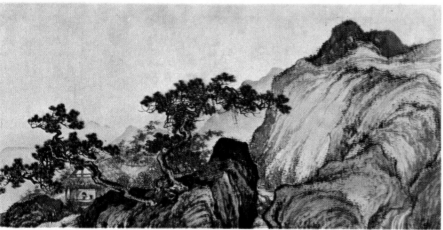

'Dreaming of Immortality in a Thatched Cottage'. Detail of a handscroll by Chou Ch'en. China, Ming dynasty. *Freer Gallery of Art, Washington D.C.*

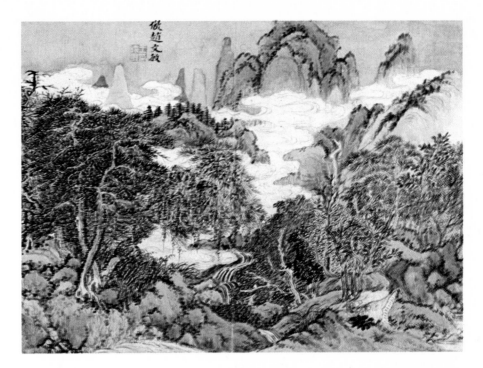

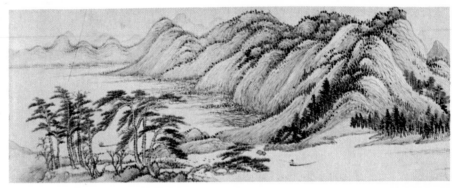

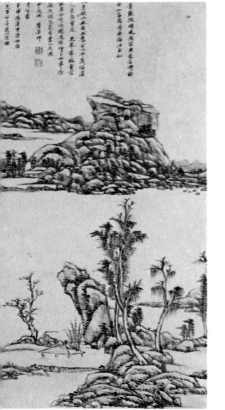

Wang Shih-min (1592–1680) landscape painter whose favourite theme was seasonal renditions of mountain valleys, packed with detail; Wang Chien (1598–1677) a contemporary of Wang Shih-min, also favoured landscapes, though of a somewhat simpler character. The two other 'Wangs' belong to a slightly later period, working mainly for the Emperor K'ang Hsi. Wang Hui (1632–1720) was a master of the atmospheric painting, his imagination and temperament being reflected in his pictures. His contemporary Wang Yuan-ch'i (1642–1715) was editor of the *Imperial Encyclopedia of Calligraphy and Painting* mentioned earlier. Although his opinion on painting was greatly valued in his day, perhaps because he sought to put into practice the theoretical ideas of painting favoured at the time, his paintings are crowded and monotonous and lack originality. His formula of composition can be seen in a landscape now in the British Museum, London. The towering mountain in the top left portion of the picture contrasts strongly with the detail and delicate foliage in the right foreground; a valley separates the two. The suggestion of distance is given by the 'fuzzy' treatment of the mountains.

Yun Shou-p'ing (1633–1690) unlike the Wangs was a professional painter, of poor parentage. A superb artist, his paintings of flowers and plants give detail without giving the impression of botanical studies. His sense of composition and colour harmonise to make paintings of great beauty. His ink studies show a superb rhythmic quality of brush work. The influence of Western ideas can also be seen in some of his works.

These painters all worked in the traditional style, but for something of the early originality seen in the paintings of the Sung and Yuan periods we must turn to the 'individualists' as they are sometimes called. Mostly Buddhist priests, they worked in the Ch'an style. Their paintings are notable for their originality and spontaneity. The pictures seem to explode on the paper. Only essentials are recorded and space again assumes an important role.

Chu Ta, (*c.* 1625–1700) also known as Pa-ta Shan-jen, produced a number of superb flower and bird paintings in ink. His works are masterpieces of

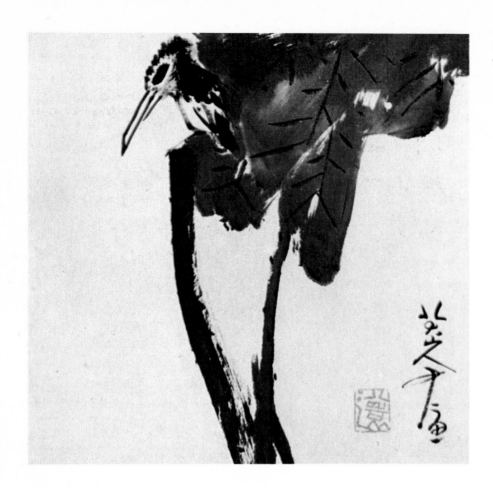

'Kingfisher'. Album leaf by Chu Ta (c. 1625–1700). China, Ch'ing dynasty. *Freer Gallery of Art, Washington D.C.*

simplicity. With a few well-chosen strokes the paper comes alive. His wit is reflected in his subjects, chosen from the world of animals, insects, fishes and plants. He also painted landscapes, usually on a larger scale than his nature pictures.

Another priest, Tao-chi (c. 1630–1714) was not only a good painter but an accomplished writer as well. Tao-chi's paintings show his determination to break away from the hackneyed renditions in traditional styles. The swiftness of his brush is best seen in his landscapes, where he imparts new life to the subject. His vision and simplicity of style produced paintings of superb quality; his subjects were unusual, and figures when included, although small in context, are full of life and movement.

Paintings of an unusual character were produced by K'un Ts'an (c. 1625–1700) another member of the priesthood. His pictures of Buddhist subjects take a different line to traditional ideas.

The individual spirit is expressed in a different way in the work of Kung Hsien (c. 1617–1689), whose paintings had something of the monumental mysterious quality of El Greco. His powerful landscapes, in ink, are among the most notable paintings of the Ch'ing dynasty. A superb landscape in the Drennovitz Collection, Switzerland, illustrates his almost surrealistic scenic power. The jagged peaks of the mountains, the heavy clouds and sparse foliage, cover the paper in various tones of ink, creating an air of extreme loneliness.

Three painters of merit who worked during the reign of the Emperor Yung Cheng were Kao Ch'i-p'ei (d. 1734), Chiang Ting-hsi (1669–1732) and Kao Feng-han (1683–1743). Kao Ch'i-p'ei, dissatisfied with the potential of the brush, was an exponent of finger painting. His famous painting of the exorciser Chung K'uei best shows the power of his technique.

The full impact of Western ideals of art can be seen in some of the paintings produced during the reign of the Emperor Ch'ien Lung, who, himself a painter, poet and calligrapher, was extremely interested in European techniques, so much so that he commissioned Western painters to record his victories. As a painter he often experimented with Western ideas, but his paintings are dull and uninspired. He loved beauty and art and was especially interested in lacquer. He is credited as the author of over 30,000 poems, some of which were inscribed on objects made for Imperial use.

Paintings with Western influences, although interesting, lose something of the essence of Chinese art. Although Europeans had an effect on Chinese

32

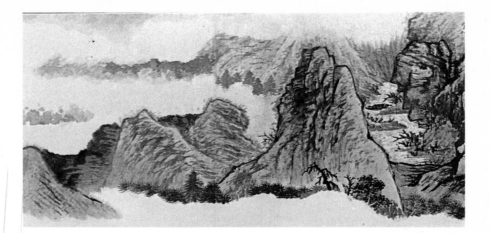

'Peach Blossom Spring'. Detail of a hand-scroll by Tao-chi (c. 1630–1714). China, Ch'ing dynasty. *Freer Gallery of Art,*

painting, China too had an effect on the arts and crafts of Europe. Chinoiserie became fashionable, and large numbers of objects of all kinds were exported from China to Europe to satisfy the fashion. Two Europeans who learned the Chinese style of painting were protégés of the Emperor. They were Castiglione (1698–1766) and Attiret, both Jesuits. Castiglione's paintings are Chinese in appearance and are sometimes signed with Chinese characters. His Chinese name was Lang Shih-ning.

An artist who learned the European method from the two was Tsou-I-Kuei (1686–1722). His paintings show the sad marriage between the two styles. Gone are the flowing lines, the rhythmic strokes, the very essences of Chinese art as outlined in the Six Canons. His subjects are dry and almost clinical in effect. Although Ch'ien Lung admired his work, his paintings are poor substitutes for the great masterpieces of earlier epochs.

The happiest marriage between the two styles can be seen in the work of Ching T'ing-piao, who while using some of the techniques of European art retains the Chinese style.

Another attractive marriage of the two styles can be seen in the work of Leng Mei who specialised mainly in paintings of ladies of high station. A fine illustration of his style can be seen in 'Lady with Children and Servants on a Terrace', now in the Museum of Fine Arts, Boston.

Many artists practised during the period, and their work, with some exceptions, generally falls into the styles outlined above.

In a somewhat different vein are the portraits of ancestors. Though usually considered the work of artisans, there are some paintings of considerable artistic merit.

During the 18th and 19th centuries, painting was still the pursuit of Wen Jen, or literati. Works were often produced in the traditional manner, with traditional subjects, while experiments were carried out with Western techniques.

To develop his taste in Chinese painting, the collector should endeavour to view as many paintings in museums and galleries as possible. In this way he will be able to distinguish the original idea from the hackneyed reproduction, but as in all fields of painting it is his taste that he must indulge. He must decide what pleases him. Whether it is the traditional rendition of the landscape, the delicate illustration of nature, or the spontaneous genius of a Ch'an work, he will find that within his chosen field he will be able to choose the minor (or major!) master from the run of the mill.

In such a specialist field the collector, even if experienced, will need help, especially with attributions. Museums are always willing to help in this respect, and Curators, eager to expand their own knowledge, will often be very pleased to see paintings and help with attributions (but not valuations). The collector should find a museum with a good collection of oriental paintings, and take his painting there. Do not take them to a general museum, unless the Curator or Keeper is a known orientalist.

Many fine works were produced during the 19th century, but we can no longer pinpoint artists of great merit, although a number of artists produced works which occasionally rose to great heights.

'Flowers, Bamboos and Rocks'. Fan by Kao Feng-han (1683–1743). China, Ch'ing dynasty. *British Museum.*

KOREA

Compared with that of China and Japan we knew little of Korean painting until comparatively recently.

When studying the art of Korea we must always bear in mind the geographical position of the country. Situated as it is midway between China and Japan, it received influences from both, but was mainly the 'middle man' for transferring Chinese ideas to Japan. Thus much of Korean art is in the Chinese style; but it is too easy to dismiss Korean work as mere 'provincial' Chinese. Korean painting developed a character of its own, though admittedly at a late date. However, the earlier works, too, have something typically Korean about them.

Ancestor worship played an important part in the early frescoe paintings of Koguryo, in North Korea, where the ideals of Han China can also be seen clearly. The influence of Buddhism was not felt until quite late in the 4th century. It never had a total effect on the art of the country, but shared its influence with a number of other philosophies such as Confucianism and Shamanism.

Paintings in the Taoist manner were also produced. Nature here was all-important and paintings in the style are closely related to Chinese painting of the Southern Sung dynasty, both in technique and subject matter. A painter of some merit who worked in the style was Yi Sang-chwa (c. 1550). Many aspects of Korean painting are similar to those of China. Most of the court painting of the Yi period, which lasted from A.D. 1392 until 1910, was strongly influenced by the art traditions of T'ang China. As in China, there was the Academy, the Tohwa-so, attached to the Emperor's court. Painting was encouraged and commissions were given to artists by a special office set up for the purpose. Apart from the professional painters of the court there were also the literati painters who indulged in painting as a part-time pursuit. As in China, there was a certain amount of rivalry between the two groups. The Wen Jen, or literati, thought themselves exponents of the Korean tradition. Their art was strongly influenced by Zen Buddhism (Korean-Son) and Confucianism. As in China an attempt was made to group together the professional painters who painted in the traditional style of the court, as the 'Northern School', while the Wen Jen saw themselves as the 'Southern School', but these terms have little significance.

The golden age of Korean art occurred in the 18th century. The traditional conservatism of the people preserved the Korean identity over the centuries, until in the 17th and 18th centuries it blossomed forth in the art of the day. The 18th century saw the continuation of the tradition of veneration of the ancestor. Ancestor portraits were painted in the traditional or neo classical style, with hard lines and well-defined colours. They are mainly anonymous, the work of professional artists.

Paintings of animals, birds and plants were extremely realistic, probably influenced by European techniques, which had such an effect on Chinese art of the period. A master of this form of painting was Pyon Sang-byok. He rose to a high position occupying the post of hyongnam (County Official) and was honoured by the Court with the title of Kuksa (Best in the Country).

His pictures are full of charm, portraying the individual characteristics of the animals he painted. He also painted ancestor portraits, and it was this that won him fame at court. He is credited with having painted over a hundred of these portraits, but few have survived. Today, however, we value more his paintings of animals, in which he allowed his humour and ideas to flow unrestricted by the rules that governed the production of ancestor portraits.

The principal exponent of the Wen Jen Hua was Sim Sa-jong (1707–1770). Considered perhaps the greatest painter Korea produced, his landscapes are

superb and were even admired in China. His delicate colouring, light swift brushwork reflect perfectly the Confucian attitude to nature.

Korean artists followed the trends in China, and often produced works in archaic style. One such artist was Yi In-mum (1746–1825) who was greatly influenced by the Ma-Hsia school of Ming China.

Kim Hong-do (c. 1760) painted waterscapes, landscapes, birds and flowers, all reflecting his powerful love of nature. A professional painter, he attained the rank of hyongnam. He was strongly influenced by the Chinese artist Tao Chi.

In Korea, genre painting reached great heights unequalled in China, although possibly receiving its original inspiration from that direction. Two exponents of the art were Sin Yun-bok (c. 1758) and Kim Duk-sin, (1754–1822) whose album paintings have an air almost of caricatures. Paintings in this style very often infuriated the conservative minds of the followers of Confucius. These fine spontaneous paintings illustrate everyday scenes giving us an insight into Korean life. Like the Japanese Ukiyo-e, they illustrate scenes of pleasure, such as drinking houses, dances, the Kisaeng, the Korean equivalent of the Japanese Geisha; musicians, lovers, women bathing, etc.

The finest Korean paintings are in the Duksoo Palace Museum, Korea.

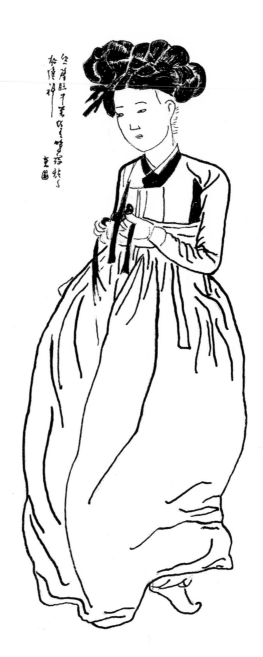

Portrait of a Girl. Painting by Sin Yun-bok (1758). Korea.

JAPAN

Painting in Japan was strongly influenced by Chinese art trends from earliest times, though it soon established its own identity, assimilating and adapting Chinese ideas to its own ends. In fact the earliest paintings in Japan are mostly by Chinese or Korean painters.

During the Asuka period (A.D. 552–645) painting was mainly religious, Buddhist in inspiration, but few examples have survived. The painting on the lacquered shrine of Tamamushi at Horyu-ji dates to this period, but as suggested in the chapter on lacquer it is probably the work of a Korean artist. An innovation found in the mural paintings of Tun Huang in China can also be seen in the painting on the shrine, where several scenes are superimposed as one. Unlike most Eastern painting, the panels of the shrine are painted in oils. The subject is drawn from the Jatakas, the previous incarnations of Sakyamuni.

During the Nara period (A.D. 710–794), Chinese influence was very great indeed. Strongly affected by the wondrous city of Ch'ang An, the Japanese produced their own miniature version, the City of Nara, and special Imperial departments were set up to encourage the arts, with the result that the Japanese learned the lesson of their Chinese model so well that it is often difficult to distinguish between the paintings of the two countries.

Other influences such as Buddhism with its Indian and Central Asian overtones were transmitted to Japan by way of China.

Little of the painting of the Nara period has survived. Even the fine murals in the Kondo at Horju-ji were devastated by fire in 1949, and we now have only the excellent colour photographs taken by a Japanese photographer shortly before the tragedy.

These fine paintings of Buddhas and Bodhisattvas, dating to the beginning of the 8th century, were among the masterpieces of Oriental painting. Both in technique and subject they can be compared with some of the mural paintings of India such as those of Ajanta, though here the figures are fuller, more abstract and monumental than the more plastic Indian prototypes. The outlines of the figures were beautifully executed with an even iron-red flowing line, and coloured with brown, yellow, red, blue and green pigments. Shading is sparingly used to give the figures a suggestion of substance.

It is to the Nara period that we can ascribe the earliest scroll paintings. There are a number of fragments of e-makimono or handscrolls illustrating the sutra of the Past and Present Incarnations of Sakyamuni Buddha preserved in private collections in Japan as well as in Tokyo University of the Arts.

The fragments illustrate scenes from the life of the Buddha, with text written beneath. The style is more akin to that of Six Dynasties China than that of the contemporary T'ang dynasty. The colours are brilliant, and the composition is simple, various scenes being divided from each other by mountains, trees or similar devices. The whole effect is one of unpretentious primitive charm.

There are several other paintings in existence which perhaps give us a more correct idea of the art of the period. A beautiful painting of Kichijo-ten, Goddess of Good Fortune, is in the Yakushi-ji Temple, Nara. She is painted in delicate colours of green and pink in typical T'ang style. Her body is plump, her face round with black sharply-outlined eyebrows and small red lips giving the appearance of make-up. Her flowing robes are rich, she wears a jewelled head-dress and holds a jewel in her left hand signifying her celestial powers.

The Shoso-in at Nara, a large log structure attached to the Temple, is a great storehouse of ancient objects given to the temple at various times. It is probably one of the oldest 'museums' in the world, and contains thousands of treasures dating back centuries. Another painting of the period, this time in ink only, is stored here. It shows a full-bodied Bodhisattva sitting on a cloud surrounded by a scarf which swirls around the figure. Similar in feeling to the painting of Kichijo-ten, it probably is only a sketch, but the brushwork gives it an air of movement more typical of a finished work.

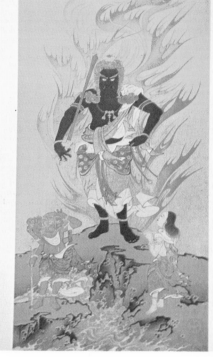

'Blue Fudo, with attendants, Seitaku and Kinkara'. Woodcut from a painting of the Korin school (Tokugawa period) but with earlier stylistic influences.

Coloured woodcut from an early illustration of Bodhisattva Avalokitesvara (Kannon), one of the murals in the Kondo at Horyu-ji, Japan, devastated by fire in 1949.

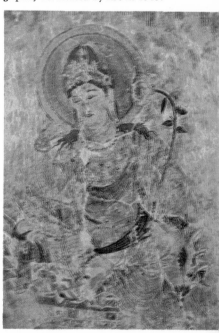

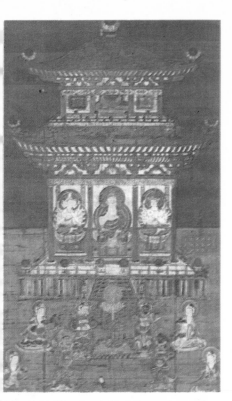

'Horokaku Mandara' (Buddha and attendant deities). Anonymous, 12th century. Ink, colour and cut gold on silk. Japan, Heian period. *Freer Gallery of Art, Washington D.C.*

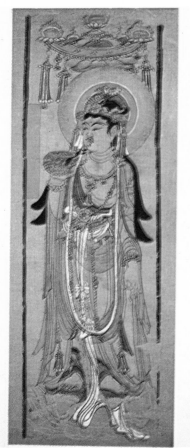

'Bodhisattva with Transparent Bowl'. Painting from Tun Huang, China, Stein collection, No. 139. *British Museum.*

Another painting sometimes attributed to the period is a portrait of Shotoku Taishi, patron of Japanese Buddhism. The work is not up to the standard of the paintings mentioned above, and it is probably a later copy.

The capital was moved from Nara at the beginning of the Early Heian period (A.D. 794–897), to Heian-kyo, present-day Kyoto. The period is sometimes known as Konin (A.D. 810–823) or Jogan (A.D. 859–876).

A number of new Buddhist sects came into being during the Early Heian period, which were to have a profound effect on the painting of the time. Tendai was introduced by Dengyo Daishi in A.D. 805, while Shingon was founded by Kobo Daishi in A.D. 806–7. Thus the simplicity of the early Buddhist art of Nara was superseded by an art strongly influenced by more elaborate iconographies of later forms of Mahayana Buddhism.

Followers of Tendai believed that Nirvana could be obtained by good living, study of the scriptures and meditation, while Shingon was based on Indian Tantric Buddhism with its mystic and esoteric rituals. Its origins can be traced back to the Vajrayana sect, 'The Vehicle of the Thunderbolt', a combination of primitive cults and Buddhism, which had established itself in Eastern India in the 8th century A.D. In the 11th century the doctrine was introduced into Tibet, already used to Tantric rituals, by Atisa and missionaries from the Vajrayana monastery at Vikramasila in Bihar, India. He founded the Ka-dam-pa sect in A.D. 1046, which was later reformed by the teacher Tsong-ka-pa to become the premier sect of Tibet. In India Tantric Buddhism was first added to the doctrine of Mahayana in the 6th century A.D. The Tantric doctrine is based on the worship of the female energy of the god (Sakti) in conjunction with the male force. Tantric manifestations are shown either pacific or angry with multiple heads and/or arms. The iconography is very complicated. The name comes from the Tantras (treatises) on the worship of the Sakti and the attainment of 'Perfection' or the 'Eight Siddhis'.

Kobo Daishi returned from China in A.D. 807 with the 'True Word' and set up his temple in a high forest in Wakayama province.

Part of the ritual was secret and only revealed to initiates, but salvation was made easy for the layman who only had to recite the public magic formulae and was not troubled by the more mysterious and esoteric beliefs. The fearsome and awful aspects of Buddhism were emphasised in paintings and sculpture.

A popular form of painting used to express the complexities of existence as seen by the Tendai and Shingon faiths was the Mandara (Sanskrit-Mandala) a kind of magic circle diagram illustrating various beliefs of present and future lives. Mandaras were used in special rituals invoking deities to grant 'Siddhi', superhuman powers. These charts are divided into geometrical sections containing various deities placed in key positions, according to the magical pattern. Instructions for producing Mandaras are included in the 22 volumes of the Tantra.

Mandaras are more of interest for their fine execution and draughtsmanship than for their artistic merit. The art of Shingon Buddhism was severely restricted by iconographic canons, but Japanese artists overcame these difficulties far better than those of other countries who embraced Tantric beliefs. Paintings other than Mandaras were produced which show the true impact of Shingon Buddhism. A superb painting of Aka Fudo, a horrific manifestation of Dainichi Nyorai, the Supreme Buddha, in the Myoo-in temple on Mount Koya, contrasts strongly with the painting of Kichijo-ten of the Nara period, mentioned earlier. Here the serene spiritual air of the Kichijo-ten painting gives way to the forceful power of Shingon Buddhism portrayed by the massive figure of Aka Fudo, as he sits on a rock, holding a rope and sword, a flame halo emanating from his body. His red form, glaring expression and canine fangs contrast with the naturalistic figures of his attendants Seitaku and Kinkara beside him. The rendering of the rocks on which he sits recalls Chinese prototypes, but the painting has a typical Japanese feeling of the Early Heian period and there are no contemporary Chinese parallels. These typical traits, first seen in the art of the Early Heian period, were to have an important effect on the art of later eras.

Although painting must have been the principal artistic outlet of the time, few paintings have survived. Literature tells us that secular painting continued, probably in the T'ang style, and gives us the names of two masters Kudara no Kawanari and Kose no Kanaoka, but none of their work exists today.

By the Heian period proper (A.D. 897–1185) also known as the Fujiwara period, the esoteric forms of Buddhism had lost much of their attraction, and although the old Nara sects were still in existence they had lost their hold. The sect of Jodo, devoted to the worship of Amida Buddha, Lord of Boundless Light, became popular. This simple form of Buddhism was first introduced in

the Nara period, but it was in the Heian period that it really found its place. Salvation was made easy, one had simply to recite the formula 'Namu Amida Butsu', and all would be forgiven, and the road to paradise secure. This new form of Buddhism had a notable effect on art. Paintings were produced of Amida in various positions, sometimes alone, other times attended by Bodhisattvas.

The painting became quieter and more realistic, and even the Shingon and Tendai sects found it necessary to introduce more beneficial, peaceful and attractive renditions of deities in order to retain their popularity with the laity. There are a number of very fine paintings of the period, mostly preserved in temples. Their warm colouring and naturalistic charm place them among the finest Japanese religious art. A popular composition showed Amida, surrounded by his attendants, descending from heaven to receive his followers. Known as the Amida Raigo, there are a number of examples of the Heian period as well as the later Kamakura periods. The most famous is the painting in the Daien-in of Mount Koya in Wakayama province.

Among the other fine paintings of the period may be mentioned the Bodhisattva Fugen, in the National Museum, Tokyo. The Bodhisattva is shown seated in the namaskara mudra, or attitude of prayer, on a white elephant. Although the deity is male the overall effect of the figure is female.

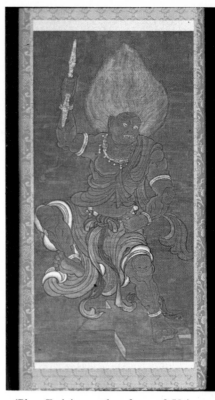

'Blue Fudo', a yaksa form of Vajrapani. Anonymous. Painting in ink, colour and gold on silk, 13–14th century. Japan, Kamakura period. *Freer Gallery of Art, Washington D.C.*

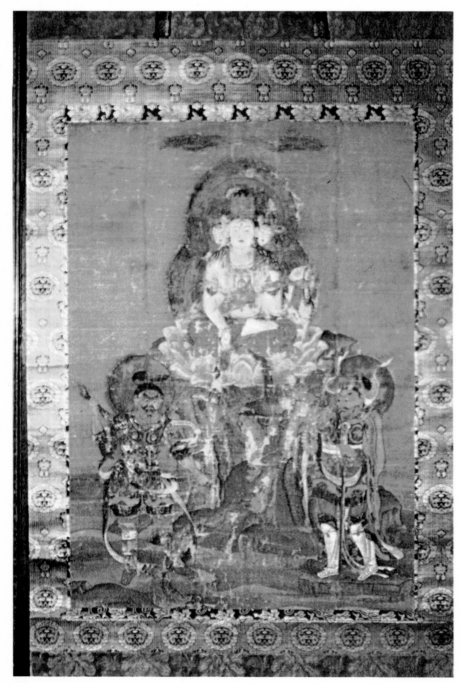

'Fuku Kenzaku Kannon and 2 Guardians'. Anonymous. Japan, Heian period. *British Museum.*

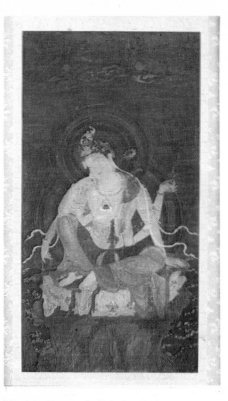

'Nyoirin Kannon'. Painting in ink, colour, silver and gold on silk. Anonymous, 12th century. Japan, Heian period. *Freer Gallery of Art, Washington D.C.*

Detail of 'Nyoirin Kannon'. Japan, Heian period. *Freer Gallery of Art, Washington D.C.*

'Yuzu Nembutsu Engi'. Detail from a handscroll. Anonymous, but dated 1329. Japan, Kamakura period. Yamato-e school. *Freer Gallery of Art, Washington D.C.*

Towards the end of the Fujiwara (Heian) period paintings were made depicting the Buddha in Nirvana, or his emergence from the golden coffin. A form of decoration, kiri-kane, the application of thin lines of gold leaf, was sometimes employed on these works.

Secular paintings were also produced, but it is difficult to ascribe many of these to the period with certainty. During the early Fujiwara the painting appears to have been essentially Chinese in style (Kara-e) but the end of the period heralded the introduction of Yamato-e, a distinctive Japanese style which was to flower during the succeeding Kamakura period.

Buddhism changed again during the Kamakura period (1185–1392) with the introduction of the Shingon and Nichiren sects, the change being reflected in the religious painting of the time, although paintings of Amida continued to be produced.

Our attention here, however, must be directed to the secular art, by far the most important of the period. For it is now for the first time that we see the Yamato-e style blossom and adapt and develop the Chinese idea of the handscroll into a distinct Japanese art form, e-makimono.

Monogatari or story pictures were produced in e-makimono form, measuring on average 12–15 inches wide and between 35–40 feet long. The artist had tremendous freedom and used every possible device to impart a sense of drama to the picture. A number of clever tricks were employed to take the viewer through the scroll from scene to scene; changing perspective, angles and close-ups, and sometimes even removing walls and roofs to show action inside buildings. The effect is typically Japanese and although originally developed from a Chinese idea they can in no way be compared with Chinese painting of the period. Unlike the Chinese artist who was mainly attracted by the abstract and transcendental, the Japanese painter was concerned with humans and human events, whether humorous or tragic. It is this quality that often makes Japanese art easier for the Westerner to understand.

The early scrolls had many of the scenes divided by areas of text, but later the text disappeared leaving only a continuous pictorial story. Two very fine scrolls in Yamato-e actually date to the late Heian (Fujiwara) period, but are more conveniently described here. They are the Shigisan-engi, 'The History of Mount Shigi', in the Chogosonshi-ji, Nara, and the 'Animal Scrolls', now in the Kozan-ji, Kyoto. Both are in ink and rely almost entirely on linear form with little or no colour. The Mount Shigi scroll relates a story of a rich man, who, when he refused to place food in a monk's begging bowl, suddenly saw his granary miraculously placed in the monk's bowl and then fly off to Mount Shigi.

The Animal Scroll, traditionally attributed to the artist Toba Sojo, depicts animals behaving as people, caricaturing and parodying humans and their establishments. There is even one scene in which a frog is shown as the Buddha, seated on a throne. The scroll is a masterpiece of tones and flowing lines, conveying a strong sense of movement.

There are other scrolls attributed to the period, but perhaps the most dramatic is the Heiji-monogatari-emaki. The three scrolls depicting scenes of

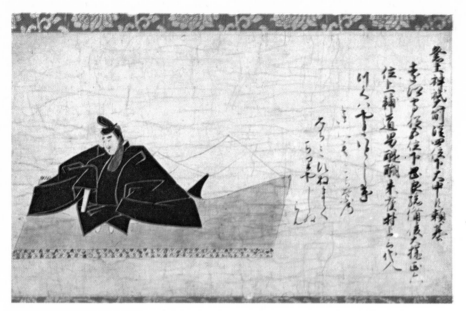

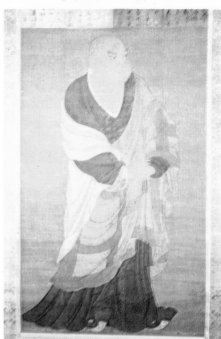

the Heiji war are now in the National Museum, Tokyo, the Seikado, and the Museum of Fine Arts, Boston.

Apart from monogatari, other forms of painting were produced during the period, including landscapes and genre scenes. Portraits were painted in a form known as chinso and subjects varied from warriors and priests to children. A typical example is the fine portrait of Minamoto-no-Yoritomo, attributed to Fujiwara Takanobu (1143–1206), in the Jingo-ji Temple, Kyoto. This sombre portrait of the founder of the Kamakura period is interesting for the geometric composition of the subject's robe, commanding the viewer's attention to the pale face. As a portrait it reveals all the character of the sitter.

Traditional Buddhist paintings continued to be produced and while ideals of Zen Buddhism influenced some of the paintings it is mainly in the succeeding Ashikaga period that we see its full impact.

Painting during the Ashikaga period (1392–1573) also known as the Muromachi period, again becomes influenced by Chinese ideals, this time of the Sung and early Ming periods, and the old colourful Japanese style fell out of fashion, though paintings continued to be painted in the style by the Tosa school, especially scrolls with a narrative.

As mentioned earlier, Zen grew in popularity until in the 14th century it became a major stimulus to painting. Artists inspired by the teachings tried to convey the message of Zen through their paintings. They were strongly influenced by Chinese Ch'an painting and techniques. Many artists of the period were in fact members of the Zen priesthood.

Favourite subjects were hermits, arhats such as Hotei, and portraits of Zen priests. There is an attractive imaginary portrait in the Freer Gallery of Art, Washington of the Chinese Zen priest, Kanzan, by the 14th-century artist Kao. A priest as well as a painter, his painting of Kanzan shows a fine sense of humour. The pot-bellied figure is shown with a mop of ruffled hair, looking unconcernedly into space. The brushwork is extremely simple, the picture composed of wash and a few flowing lines.

The Ashikaga Shoguns were greatly attracted to the new styles and made collections of Chinese paintings, many of which served as models for Japanese artists. A catalogue of the collection of the 8th Shogun was made by the artist So-ami (1472–1525).

Landscapes were produced mostly in ink in the Chinese Sung and Yuan tradition, and it is often very difficult to distinguish between Chinese and Japanese painting in the style, perhaps the only distinguishing feature being the brushwork, which sometimes tends to be carefully arranged, and lacks the originality of some of the Chinese prototypes. The landscapes, too, tended to be Japanese idealised impressions of Chinese terrain. An exception to this was the work of Sesshu (1420–1506) who had been to China and had seen the landscape for himself first hand. His paintings were greatly valued in China as well as Japan. However, apart from painting typical Chinese landscapes in his own style, he is noted as the first Japanese artist who recognised the beauty of his own countryside and translated it into painting.

The atmospheric paintings of landscapes again suited the ideals of Zen teachings. One of the first artists to paint in the new style was Mincho (1352–

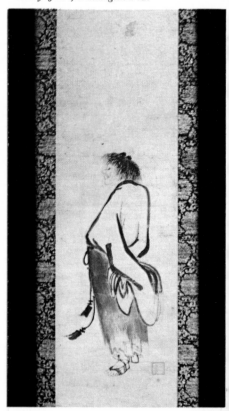

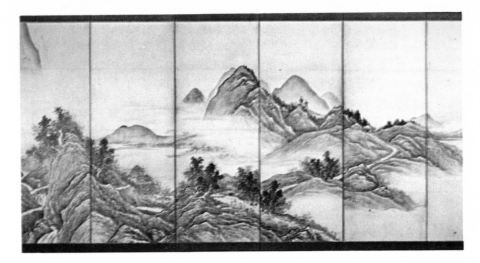

Landscape'. One of a pair of screens. Ink and slight colour on paper by Sesshu (1420–1506). Japan, Ashikaga period. *Freer Gallery of Art, Washington D.C.*

'Landscape'. Hanging scroll, ink on paper, attributed to Shuban (active first half of the 15th century). Japan, Ashikaga period. *Freer Gallery of Art, Washington D.C.*

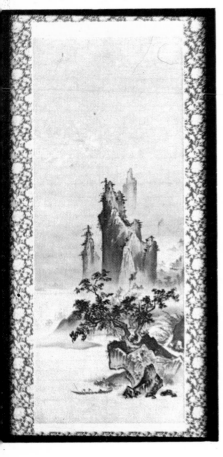

'Spring and Summer'. One of a pair of screens 'Birds and Flowers of the Four Seasons' by Sesshu (1420–1506). Japan, Ashikaga period. *Freer Gallery of Art, Washington D.C.*

1431). A member of the priesthood, his works are in the traditional Sung manner, although with overtones of early Ming ideals. Another monk, Josetsu (active 1405–30), painted a masterpiece illustrating Zen doctrines. The painting, the only one that can be attributed to him with certainty, is in the Taizo-in, Kyoto. It shows a man trying to catch a catfish with a gourd, illustrating the philosophy that Enlightenment is as impossible to obtain by reading as catching a fish is with a gourd. The painting in ink with soft colours is very simple, the scene being set with a stream and foliage, with just the slightest hint of misty mountains in the background.

A far greater number of works can be attributed to Josetsu's pupil, Shubun, who was active during the first half of the 15th century. He was strongly influenced by the 13th-century Chinese painters, Hsia Kuei and Ma Yuan, and there is a fine scroll by him in the National Museum, Tokyo, entitled 'Reading in a Hermitage in a Bamboo Grove'. It follows a theme used by Shubun in most of his paintings, that of placing a figure with a hut in a mountainous landscape. Mist plays an important part in his pictures, merging the water with the background, suggesting a dream-like vision.

His pupil, Sesshu (1420–1506) is considered one of the greatest of Japanese artists, certainly the greatest of the period. As mentioned earlier he travelled to China where he studied Chinese painting and observed the scenery first hand. Greatly influenced by what he had seen and learned, he adapted techniques and evolved his own style, although he painted with a number of techniques.

In China his work was greatly admired, and it is said that he was asked to paint a room in the palace at Peking. He was also offered the headship of a Chinese monastery.

He produced what may be said to be his greatest work in 1486 at the age of 66. A landscape scroll, it measures some 50 feet long and portrays the countryside in different seasons.

This superb work is in the Chinese style and would be hard to tell from a Chinese work were it not for his typical powerful brushwork. Sesshu developed his own style of brushwork from the Chinese by thickening and accentuating lines, producing a unique effect. A fine painting illustrating this technique is his 'Winter Landscape', in the National Museum, Tokyo.

Perhaps most interesting are his paintings of Japanese scenery. Another painting in the National Museum, Tokyo is a masterpiece of the 'spontaneous' style. In just a few explosive strokes he has created a landscape with misty mountains in the background, and hut, trees and water in the foreground.

The Japanese style of landscape first introduced by Sesshu was further developed by the artist Sesson (1504–1589). There were a number of imitators of Sesshu's style, but the only artist who added something new was Sesson, whose finest work is perhaps the stormy seascape in the Nomura Collection, Kyoto. The scene is vividly brought to life by Sesson's lively brush strokes creating a storm on paper. The trees bending in the gale, the waves crashing on the rocks, and the ship's sails blowing in the wind; all seem to be actually happening.

So-ami, (1472–1525), a painter mentioned earlier as the author of the catalogue of the Shogun's collection of Chinese painting, was the last of a family of artists called 'Ami'. His father Gei-ami (1431–1495) and his grandfather No-ami (1397–1471), were all painters in the Chinese tradition.

41

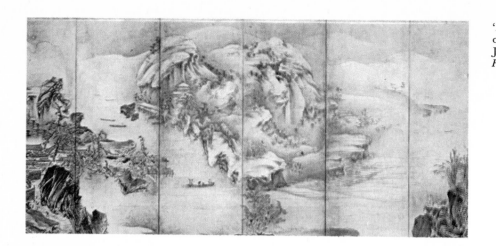

'Autumn and Winter'. Screen painting, ink, colour on paper by Sesson (1504–1589). Japan, Ashikaga period. Suiboku school. *Freer Gallery of Art, Washington D.C.*

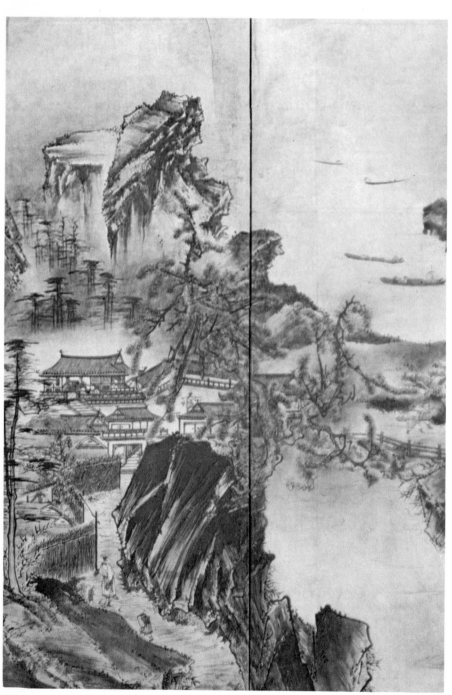

Detail of 'Autumn and Winter'. Screen painting by Sesson (1504–1589). Japan, Ashikaga period. *Freer Gallery of Art, Washington D.C.*

The influence of Zen declined towards the end of the Ashikaga period and greater attention was paid to decorative pictures. This decorative aspect is hinted at in the paintings of So-ami, but becomes a major factor in the paintings of Kano Masanabo (1434–1530) and his son Kano Motonobu (1476–1559), founders of the Kano School. Few paintings of the former exist, and it is in the work of his son Motonobu that we can perhaps best see the decorative element. A fine example is his 'Waterfall' in the Yamato Bunka-kan, Nara. A professional court painter like his father, he painted in a number of styles, sometimes even in Yamato-e, which was the tradition adopted by the Tosa School, founded by Tosa Yukihiro. The Kano School continued well into the 19th century but had its heyday during the Momoyama and early Tokugawa periods.

As already mentioned, the traditional native style with its brilliant colours was kept alive by the Tosa School. The greatest exponent of the style was Tosa Mitsunobu (1434–1525) who was master of the Imperial department of painting at court.

The decorative quality of works in the Kano style was to be recognised during the Momoyama period (1573–1615) when they were put to good use. Buddhism had declined and there was a marked increase in secular painting. During this period Japan was dominated by three military men, Oda Nobunaga (1534–1582), Toyotomi Hideyoshi (1536–1598) and Tokugawa Ieyasu (1542–1616) the founder of the Tokugawa Shogunate. Although it may seem strange, all were patrons of the arts and commissioned many works to decorate their castles.

Both the Tosa and Kano styles were used in paintings, sometimes combined together. Wall paintings and screens in the large public rooms of the castles used bold colours, sometimes with gold backgrounds, while paintings for the private rooms were often in monochrome. The paintings for these castles were often massive, Kano Eitoku (1543–1590) grandson of Motonobu, painted many screens and pictures for Nobunaga as well as Hideyoshi, and it is said that because of their huge size he had to paint some of the pictures with a large straw brush.

The climate was ripe for experimentation and invention, and it is in this period that we can identify the essential Japanese quality that was to be so important in later years.

Kano Eitoku combined the colour of the Tosa palette with the tradition of the Kano School to produce masterpieces of Japanese art. A superb folding screen by him, decorated with paintings of nine trees, is in the National Museum, Tokyo.

Although much of Eitoku's work has not survived, we know he produced works in the traditional ink style used by his grandfather, but they lacked originality. After his death in 1590 the Kano tradition was carried on by his adopted son Kano Sanraku (1559–1635). Although some of his work is more realistic than Eitoku's he also continued Eitoku's more abstract style.

Although the court was dominated by the Kano school, other artists were also at work, painting in a number of styles. One such artist was Hosegawa Tohaku (1539–1610). His work is fascinating because of the skill with which he mixes the Chinese ink style with Japanese decorative ideas. There is a fine pair of screens, 'Pine Trees in the Mist', by him in the National Museum, Tokyo. He also painted in the more colourful Momoyama style, and there is a series of paintings by him in the style in the Chishaku-in, Kyoto.

Japanese art received other influences during the period, this time from the West. Portuguese missionaries were allowed into the country and for a time Christianity flourished under the patronage of the Shogun, as Buddhism declined. The Japanese were fascinated by the Europeans and painted a number of screens depicting the everyday life of the foreigners in their settlements. These Namban Byobu, or screens depicting 'Southern Barbarians' as the Japanese called them, are most attractive, and herald a type of painting, that of genre scenes, that was to gain popularity during the succeeding Tokugawa period. Genre scenes of other subjects were also painted by artists of the Kano school, but were unsigned as they thought them a lesser art.

Painting, like the politics and economics of the country, underwent a number of changes during the Tokugawa period (1615–1868). A new and extremely popular style was to be born which reflected the everyday life of the people. Called Ukiyo-e, 'Pictures of the Fleeting World', it became the standard form of expression for another Japanese art form, the woodcut. However, during the early days of the period the painting remained more in the Momoyama style.

Afraid of what they had heard about the foreign missionaries in China and

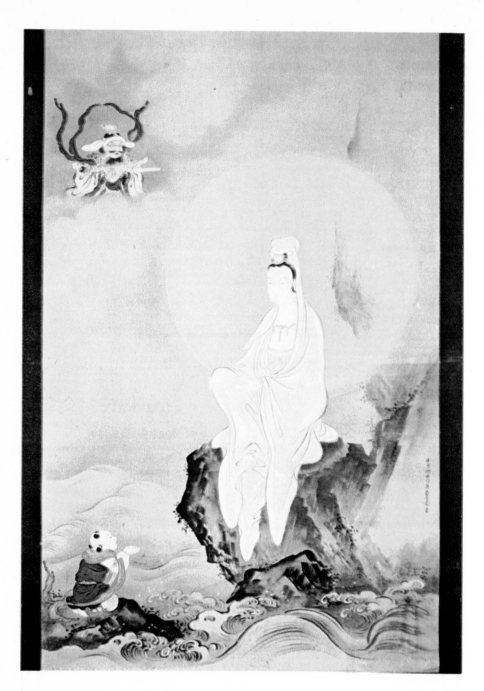

'Kannon the Unsurpassable'. Painting in ink and colour, by Tanyu. *British Museum*

the Philippines, the Togugawa Shogunate banished Christianity and imposed an isolation policy which lasted until the 19th century. This was to have a marked effect on the Arts.

The Tokugawa Shoguns patronised the arts, supporting the Kano School, a position the School was to hold until the end of the period. Painters in the style produced works for the Shoguns right down to the lowest ranks, hence we have a large number of works in the style. Included in this mass of painting are some very fine paintings as well as some extremely mediocre works.

The first painter of note working in the style during the early Tokugawa period was Kano Tanyu, (1602–1674), Eitoku's grandson. He painted in the Momoyama style as well as the more typical Chinese style of the Kano School. His younger brother Kano Naonobu (1607–1650) produced works more characteristic of the Sung masters. His free-flowing brushwork and superb use of tone produced works of great beauty.

Perhaps one of the greatest artists of the early Tokugawa period was Sotatsu (active 1596–1623). Strongly influenced by the colourful painting of the Tosa School, he established a style of his own. The result was superb. All the ingredients were carefully thought out; his clever use of space gives a misleading effect of simplicity, while his bright colouring creates an effect similar to that of Yamato-e with the overtones of Momoyama taste. His superb control of the brush was the crowning touch. His masterpiece is a screen illustrating the 'Tale of Genji', in the Seikado Foundation, Tokyo.

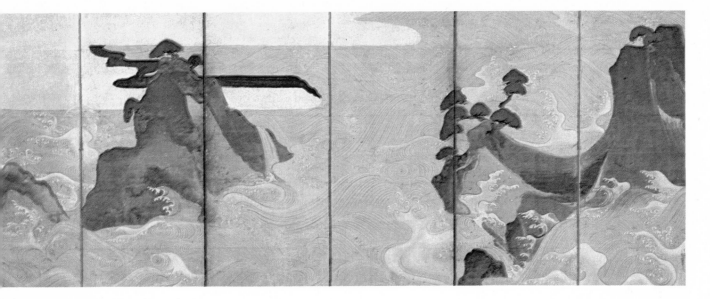

'Waves at Matsushima'. One of a pair of screens, ink, colour and gold on paper, by Nonomura Sotatsu (active 1596–1623). Japan, Momoyama/Tokugawa period. *Freer Gallery of Art, Washington D.C.*

A successor to the style was Ogata Korin (1658–1716). The son of a textile merchant, he was forced by financial difficulties to become a professional painter. Apart from being familiar with the work of Sotatsu, he was well versed in the other styles of the day, all of which influenced him profoundly. An interesting feature of his painting is his use of block colour directly on to the paper, without first outlining the composition as in traditional Chinese style. A superb example illustrating this technique is his folding screen of irises in the Nezu Museum, Tokyo. Another work of his, a pair of screens 'Red and White Plum Trees' is in the Atami Museum. Apart from being a great painter he was also a master of lacquer work (see chapter on lacquer).

In spite of the Tokugawa Shogunate's isolation policy some foreign influences did penetrate Japan, both Western and Chinese, probably by way of Nagasaki, where there was a Dutch settlement as well as a few resident Chinese.

The Chinese Wen Jen style (Japan: Bun-Jin) of literati amateur painting was adopted by such painters as Ike-no-Taiga (1723–1776) and Yosa Buson (1716–1783). Here again we see a return to the Chinese style. Paintings in the Bun-jin style in Japan show strong elements of Sung and Ming techniques, though the Japanese brush style tends to come through stronger than ever, leaving no doubt that the paintings in the style are Japanese. There is a fine sliding door with a landscape by Yosa Buson in the Museum of Eastern Art, Cologne.

Another artist in the Chinese manner, more influenced by the 'Individualists' of the 18th century, was Uragami Gyokudo (1745–1820).

Western influence can be seen in the work of Maruyama Okyo (1733–1795) whose naturalistic treatment, however shows that although he may have been influenced by Western ideals of art, his treatment of his subjects remains essentially Japanese. His most famous work is a pair of screens, painted with a scene of 'Pine Trees in the Snow', which is in the collection of the Mitsui family, Japan. A number of artists followed his style.

The art of genre painting, which some Kano artists had practised during the Momoyama period, became a major art form during the Tokugawa period. The merchant class wanted a style of art which pleased them and which they understood. Gradually the style of Ukiyo-e, 'Pictures of the Fleeting World', was born. Elements of both the Kano and Tosa Schools, together with inspiration from the established style of genre painting, were cleverly mixed together until finally a new art form was created. One of the first artists to work in the style was Hishikawa Moronobu (c. 1625–1694).

Although the style was principally used for the production of coloured prints, a number of very fine paintings were produced, sometimes by the print artists themselves (see chapter on Japanese Prints). It is sufficient, however, to mention that paintings were produced in the style as well as prints, though in much smaller numbers.

Japanese painting continued to be a major art form long after painting had declined in China, and there are many minor works of merit that were produced in Japan right up until the end of the 19th century.

Some collectors complain that they find it difficult to distinguish between Chinese and Japanese painting. While this may be excusable in some circum-

'Chrysanthemums and a Stream'. Fan painting by Ogata Korin (1658–1716). Japan, Tokugawa period. *Freer Gallery of Art, Washington D.C.*

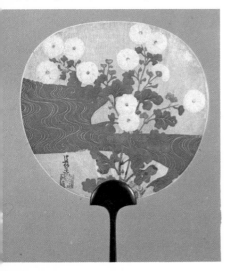

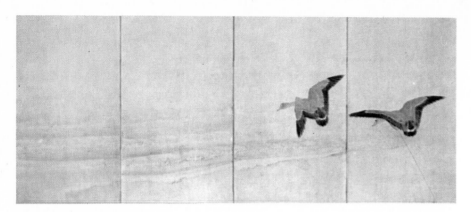

'Geese in Flight over a Beach'. Ink on paper, by Maruyama Okyo (1733–1795). Japan, Tokugawa period. *Freer Gallery of Art, Washington D.C.*

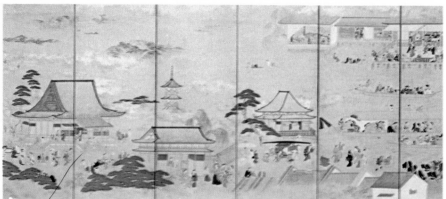

'Maple viewing at Asakusa'. One of a pair of screens, ink, colour and gold on paper, by Hishikawa Moronobu (*c.* 1625–1694). Japan, Tokugawa period. *Freer Gallery of Art, Washington D.C.*

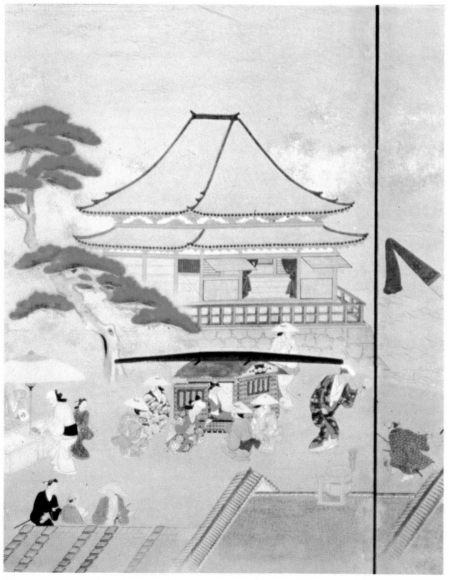

Detail of 'Maple viewing at Asakusa'. Screen painting by Hishikawa Moronobu (*c.* 1625–1694). Japan, Tokugawa period. *Freer Gallery of Art, Washington D.C.*

stances, if the collector looks for the points described above he should be able to tell the difference with ease. On the whole the Japanese artist was altogether more adventurous than his conservative Chinese colleague, who preferred to use his skill and artistry within the limitations of accepted artistic canons, often producing masterpieces, which themselves provided the inspiration and stimulation for the Japanese artist. As has been shown, the Japanese painter did not simply copy, but adapted and altered ideas with typical Japanese ingenuity, often adding original ideas of his own. In a general comparison between Japanese and Chinese painting it could be said that the Japanese has more individuality, and is enhanced by the artists' superb sense of colour and form. The collector, however, must decide for himself his preference for a particular school or style.

As with Chinese paintings, there are a number of Japanese paintings in existence with most optimistic attributions. Later works and copies abound, and the collector will do well to seek advice in the beginning. As mentioned earlier, museums are most willing to help. When buying, as with other categories of art, if the collector is unsure he should value as if the work was modern. Do not over-estimate age, rarity or value.

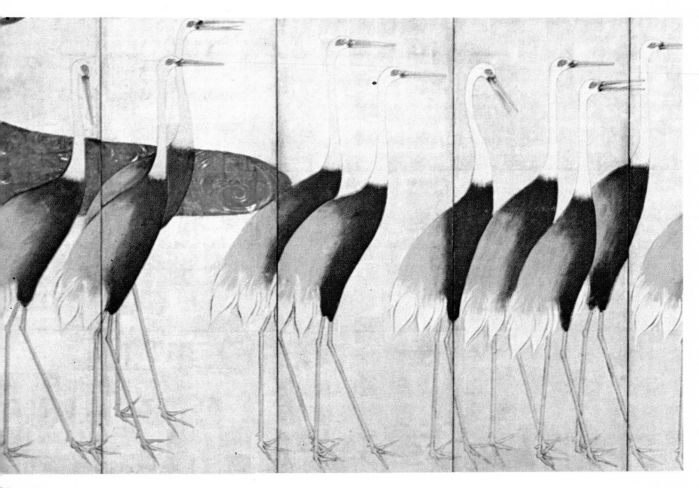

'Cranes'. One of a pair of screens, ink, colour and gold on paper, by Ogata Korin (1658–1716). Japan, Tokugawa period. *Freer Gallery of Art, Washington D.C.*

Japanese Prints

Ukiyo-e 'Pictures of the Fleeting World'. This generic term for the art of the Japanese woodcut is both apt and accurate. Ukiyo-e first developed as a style of painting; it was only later that it became the standard form of artistic expression for the woodcut.

Ukiyo-e is essentially a popular art directed at the urban masses of low income and can in no way be compared to the early philosophical master-pieces of the classical schools. It makes no lofty pretences, and apart from the occasional pun, analogy or parody, paintings and prints in the style are quite straightforward. Their appeal and artistic merit lie in the artist's flare for design, line and colour. For this reason they need no special introduction to the connoisseur and are readily appreciated by anyone with the slightest interest in art. But, for this very reason, they have long been neglected by the Japanese connoisseur, who was more in sympathy with the classical schools than this plebian art form. In recent years this has changed and collections have been formed in Japan, but the greatest collections are outside that country.

Apart from the public for whom they were originally intended, Westerners were the first to recognise their artistic merit. Many of the great impressionist painters were familiar with Japanese prints, and some had their own collections.

The development of the Ukiyo-e style had a lot to do with the political and social development of the towns, especially Edo, where it was born.

The Tokugawa Shogunate's isolation policy imposed in 1638 resulted in great economic prosperity during the 18th century. The new capital, Edo, supported a middle class of artisans, merchants and tradesmen, all intent on living life to the full. It was to satisfy the demands of this new urban clientele that the colour print came into being, to illustrate publications and to decorate the home.

The subjects were drawn from the life of the city, and reflected the population's appetite for pleasure and the arts, hence the name 'Pictures of the Fleeting World'.

The old art forms of the classical school were beyond the average man, both in appreciation and in price. The new Ukiyo-e style was essentially a popular art form and it is as such that it must be viewed. It can in no way be compared to the traditional schools, though it embodies elements of both the Kano and Tosa styles.

The first artist to successfully combine elements of both these styles to found the school of Ukiyo-e was Iwasa Matabei (1568–1650). His works were paintings and therefore expensive and out of the reach of the common people. All the early works in the style were paintings. It was not until the second half of the 17th century that the Ukiyo-e print appeared, and made art available to the urban masses.

The first prints were designed by the artist Hishikawa Moronobu. Born in the province of Awa, some time between 1625 and 1640, the son of an embroiderer, he first followed his father's trade, but later trained as a painter in both the Kano and Tosa styles. Influenced by Matabei, he developed his own style of Ukiyo-e, which was to influence all later print designers in the style.

At first he confined his efforts to book illustrations, but later turned his attention to ichimai-e, single-sheet prints. These early prints were in black and white and known as sumi-e or ink pictures. His earliest signed and dated work is to be found in the *Buke Hyakunin Isshu* of Kwambun 12 (1672).

The next important development was the introduction of two-colour printing about the year 1743. This was made possible by the invention of the guide-mark, allowing two or more colours to be printed in register. This development seems to have been made completely independently of China, where colour prints had been produced almost half a century earlier, examples of which must certainly have reached Japan. Until the invention of the guide-mark all prints were black and white and any colouring was applied by hand.

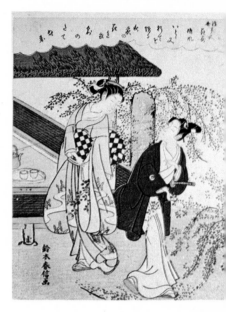

'The Lespedeza' (Beauties of the Day). Woodcut by Suzuki Harunobu (*d.* 1770). Japan, Tokugawa period. *British Museum.*

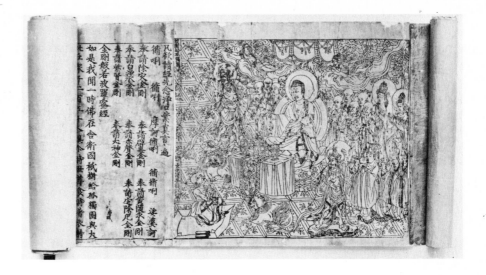

Other important innovations were introduced by Okumura Masanobu (1686–1764) one of the first to design two-colour prints. He developed Uki-e, perspective pictures and lacquer prints. However, it was left to Suzuki Harunobu (*d.* 1770) to introduce full colour printing, nishiki-e, in 1764.

It is easy to over-simplify the development of the colour print in a chapter of this length, and the reader must make allowances for the space available for discussion.

It is interesting to note that the Japanese print developed almost independently from the Chinese. The earliest woodcuts were found in the Cave of the Thousand Buddhas at Tun Huang, on the western frontier of China, by Sir Aurel Stein in 1908. They are all illustrations from a Chinese translation of a Sutra, and are dated A.D. 868. Others, also from Tun Huang, are dated A.D. 947 and 983.

The technique of printing was established early in Japan. Books were printed from engraved blocks made directly from pages of calligraphy. It was therefore an easy matter for the wood engraver to engrave the design of the Ukiyo-e artist, as Japanese painting is merely an extension of the calligrapher's art.

In just the hundred years between the time of the invention of colour printing by Harunobu in 1764 and the death of Utagawa Kunisada in 1864, the Japanese colour print bloomed, wilted and died. Thousands of prints of all descriptions were produced. Sizes were constantly changing to meet fashion and individual needs. Kakemono-e prints were produced so that they could be mounted on rollers like pictures and hung in the tokonoma or quiet corner. Diptych and triptych prints were also produced for hanging as well as for mounting in books. Hashirakake 'pillar-hanging' prints were produced to decorate the wooden pillars of the Japanese dwelling. Some of the greatest prints were produced in this format, by artists such as Harunobu, Koryusai, Utamaro, Toyohiro etc. Surimono, 'printed things' were usually small in size and made for a variety of purposes such as advertisements, greetings, and announcements of various kinds. Hokusai and Shunman excelled in this field.

The subjects of the Ukiyo-e print were many and varied. Each artist had his pet subjects and themes, and his own individual style. On the whole the prints reflect the gay life of the people of Edo, the pleasure parties, the Kabuki theatre, the Yoshiwara or brothel quarter with its 'Green Houses' and inmates, courtesans, and shunga or erotic pictures. Other subjects were taken from nature, though not directly, such as landscapes and pictures of birds and flowers.

Probably the most prolific are pictures of courtesans and the inmates of the 'Green Houses'. Numerous prints and books are entitled 'Pleasures of Edo'.

A large number of shunga or erotic prints were published. Although half-heartedly frowned upon by the authorities, they were quite popular and most of the well-known artists contributed works of this kind. It is unfortunate that present-day morality does not allow their reproduction or exhibition, for although many of the prints are crude there are some brilliant masterpieces. Utamaro produced some of his finest works in this field.

The Kabuki theatre played an important part as subject matter for the Ukiyo-e print. Numerous prints and books were produced showing actors in various roles and illustrating popular scenes. It is difficult to realise that some of

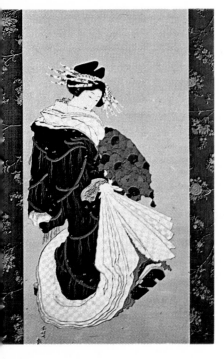

the attractive female beauties are in fact male actors in female roles.

Little attention is paid to scenery, the figures being all-important. Among the masters in this field were Kiyonobu, Kiyonaga, Shunsho, Shunko, Toyokuni, and Kunisada.

The artist Sharaku produced actor prints but must be treated separately from these masters. His style is unique, his dynamic quality, characterisation and colouring, distinguishing his prints from all others. The history of this great artist is shrouded in mystery. Apparently without previous training, in one year, 1794, he produced a series of more than 100 actor prints, after which he ceased to work. His total production is confined to this one year. His work remains unique in the history of Ukiyo-e.

The Japanese love of nature is reflected in the landscape and kacho-e, bird and flower prints. These beautiful pictures are full of feeling. The artists Hokusai and Hiroshige excelled in the former while Utamaro produced a fine set of prints of insects and flowers in his '*Yehon Mushi Erabi*', a picture book of insects published in 1788. Hokusai produced a number of landscape works after 1820, including the famous '*Thirty-six Views of Fuji*', while Hiroshige produced numerous masterpieces including his '*One Hundred Views of Edo*', '*Thirty-six Views of Fuji*', '*Eight Views of Lake Omi*' etc. He also produced kacho-e.

An added stimulus was given to the production of landscape and heroic prints in 1842, when an edict was issued prohibiting the production of prints of courtesans and actors.

Some of the greatest compositions can be seen in the prints of historical and legendary scenes and heroic battles, the master of which was Kuniyoshi. These prints contrast strongly with the peaceful scenes of the landscapes and kacho-e.

The history of the Japanese print is studded with names of famous artists. Names which are associated with masterpieces of graphic art. Artists such as Okumura Masanobu (1686–1764) inventor of Uki-e; Suzuki Harunobu (*d.* 1770) prolific artist, father of nishiki-e, brocade print; Kitagawa Utamaro (1753–1806) famous for his insect book and prints of Yoshiwara women; Utagawa Toyokuni (1769–1825) master of the actor print; Ando Hiroshige (1797–1858) supreme for his landscapes; Katsushika Hokusai (1760–1849) master of the landscape print; and Toshusai Sharaku, the mysterious master of the actor print. All are recognised as masters in their field, the flower of the Ukiyo-e School.

Less well-known and sometimes strongly criticised by some writers are the artists Utagawa Kunisada (1786–1864) and Utagawa Kuniyoshi (1797–1861), although the latter has recently become more fashionable. Both were students of Toyokuni.

By the middle of the 19th century most Japanese prints had deteriorated and had become somewhat degenerate. Vast numbers were produced for a growing uncritical public. Quality was sacrificed for quantity.

After the death of Hokusai in 1849, the fate of the Ukiyo-e print was left in the hands of Hiroshige, Kunisada and Kuniyoshi.

Kuniyoshi was born in Edo in 1797; the son of a Kyoto dyed goods dealer, he studied under Toyokuni, receiving his diploma in 1818. His work is noted for its

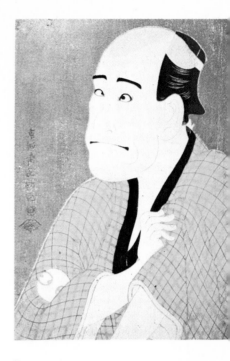

'Portrait of Arashi Riuzo'. Woodcut by Sharaku (*c.* 1794). Japan, Tokugawa period. *British Museum.*

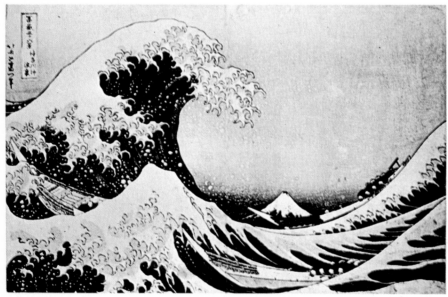

'The Great Wave'. Woodcut by Katsushika Hokusai (1760–1849). Japan, Tokugawa period. *British Museum.*

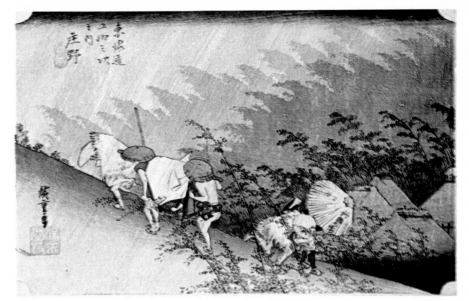

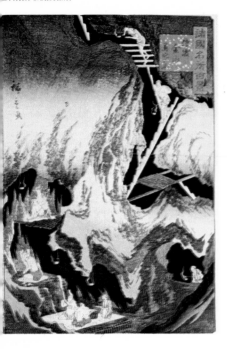

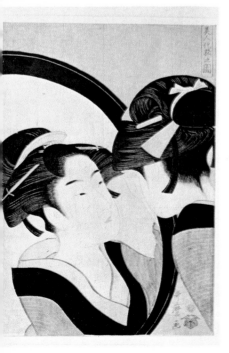

dramatic quality. His fantastic compositions of battles and heroic exploits stand out in the history of the Ukiyo-e print. His first attempts at actor prints were unsuccessful and were not popular. An early success was his *'Heroes of the Suikoden'* published in 1827. The success of this work encouraged him to produce a melodramatic set of prints entitled *'One Hundred and Eight Heroes'*. One of his finest sets are the 10 prints illustrating scenes from the life of the Buddhist saint Nichiren.

Many of the heroic scenes show his fine treatment of landscapes, a subject which he regrettably neglected, leaving us few examples.

Kunisada was born in Edo in 1786. His real name was Sumida Shozo. He studied under Toyokuni, leaving his studio in 1806. In 1844, on the anniversary of Toyokuni's death, and with the approval of Toyokuni's relatives, he succeeded to his title. Prints signed with this title can usually be distinguished from those of Toyokuni I by the fact that Kunisada usually signed this name within a red cartouche, a practice never employed by the original Toyokuni.

He specialised in theatrical prints, though he also illustrated other subjects such as women and landscapes. Some of his landscapes are very fine indeed. His very rare and beautiful print of *'Autumn Maples'* is wonderfully coloured and shows his real talent, not so obvious in most of his prolific output. He sometime collaborated with Hiroshige.

A criticism often levied at his prints is that they are badly printed. This may be so, but so are a great number of prints of this period. However, he produced some very fine works indeed with superb colouring and printing.

As with the art of any country, one may generalise and criticise degenerate periods. Japan is no exception. There are many reasons for the decline of the Ukiyo-e print during the middle of the 19th century, and some have been stated, but it would be unjust to dismiss all works of this period as degenerate. The same with the works of Kunisada who was a product of this age. While many of his prints are sub-standard, there are some very fine works indeed, and he must be considered as one of the last great masters of the Japanese colour print.

His death in 1864 also marked the death of the Ukiyo-e print. The pupils of the great masters did not have the vitality and imaginative ability to compete against the foreign innovations that were flooding into the country after it was opened to foreigners in 1868.

Although an attempt was made to revive the art in the later part of the 19th century, it did not succeed. The engravers still had their skill but the designers had lost their touch.

Collecting Japanese prints is an interesting and exciting hobby. The potential is great. Although many of the prints by the more famous artists are scarce and command high prices, the collector will be able to form a collection of some of the lesser artists without going to great expense, and he can gradually aspire to greater things as his knowledge (and his purse) grows. It is possible to obtain works by Masters at bargain prices in antique shops, but this is very rare indeed. The collector must beware of the numerous fakes and later copies that abound. Always be suspicious if offered a Hokusai or Hiroshige at a ridiculously low price. A number of copies were made, and sometimes even prints using the

original blocks. The collector should familiarise himself with as many prints as possible and take note of such things as paper quality, colour, size. He should examine prints very carefully indeed before buying. He must also develop his taste, for many thousands of prints were produced during the late 19th century with little or no merit. He should beware of these and not be tempted by the low price, for it is highly unlikely that they will rise in price. The best buy is quality.

There are a number of aids the collector will be able to use to identify his prints. Most were signed (although this is sometimes not reliable) and there are a number of specialist books that the collector will be able to refer to, to check the signatures. Also included on prints were such devices as publishers' marks and censors' marks. All can be dated within narrow margins. The collector is strongly recommended to consult the works mentioned in the bibliography.

Make it a rule, unless you are absolutely sure of the authenticity of a print do not pay more for it than you would for a modern work.

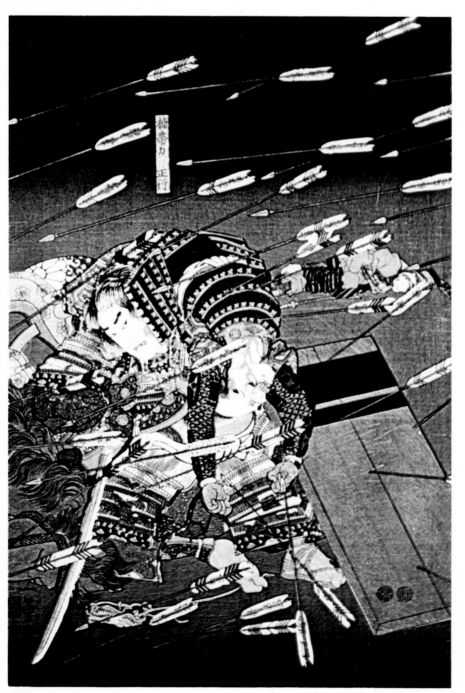

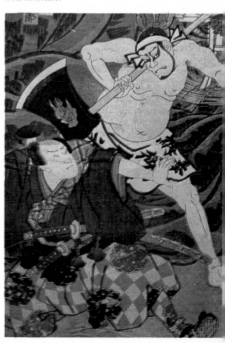

Detail of 'The Last Fight of the Kusonoki at Shijo Nawate'. Woodcut by Utagawa Kuniyoshi (1797–1861). Japan, Tokugawa period. *British Museum*.

Detail of a triptych, woodcut by Utagawa Kunisada (1786–1864). Japan, Tokugawa period. *Russell-Cotes Art Gallery and Museum, Bournemouth*.

52

Lacquer

Lacquer is made from the sap of the tree *Rhus vernicifer* (Chinese: Chi shu). The technique involved is long and laborious, requiring great skill and patience. A number of methods have been employed at different times and places, but the basic technique remains the same.

The technique of extracting the sap from the tree is very similar to that for tapping rubber. The lac tree is not unlike the ash in appearance. It grows wild in China, chiefly at high altitudes on the plateaux above the 7000 ft. line. It also grows wild in Japan, though there are records which state that the Emperor Mommu Tenno (7th century A.D.) ordered estate owners with extensive land to allocate part of their holding for the planting of lac trees, a state of affairs that would indicate a shortage of the raw material. Some scholars have suggested that the tree was not indigenous to Japan and that it was especially imported.

When about 8 to 10 years old a horizontal incision is made in the trunk of the tree and a cup attached underneath to catch the sap. The sap is then collected, purified ready for use and stored in special wooden vessels which are protected from the light. When fresh from the tree the sap is white but on contact with the air it gradually thickens and becomes blackish. The lacquer is purified by a process of boiling, skimming and straining through cloth. Sometimes the sap is dried in cakes and when in this form it has to be crushed and strained through cloth before it can be used.

The earliest techniques were lengthy. Lacquer was not used on its own, except in a process known as dry lacquer which will be described later. A ground was first prepared, usually from soft wood for large objects and hemp cloth or similar thin material for smaller articles. The techniques used for large and small works were different.

Cups and other small objects were made by sticking hemp cloth on to a form or mould of clay. This was then given a priming of lacquer to stiffen it, after which the clay was removed leaving the stiffened cloth form. Numerous layers of lacquer were then applied until the required effect was achieved. The process was extremely elaborate. Only a thin coat of lacquer was added at a time, which had to be left to dry thoroughly before it could be rubbed down with charcoal.

ix of the many stages in the process of
aking a lacquer plate. Top left, wooden
ase; bottom right, finished product.
utherland Collection of Japanese Lacquer.
*ussell-Cotes Art Gallery and Museum, Bourne-
outh.*

In some cases as many as 200 to 300 coats were applied to one article, and yet in most instances the overall thickness of the lacquer was extremely thin. Care had to be taken to ensure that the lacquer dried very slowly, otherwise it would become brittle and flake off. For this reason Japanese lacquer was often made beside rivers, while the Chinese invented an ingenious vapour bath to solve the problem. When finally the right thickness had been obtained the surface was smoothed with horn ash.

The ground for objects with flat surfaces was made by stretching hemp cloth over a wooden form or mould and priming it with lacquer until stiff. It was then removed from the form and finished as above.

For large objects such as furniture or sculpture the different sections of wood were joined with wooden pegs, and then covered with cloth and gesso. Lacquer was then applied and finished in the same way as for the smaller objects.

A core of mud mixed with ashes and fibre was sometimes used instead of wood for sculptures of more modest proportions. In these cases the layer of cloth was omitted and the lacquer was applied direct to the core.

Dry lacquering is essentially lacquerwork without a core or ground. Small images and figures were produced by casting. A mould was made from a model, lacquer was then pressed into it and allowed to dry and harden. The lacquer cast was then removed from the mould. When more than one mould was used for a single object the separate parts would be stuck together with liquid lacquer. The whole figure would then be coated with lacquer, disguising the joints.

The above describes the basic ancient techniques. There were other processes and variations of those described but the principle remained the same.

For many years it was generally thought that lacquer was a Japanese invention. In Europe the term 'Japanning' was invented for describing lacquerwork, probably inspired by the Japanese lacquer which had reached the West by the end of the 18th century, though Chinese laquer work had reached Europe through the hands of Portuguese and Dutch traders by the beginning of the 17th century.

The Japanese themselves claimed the accolade for the invention of lacquer. Tradition has it, according to the early chronicles, that the first 'Master of Lacquer' was Mitsumi-no-Sukune of the court of the Emperor Koan Tenno, at the end of the 4th century B.C., though the mythological aspects of this period leave it open to question.

The fact is that lacquer, like many other crafts, originated in China, though the Japanese can justly claim to have developed it to perfection, adding many new innovations. In Japan it became a major outlet of artistic expression, developing into an advanced craft, probably to the detriment of ceramics. It is to Japan what porcelain is to China.

There is evidence to suggest that lacquerware originated in China during the Chou period. Recent excavations have revealed the crumbled remains of wooden objects, with traces of a substance that may be lacquer. In this case the lacquer would have been used more as a preservative than for decorative purposes.

The earliest lacquerware which has survived dates to the 'Warring States' period. Excavations of tombs at Ch'ang Sha in Hunan province have produced a number of very fine objects. The tombs of the ancient capital of the state of Ch'u date from the 4th century B.C. to the 1st century A.D. The majority of the lacquer 'finds' were small in size, and included cups, plates, brushpots, trays and bowls. The lacquer is painted except on the bottom of the articles, where it is usually black. The motifs are varied. The older pieces have abstract and geometric designs, while later spirals, twirls and stylised dragons conveying a marvellous feeling of movement and objects decorated with compositions of equestrian processional and figurative scenes were fashionable. The fantastic designs of the Han period were usually painted in red on lacquer of a soft brown colour. These fine articles reflect the sophistication of the everyday life of the upper classes of the period. In contrast to the smaller pieces mentioned above a few specimens of lacquered wood sculpture were found. These differ greatly from the traditional style of the north, and were for a time thought to have been the result of foreign influence, though we now know this to be false. Examples of these sculptures can be seen in museums, both in the United States and in Britain.

The Cleveland Museum of Art has an unusual sculpture of two long-necked birds (thought by some scholars to be cranes) standing back to back, on a base formed by two intertwined serpents. The surface of the wood has been painted with red, black and yellow lacquer in a stylised design of feathers and scales. The

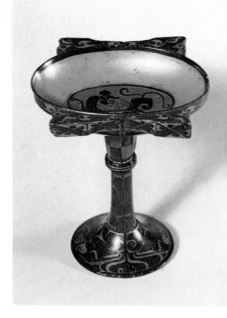

Winged pedestal cup. Lacquer, attributed to the late Chou period. China 5th–4th century B.C. *Freer Gallery of Art, Washington D.C.*

'Cranes and Serpents'. Wood and lacquer sculpture from Ch'ang Sha. Late Warring State period. *Cleveland Museum of Art.*

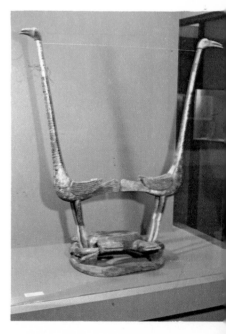

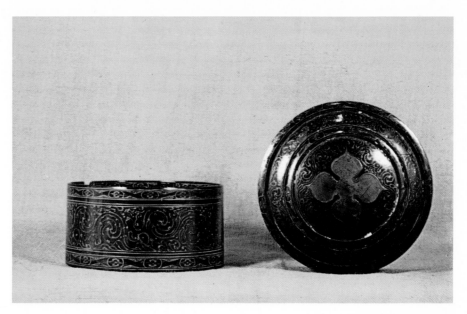

back of the snakes and the breasts of the birds are decorated in the classic
style of the 'Warring States' period, with triangles, squares and spirals.

Another sculpture of a stylised human figure is in the Ashmolean Museum,
Oxford. Dating to the 3rd century B.C. it is the forerunner of the tomb figures
which were so fashionable in the Han and T'ang periods.

Another sculpture from Ch'ang Sha, now in the British Museum, is in the
form of a grotesque human head with stag horns.

Further examples of early lacquerware were discovered during 1931–1932,
in Korea at Lo-lang, by Japanese archaeologists. A large number of lacquered
objects were recovered from tombs dating from the 3rd century B.C. to the
2nd century A.D. One of the most famous pieces, now in the National Museum
of Korea, at Seoul, gave its name to the tomb in which it was found – 'The
Tomb of the Painted Basket'.

This exquisite object, originally the property of a Chinese nobleman, is
decorated with a central motif depicting a line of men realistically painted in
yellows, reds, greens, and whites surrounded by a floral band of vine tendrils.
The wickerwork is fixed in a lacquer frame decorated with figures, and geo-
metric motifs. These early pieces from Lo-lang, the capital of the Chinese
military colony in Korea, are Chinese and not Korean work.

. A fine drinking vessel found in one of the tombs (now in the British Museum),
is dated 44 B.C., and has an inscription recording the names of the craftsmen
who had a part in making it. There were separate artisans for each step, the
wooden form, primary lacquer, general lacquer, gilding, painting, polishing,
and in addition the 'producer', the guard commander of the workshop, the
manager, and the overseer. All the names are faithfully recorded. The inscrip-
tion also states that it was made in the Imperial workshops at Szechuan, in the
4th year of the Emperor Yaun Ti.

Apart from all the excavated evidence there are many documentary references
mentioning the antiquity of lacquerware in China.

The Han chronicles record the Emperor Wu Ti's interest in lacquer. They
also record that the manufacture of lacquer objects was put under the direct
patronage of the Emperor. There must have been a number of Imperial
workshops but only three are recorded in the chronicles – Szechuan, Hunan
and Kiangsu.

Lacquer was made in Korea at Lo-lang by Chinese craftsmen, but at the
end of the Han dynasty, when China lost control of Lo-lang, many artisans left
for Japan where they were warmly welcomed.

The lacquer of the T'ang period is extremely scarce. Most of the specimens
were for personal use and perished with age. Little or no lacquer was placed
in tombs as ceramics had become more fashionable as tomb furniture.

Lacquer of the Sung and Yuan periods is mainly represented by large
Buddhist images, mostly of Kuan Yin. These figures were usually of wood
covered with gesso and lacquer and are fully described in the chapter on
sculpture. Smaller articles were made, and incised lacquer was widely used
for the first time, though it had probably been invented much earlier.

'*The Eight Discourses on the Art of Living*', a Chinese text published in 1591,
describes a number of methods of using lacquer that were current during the

Sung dynasty. Incised lacquer, some on bases of precious metal, was made for the palace. Another method using red lacquer together with other colours produced a multi-coloured cameo effect.

Ts'ao Chao in a text written in 1387 contradicts this, asserting that red lacquer was applied to precious metals and left plain. This would be more in keeping with the simplicity of Sung ceramic styles. Sung lacquer is extremely rare and to date no specimens with precious metal forms have been found.

Our knowledge of Yuan lacquerware mainly comes from Chinese and Japanese documentary sources. Altogether five groups of lacquerware are described. Plain red and black ware; the ch'iang – chin process of engraving and gilding the lines; mother-of-pearl inlay; guri-lacquer or multi-coloured layers of lacquer deeply carved like cameo, some on a yellow base; and finally carved lacquer. The latter was highly prized in Japan.

A recent exhibition at the Cleveland Museum, 'Chinese Art under the Mongols', assembled together for the first time these five types of lacquerware, which may perhaps be convincingly attributed to the Yuan period.

By the beginning of the 15th century carved lacquer was being produced on a large scale. Between the years 1403 and 1407 more than 100 pieces of lacquer were sent to Japan as Imperial gifts.

Lacquer attributed to the Ming period is more plentiful, but it is still rare and it must be stated that the majority of the articles attributed to this period cannot be authenticated conclusively. However, we know more about the lacquer of the Ming period than we did a few years ago, and we have a few dated pieces which we can reliably accept as genuine. All our attributions are usually made by careful comparisons with dated pieces.

From the Ming dynasty onwards Chinese lacquer is nearly always red and carved. It is easy to generalise but most Ming pieces are clearly carved with deep incisions. The most common motifs are floral, though figure compositions are also known. The marks of the Emperors Yung Lo and Hsuan Te have been found on some lacquer, but it is possible that in some cases the seals were added later. Ming lacquer is usually a deep vermilion, but it is difficult to apply this with any certainty as lacquer is apt to fade when exposed to the light of centuries, especially strong sunlight. It is highly probable that there were differences in the brilliance and tone of the lacquer of different periods, but it needs an expert eye to detect it. As well as studying books the collector must familiarise himself with the fashionable motifs of periods, and acquaint himself with dates of specimens of lacquer in museums. It takes experience to know lacquer. There are many pitfalls for the inexperienced collector. Fakes and copies abound which though made at later periods are endowed with seals and designs of earlier epochs.

During the 18th century many copies of earlier works were made, and it is often very difficult to distinguish the later pieces from the earlier. Ming ware is generally of a much higher quality; the designs are simple and although they usually cover the whole surface the effect is less crowded than those of the Ch'ing dynasty. Often the plain surface is covered with numerous minute hair cracks.

Lacquer covered box. China, Yuan dynasty.
Freer Gallery of Art, Washington D.C.

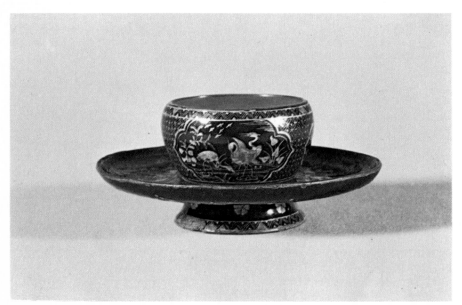

Lacquer cupstand. China, Ming dynasty.
Freer Gallery of Art, Washington D.C.

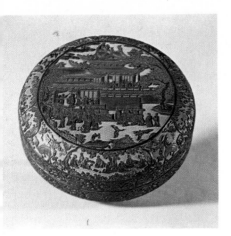

Lacquer covered box, 15th century. China, Ming dynasty. *Freer Gallery of Art, Washington D.C.*

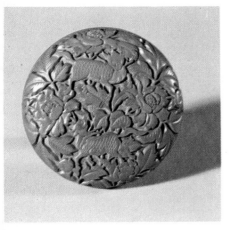

Carved lacquer covered box. China, Ming dynasty. *Freer Gallery of Art, Washington D.C.*

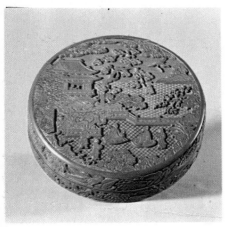

Carved lacquer covered box, reign of Yung Lo (1403–1424). China, Ming dynasty. *Freer Gallery of Art, Washington D.C.*

One of the finest specimens attributed to the Ming dynasty is a superb table of red carved lacquer in the Low-Beer collection, New York. Made for Imperial use during the Hsuan Te period (A.D. 1426–1435), the surface, drawer fronts, legs etc., are all covered with superb designs. A small cup and stand of red carved lacquer is in the Sir Percival David Collection, London. This fine piece is carved with a design of phoenixes on a background of peony scrolls. It has the date of Yung Lo (A.D. 1403–1424), but is also inscribed with a poem of 1781.

The above will largely be of academic interest to the collector, as it will be most unlikely that he will have the good fortune to obtain pieces of these periods. The majority of the objects that will come his way will be of later Ch'ing dynasty date, or 18th and 19th-century Japanese.

During the Ch'ing dynasty designs. became more detached and fussy, the artist often including minute details, sometimes to the detriment of the overall artistic quality of the piece. The boldness of the Ming designs was lost, but it was compensated by the delicacy and quality of the work. The colour of the lacquer is more brilliant than the Ming. Objects of all kinds were made, from the tiniest ornament to large pieces of furniture.

Little is known about lacquerwork of the early days of the Ch'ing dynasty, and it is difficult to distinguish the work of the reign of K'ang Hsi (A.D. 1662–1722) from that of the Yung Cheng period (A.D. 1723–1735).

The Emperor Ch'ien Lung (A.D. 1737–1795) was very fond of lacquer and ordered objects of all kinds to be made. His throne, a superb piece of lacquerwork, is now in the Victoria and Albert Museum, London. This piece shows to perfection the artistic ideals and fashion current during this period, while keeping some of the Ming boldness of design. Ch'ien Lung's more conservative taste is shown by the small cups of plain cinnabar lacquer in the form of chrysanthemum blossoms.

During this period, especially towards the end, a number of works of inferior quality were exported to the West. Many specimens of Imperial lacquer of the period found their way to Europe after the sack of the Summer Palace during the Boxer Rebellion.

Coromandel lacquer first makes its appearance during the Ch'ing dynasty. Although named after a town in India, it has, to the best of our knowledge, no connection with India, and scholars have puzzled over the origin of the name. Furniture of various kinds was made in this lacquer, but screens were the most common and large numbers were exported to Europe.

The method of manufacture was different to traditional lacquer techniques. The base was made of cloth, sandwiched between thin layers of pinewood. Finely-powdered slate was mixed with vegetable glue, and applied to the surface of the cloth-covered wood. After drying the surface would be levelled and smoothed with ash, until a high sheen had been obtained. The surface was then lacquered until the required thickness was reached, usually about an eighth of an inch. The design was later cut into the lacquer, care being taken not to cut too deeply, lest the wood be revealed. The design was then coloured with tempera. Panels of this nature were fixed into lacquered wooden frames, to form furniture or screens. The screens were decorated on only one side by this method; a simple painted design usually covered the other. The oldest specimens of this work date to the K'ang Hsi period. Later works have pieces of mother of pearl, jade and other hard stones, carved and applied to the lacquer surface. Lacquer as an art form continued to be made in China until the mid-19th century; thereafter it became mass-produced and lost its artistic appeal.

JAPAN

In Japan, the oldest specimens of lacquer are of Chinese workmanship. Numerous specimens are stored in vast temple warehouses known as Shoso-in. The oldest specimen made in Japan is the 'little temple of Tamamushi'. Standing about six feet high, it is black with decoration formed from the iridescent wing cases of beetles, and the surface is painted in red, yellow and green with Buddhist figures. It dates to the 7th century A.D. and is probably the work of a Korean artist. The first purely Japanese piece is the sheath made for a dress sword of the Emperor Shomu, mid 8th century A.D.

As mentioned previously, there are early documentary sources relating to the mythological origin of lacquer in Japan. There is one story told that lacquer was invented by Prince Yamato-daki, of the court of Emperor Keiko (A.D.

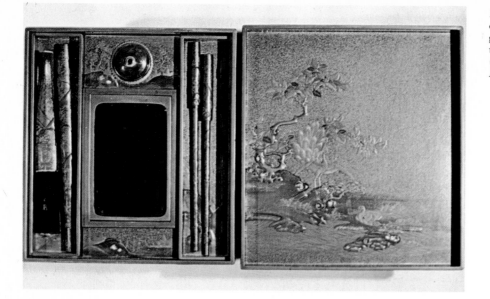

72–130). When hunting in a wood, the Prince noticed that a black sap was oozing from a broken branch of a tree. From this he is said to have conceived the idea of using it to decorate objects. He later conferred the title of Court Lacquerer on his servant who had helped him.

There are many legends, but there are also a number of historical documents relating to lacquer. In the Imperial archives, there is a document, believed genuine, which relates that the Emperor Kotoku Tenno (A.D. 645–654) imposed taxes on lacquer production. A book of the 10th century, also in the Imperial archives, describes a method of decorating lacquer with mother of pearl.

A number of lacquer objects dating to the Nara period (A.D. 645–794) have been preserved, mostly in the Shoso-in. A variety of different bases were used and boxes using wood, leather, bamboo and cloth are known. There are some fine specimens of early musical instruments which have been decorated with lacquer. Designs of trees, flowers, birds and mythological scenes were executed in gold, silver, mother of pearl and colour.

At the beginning of the Heian period (A.D. 897–1185, also called the Fujiwara period), the art of lacquerwork became extremely popular and a number of innovations were made. It began to replace pottery in its many uses. A large number of lacquer objects of this period have been preserved, showing a wide variety of uses to which lacquer was put, including large articles such as furniture and saddles and smaller items such as boxes and bottles. A fine specimen of a cosmetics box is in the National Museum, Tokyo. It is a beautiful piece; a wooden framework decorated with a design of wheels floating in water. in gold maki-e and raden, thin flakes of mother of pearl on a black lacquer background. Maki-e, (sprinkled picture) a Japanese innovation, was the use of gold or silver dust which was sprinkled over the object after the design had been drawn in lacquer on the surface. When covered with a thin coat of lacquer and polished until the gold shows through it is called togidashi-maki-e.

A number of interiors of temples were decorated with lacquerwork during the Heian period, and some still survive. The Temple of Byodo-in, near Kyoto, has a wall decorated with the raden mother of pearl technique.

A further innovation was introduced towards the end of the Heian period; that of hira-maki-e decoration, the application of gold lacquer on a uniform flat background. The lacquerwork of the succeeding Kamakura period was similar to the Heian, though less sophisticated.

The Kamakura period (A.D. 1185–1392) saw the introduction of the taka-maki-e and the Kamakura-bori techniques. In taka-maki-e, the design was produced in relief, using multiple layers of lacquer. This technique was developed further during the Ashikaga period (A.D. 1392–1573) when ochre was added to the lacquer to obtain greater relief. Kamakura-bori was the technique of incising the design on the object before lacquering in red and green. The designs were simple and plain and the technique was probably inspired by Chinese lacquerware.

Designs in the Ashikaga period, sometimes called the Muromachi period,

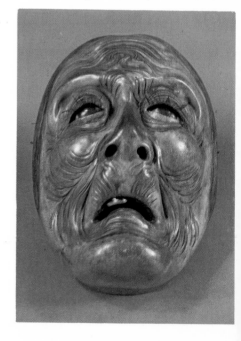

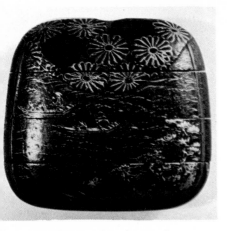

Three case lacquer *inro* decorated on one side with chrysanthemums and on the other with a landscape and boats. Said to have belonged to Hideyoshi (1536–1598). Japan. *British Museum.*

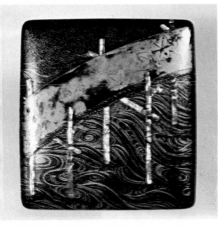

Lacquer writing box decorated with a design of a bridge over a river in *hira-maki-e* and *takamaki-e* with pewter, gold and shell. Style of Koetsu, 17th century. Japan, Tokugawa period. *British Museum.*

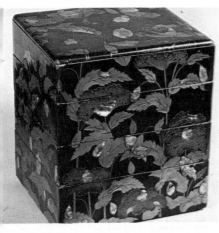

Lacquer document box in four tiers with poppies in bloom in gold *togidashi-maki-e* and *hira-maki-e* and mother-of-pearl on a black ground. 17th century. Japan, Tokugawa period. *British Museum.*

Lacquer document box decorated with insects in mother-of-pearl and silver *maki-e*. 18th century. Japan, Tokugawa period. *British Museum.*

became more flexible and varied. Subjects included birds, flowers, landscapes and figures. It was during this period that the Chinese idea of red carved lacquer reached Japan, where it became most popular. A variation was perfected, using alternate layers of red and black, so that when the lacquer was carved, the design would be outlined in black.

Whereas the Kabuki theatre provided inspiration to the artists of the Ukiyo-e print, the No theatre provided impetus to the production of lacquer. Fine masks were produced, superb works, some signed by famous artists of the period.

Lacquer was used for making a number of different types of utensils during this period, including boxes, cake plates and incense boxes etc. Designs were highly stylised, often executed in maki-e, in keeping with the object they were intended to decorate. Sometimes motifs were taken from contemporary paintings or specially designed by famous painters.

During the Momoyama period (A.D. 1573–1615), a technique involving the application of gold relief designs on a golden background was introduced. Sometimes mother of pearl or silver chips would be added. Maki-e was also popular. Designs are purely decorative, in contrast to the descriptive nature of the Ashikaga motifs. Perhaps most interesting is the revival of the art of lacquer painting. Designs were freely but delicately painted in yellow, red and green on a background of brilliant red.

A genius of the Momoyama and Tokugawa periods was the artist Koetsu. His Raku pottery ware is amongst the masterpieces of Japanese art. Schooled in the Tosa style of painting he also produced fine lacquerware, introducing many new techniques of his own. He decorated objects with cut-out shapes of lead on backgrounds of black or gold, producing a beautiful, almost three dimensional, effect. As lead is soft, the piece was finished using the togidashi technique, coating with a protective layer of lacquer. There is a fine writing box in the National Museum Tokyo, by this artist. The design in maki-e shows a bridge at Sano. The bridge is lead, while characters of a poem in silver are incorporated into the design. The poem from an anthology of the Heian period has a play on words, but according to Moran the translation reads:

I hold to the hope that in the far future (I shall be united with) her I have always loved, but it is not likely that there is anyone who can realise the anguish of my heart. That is to say, I yearn (for her) to an extent that it is impossible for others to realise.

The Tokugawa period, (A.D. 1615–1868) can perhaps be best described as the golden age of Japanese lacquer. Designs were produced by great artists who competed to produce fine works of art, to a degree which has never been surpassed. The accent was on elegance and variety.

The greatest lacquer artist of the 18th century was Ogata Korin. As well as working lacquer he was a painter and a calligrapher. He was a follower of Koetsu both in painting and lacquerwork, and was greatly influenced by him. Like Koetsu he made an ink box, called Yatsuhashi, depicting a bridge. The bridge is executed in lead with posts of silver. Shell and maki-e are used. Unlike much of the art of the Tokugawa period, Korin's designs are marked by their simplicity.

Korin introduced a number of new ideas, achieving unusual effects. He blended greys of different tones, silver, lead and tin on a background of gold, producing a great sense of depth. Lacquerware by this great artist is very rare,

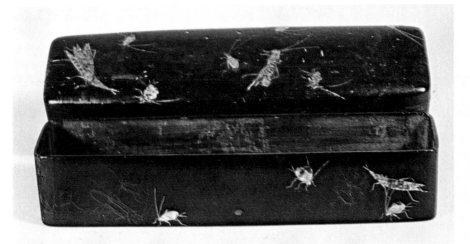

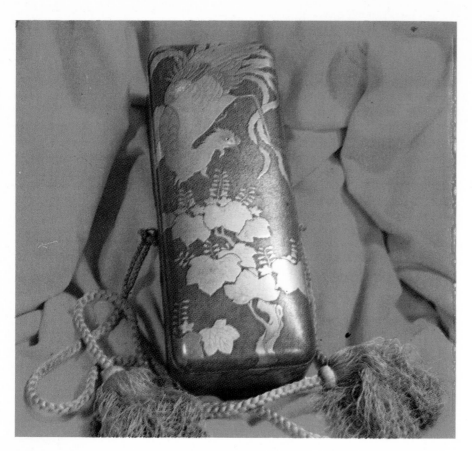

Lacquer document box, decorated with a design of phoenix with vine in gold. 18th century. Japan, Tokugawa period. *Russell-Cotes Art Gallery & Museum, Bournemouth.*

however there is a fine piece in the Berlin Museum.

His pupil, Ritsuo, (A.D. 1663–1747) was also an artist in ceramics, and conceived the idea of using fragments of ceramics as overlays on lacquer. This is known as hiaku-ko-kan or 'incrustation with a hundred precious things'.

There were slight variations in the technique of lacquer working in Japan during the Tokugawa period. Burnt clay and charcoal were sometimes mixed with the lacquer before being spread on the prepared ground. As many as thirty or as few as five coats of lacquer would be applied, depending on the desired quality. As the total thickness of the lacquer should not exceed one one millimetre, the process of rubbing down was a long and laborious one. Decorative lacquer had the first coats (one or more) of black lacquer, before the colour decoration was applied on the upper layers. Each layer was polished before the next was applied. A coat of thin transparent lacquer was then applied, all over. The final polishing then took place. Lacquer is hard though not brittle, and is resistant to heat, acids and alcohol. Because of this it was widely favoured for the production of sake cups, bottles and kettles.

The lacquerwork of the Tokugawa period was a development of innovations made in the Momoyama period. It is noted for the wide variety of unusual and decorative works and superb elegance and style. Unlike the Chinese artist, who was extremely conservative, the Japanese artist has always preferred to experiment and allow his creative genius license. This of course did not always result in success, and there were many dismal failures.

A number of works of the Tokugawa period are signed. The better-known artists of the 19th century are Izuka Toyo, Koma Koryo, and Nishimura Zopiko, and the collector may be fortunate in finding specimens by them.

Towards the end of the 19th century, the art of lacquerwork was already becoming decadent, and by the 20th century had sold out to mass production methods. Cheap and rather loudly decorated lacquer with little taste was exported in large quantities. As Japan westernised, the local market for lacquer diminished, the inro, or medicine box and the tabako-bon, for tobacco, previously so much in demand for the obi, the Japanese sash, were no longer needed as the Japanese took to Western dress. Lacquer is still made, of course, mainly for tourists, but the art has largely disappeared.

The collector must proceed with caution when buying lacquer. He must acquaint himself with as many specimens as possible in museums, attend sales, and handle specimens whenever possible. When he is sufficiently confident, then and only then, should he start buying. Even then he should proceed with caution. Remember there were many honest copies made of early works.

Lacquer plate decorated with a design showing a performing monkey, in silver and gold on a red background. 19th century. Japan, Tokugawa period. *Russell-Cotes Art Gallery & Museum, Bournemouth.*

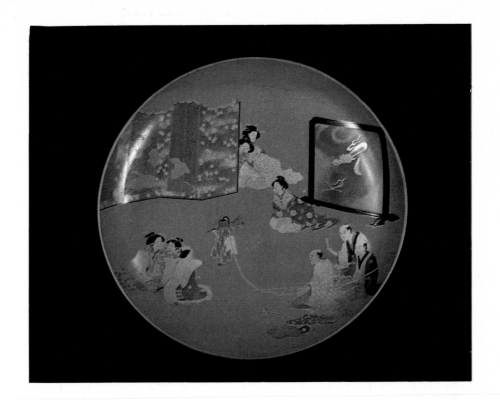

One of a pair of mail boxes (document boxes) decorated with chrysanthemums in gold on black background. Originally in the possession of Munetomo Date, Lord of Sendai. 18th century. Tokugawa period. *Russell-Cotes Art Gallery & Museum, Bournemouth.*

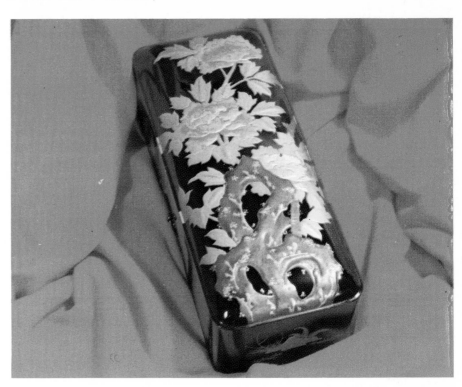

Large sake cup, with a design depicting two men playing *Go*, while a third man with an axe on his shoulder watches intently. Gold lacquer with ivory and mother-of-pearl. Japan. Tokugawa period. *Russell-Cotes Art Gallery & Museum, Bournemouth.*

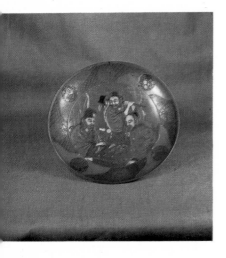

The Chinese veneration of the past often prompted them to place marks of special periods on objects of much later date.

Take note of what your hands and eyes tell you. Look at the quality of the work, how it was made, has it been repaired or touched up, and remember what you have seen and read. Above all don't kid yourself, it is most unlikely that it is a long-lost treasure, it may be good, but always keep it in perspective. An accurate idea of prices may be had by attending sales and visiting antique shops, especially specialists'. Lacquer should be a good investment if one is careful, and prices are bound to rise in the future.

Remember the rule, if unsure of a piece, price as new.

Bronzes

The art of bronze casting began early in China. Hundreds of superb vessels dating to the Shang (1523–1027 B.C.) and Chou (1027–221 B.C.) dynasties have been recovered from excavations of tombs and burials in the area of the great Shang and Chou cities over the last 50 years. These bronzes are magnificent works of art and are highly treasured, and although it is very unlikely that the collector will be able to acquire specimens of these dates (the prices are extremely high) it is well worth including a description of them and their history for two reasons. Firstly, because it gives a good background to the bronze art of the later periods, and, secondly, because there is always a chance, however slender, that the collector will be able to acquire a genuine piece at a price that will not ruin his pocket.

When we talk about ancient Chinese bronzes, we mean ritual bronze vessels, not figures. The art of casting images and figures in China is essentially a later development. For our purpose we will divide the bronze art of China into two. The ritual vessels and secular bronzes of the Shang, Chou and Han periods and the later bronzes of the T'ang dynasty onwards, inspired by Buddhism, consisting mainly of images and religious works.

During the Shang dynasty, as in later China, ancestor worship was prevalent, and many bronze vessels were cast to commemorate certain rituals and sacrifices. Others were part of funerary furniture, buried with royalty, nobility and men of substance. Rituals during this period required offerings of food and drink, while sacrifices, both human and animal, were made especially at funeral rites.

The workmanship of these vessels is superb and their appearance is often enhanced by wonderful blue and green patinas, the result of being buried for centuries in the earth. The surface of the bronzes are mostly decorated in relief with highly stylised motifs of dragons, animals, masks and geometric designs.

The quality of the workmanship is such that it appears that they were cast by the *cire perdue* or lost wax process, although on this scholars are not always in general agreement, and it is possible that several methods were used. Briefly the process is as follows:

An original is made by forming a heat resistant core of clay, husks and other ingredients, in the proposed shape of the interior of the vessel and then this is covered with several layers of beeswax. On to this the shape and design of the vessel is moulded or carved. The wax 'master' is then covered with a layer of very fine clay, so that all the design on the surface of the wax original is covered without introducing bubbles. On to this several layers of thick clay composition are added. Then, several stays are carefully inserted into the mould so that they pierce the wax and the core, holding it in place with the outer mould. Holes are left to allow the wax to escape and later to admit the molten bronze to the mould and let the hot gases escape. The mould is then placed in an oven so that the clay mould hardens and the wax melts, evaporates and escapes, leaving a perfect impression of the wax original. While still hot the molten bronze is introduced and then allowed to cool. Finally the mould is broken open to reveal a bronze copy of the wax master. The piece is then finished, removing all traces of the casting process. The early bronze workers of China were extremely clever; stays etc. were so arranged that the marks, if any, would merge with the design.

Another method we know was employed was casting from a several-section pottery mould. Whether or not the design was impressed into the clay or simply worked directly we do not know. However, the multiple sections of the mould were made in clay with key grooves so that they would fit together after they had been fired. The sections were then assembled, an inner core suspended from the top and the molten bronze poured in. When cool the

Chueh. Ritual bronze libation vessel, 12th–11th century B.C. China, Shang dynasty *Victoria & Albert Museum, London.*

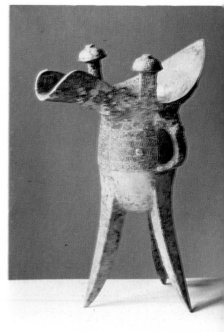

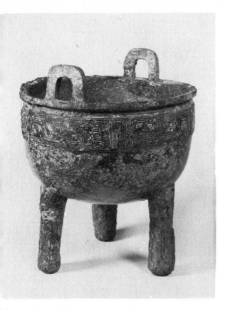

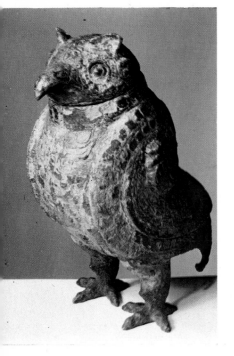

sections of the mould could be dismantled to extract the bronze vessel. Scholars are not agreed on this, although we have fragments of moulds, one of which actually has a minute fragment of bronze attached. It has been suggested that the pottery moulds were used to make wax originals for casting by the *cire perdue* process. This would certainly be possible and it could well be that both methods were used. Thus we have a possibility that all three methods described above were employed. Modern technologists, however, are of the opinion that some of the more intricate bronzes could only have been cast by the *cire perdue* process.

RITUAL BRONZES

Great attention was paid by classical Chinese scholars to ancient bronzes. Sung academics studied early Chinese ritual texts which described the vessels and their uses, and tried to identify bronzes in existence with the descriptions. The names we use for the bronzes today are largely based on the results of this scholarship. Although some have been proved by inscriptions on vessels themselves, others are at variance and it is probable that the descriptions of the vessels were not as rigid as we might suppose. There were also, of course, mistakes. However, a short description of the bronzes will not be amiss and will help collectors to identify pieces, as well as understand more detailed literature on them. They can roughly be divided into containers for (a) cooked food; (b) preparing sacrificial food; (c) wine; (d) warming black millet wine; (e) drinking wine; (f) water.

FOOD VESSELS
Group A – containers
Kuei – Developed originally from pottery prototypes of the Neolithic Yang-shao type. It is basically a high-sided bowl with handles on a ring foot. The shape varies, and it may have two or four or no handles at all. This type of vessel continued to be made during the Han period (206 B.C.–A.D. 220).
Tou – A pedestal bowl with cover. The cover itself has a handle which acts as a pedestal base to allow the lid to be used as a separate vessel. Originally derived from prehistoric prototypes, the vessel continued to be made in the Han period.
Group B – cooking vessels
Li – One of the oldest bronze forms, it was first made in pottery in Neolithic times. Basically a tripod vessel in which the lower part of the globular body is divided into three lobes which act as the legs. Except in some late bronzes there is no cover.
Ting – Is very similar to the Li. It is a tripod cauldron, but has solid legs. There is also a four-legged form, but this has a rectangular body. This type of vessel continued to be made at later times.
Hsien – Very similar to the Li to look at. It is a composite tripod 'steamer' cauldron. The lower part of the body is basically a Li to which is added a bowl, sometimes cast in two but more generally as one. There is usually a rigid grill between the upper and lower halves. Ancient prototypes have been found in prehistoric pottery.

WINE VESSELS
Group C – containers
Tsun – There is disagreement among scholars as to the exact type of vessel meant by this term. However for our purpose we can say that it is generally used to describe two types of vessels. (1) A tall slender vessel related to prehistoric pots of similar shape and much more widely used. (2) Vessels in the shape of animals.
Yu – A bucket-like vessel with lid and a swinging handle. There is no pottery prototype and the vessel was probably designed for carrying wine from place to place.
Hu – A large bulbous vase-like vessel with lid. One of the largest types of bronze, it has a globular body with long slender neck and rests on a ring foot. There are lugs at the side for holding a rope. Although there seem to be no pottery prototypes, the shape varies little and was still in use during the Han dynasty.
Group D – vessels for heating and mixing wine
Ho – A vessel similar to a Li/Ting but with a spout, handle and lid, like a teapot. There are no pottery prototypes and the shape varies somewhat. It sometimes has four legs. The vessel was probably used for mixing wine with water.

Kuang – A vessel very much like a sauce boat with a lid. Although similar to the I, it is, however, different, the Kuang being fuller in shape than the I which was raised on legs and did not have a lid. Used for mixing wine and water.

The Chih and the Chueh could also have been used for heating wine.

Group E – goblets and drinking vessels

Chih – Similar to the Hu, it is smaller and does not have handles. It may or may not have a lid. The neck is usually shorter and more flared than the Hu.

Ku – A tall cylindrical vessel with flaring trumpet-like mouth. It was produced for only a limited period, during the First Phase of bronzes 13th–10th century B.C.

Chia – An archaic type of tripod vessel not produced after the 10th century B.C. The inverted, almost bell-shaped, body rests on splayed legs which taper to a point. Two capped pillars rise from the bell mouth. There is a handle which vertically spans the bell body.

Chueh – A similar-shaped vessel to the Chih, but with a large boat-shaped spout. Like the Chih it was not produced after the 10th century B.C.

Group F – watervessels

I – As mentioned above there seems to be a close relationship between the I and the Kuang (group D), the I almost being the later evolved shape of the Kuang. It is not found before 900 B.C. A ewer for water, its relationship with the Kuang may also extend to its use.

P'an – A shallow circular (sometimes oval) dish-like bowl, sometimes resting on short legs. They may or may not have handles. A fairly late type, they are not found before the early Chou period, but their use extends to the Han dynasty.

Chien – A large-size deep basin-like bowl, usually with ring or vertical loop handles. Their use is uncertain. It has been suggested that they were filled with liquid and used as mirrors, but early texts suggest that they were filled with ice and may have been used to prevent the corpse putrefying before burial. They were not made earlier than 900–600 B.C., but continued to be made in the Han dynasty.

The above is a very much simplified description of the various shapes and types of ritual bronzes. There are other shapes not described here, both variations of the terms mentioned and rare types, only found occasionally, which need not concern us.

A number of styles of decoration are used on the bronzes, both realistic as with some Tsun, and stylised and geometric, and within these styles or forms there were variations, popular during different periods.

The production of bronzes falls into several distinct phases, during which various shapes and motifs came either in or out of fashion. First put forward by Yetts in 1935, they are as follows:

1st phase (Shang-Yin and early Chou) 13th–10th century B.C.
2nd phase (Chou) 10th–6th century B.C.
3rd phase (Chou) 6th–3rd century B.C.

Vessels distinctive of the first phase are the Yu, Ku, the rectangular Ting, Chueh, Chia, Kuang, and the Li-Ting, a cross between the Li and the Ting.

The decoration current during this period consisted of either purely geometric designs, or designs composed of animals, birds or parts of animals. Those of animals are highly stylised geometrically and it is often difficult to discern exactly what animal is being portrayed. The most popular and important forms were the t'ao-t'ieh, or masks of dragon and animal heads, of which there were a number of forms. Creatures with large eyes such as snakes, owls, and cicadas, were favoured.

There are numerous versions of the t'ao-t'ieh mask. Basically it is a stylised geometric mask produced by the merging of two animals in profile, face to face, the two merging to form a mask. It is almost as if the animal has been split down the middle and opened up, flat. The various parts such as the legs, tails, snout, jaws, fang or beak, eyes etc., then form a highly-stylised face. In a later form the mask is further broken up and the elements scattered over the surface of the bronze, merging with the spiral background.

The so-called dragon motifs are like the unsplit side section of the t'ao-t'ieh. Although some are obvious portrayals of recognisable animals, others are too highly stylised to be identified, and probably never were intended to be any simple animal but a composite creature endowed with the power of all. Like the t'ao-t'ieh, the animal is composed of parts such as the eye, jaw, crest, horn, tail, quill, leg etc. A number of variations of horns have been noted, 'C' shaped

T'ao-t'ieh mask from a Chinese ritual bronze vessel. 10th century B.C.

64

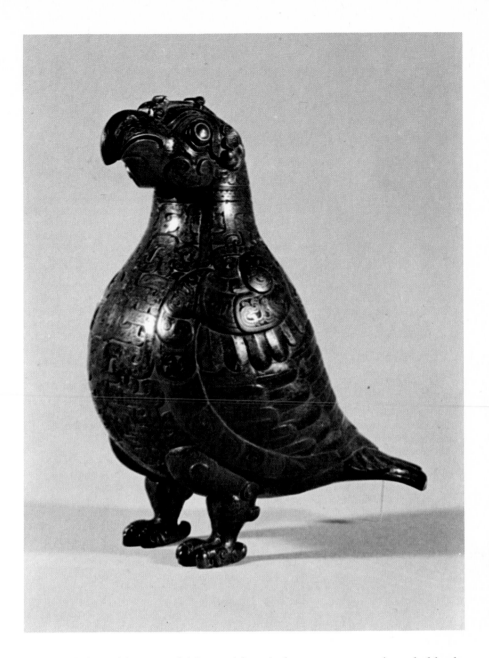

horns, 'T' shaped horns and others, although the most common is probably the 'C' horn. Sometimes the body of the 'dragon' is split into two horizontally, giving the impression of a wing.

In the early bronzes the whole surface was covered with design, the t'ao-t'ieh or dragons were raised in relief above a background composed of spirals. The spiral or lie wen 'thunder pattern' is the most important decorative device after the t'ao-t'ieh. Other devices include lozenges, spiral bands, and zig-zag bands formed like interlocked T's etc.

Zoomorphic vessels were made in a variety of forms, with bird shapes predominating. Purely zoomorphic bronzes, however, are rare, especially when no background design exists. There is a superb Tsun in the shape of a rhinoceros, dating to about the 11th century B.C., in the Avery Brundage Collection, now in the M. H. de Young Memorial Museum, San Francisco.

The first phase has been subdivided by Karlgren into two groups, Primary and Secondary. Stylistically they differ, and may in fact be separated chronologically but it is more probable that they overlap and in some cases are contemporary with each other. In this case Secondary bronzes are probably the work of a separate school of bronze casters.

The principal difference between the two types is that in the Primary Style the whole surface of the bronze is covered with symbolic motifs, while in the Secondary the decoration has a tendency to be arranged in horizontal groups.

The Secondary Style was simplified and further developed in the Second Phase of bronze casting (10th-6th century B.C.). The changeover from the stylistic identity of the First Phase to that of the Second Phase was not abrupt, but as would be expected was gradual and there are a number of hybrid vessels

65

in existence. Although some motifs disappeared almost immediately, others survived, such as the t'ao-t'ieh etc. Bronzes tended to be decorated in horizontal bands, the rest of the surface being left undecorated. Popular designs included horizontal fluting, an overlapping scale pattern, squared spirals, t'ao-t'ieh, dragons etc. etc. Some vessels disappeared completely such as the Chueh, Ku, Yu, and the rectangular Ting.

During the Third Phase, some of the First Phase designs were adapted and reappear in a somewhat modified form. These motifs are combined with shapes and designs of the Second Phase with the addition of motifs derived from 'nomadic' art, and others to which we can assign no reliable source.

Designs once again tend to cover the entire surface, though still in horizontal bands. The motifs appear to be purely decorative and altogether much freer than those of the First Phase. Popular motifs include the t'ao-t'ieh, interlocked T's, animal heads, plaited cord pattern, spirals etc., etc.

As mentioned above, during the Third Phase, elements of nomad art became evident on bronzes. This nomad art of the Steppes was to have a profound effect on the bronze work of the succeeding Han period, but before we discuss this we should mention the secular bronzes that were made during the First to Third Phases, which must be considered separately. They are principally weapons, harness-fittings, mirrors etc., which differ somewhat in style from the ritual bronzes in that they have strong overtones of nomad art. However, other objects such as the Chung and Cheng, both types of bronze bells, show affinities to the ritual vessels of the period.

During the Han dynasty some types of ritual bronzes continued to be made, but by now the force of the earlier decorative motifs had been lost to the 'nomadic' artistic influences, which exerted themselves during the period. Secular bronzes of various kinds were also made, including mirrors, belt hooks, harness-fittings, bells etc. With the artistic influence of the Steppes came a tendency for increased naturalism. Although sometimes accentuated and embellished with stylised motifs, the animal or human figures when portrayed are instantly identifiable.

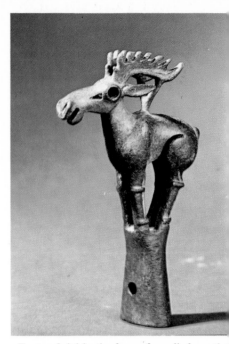

Bronze finial in the form of an elk from the Ordos region. China, Han dynasty. Steppe nomad art. *British Museum*.

Bronze mirrors, circular discs with ornamental backs and loops for suspension, were made during the Han as well as the Chou dynasties, and there is even an example which was recovered from Shang tombs near Anyang. Some scholars have suggested that the idea of mirrors may have been introduced into China by the Steppe nomads, who borrowed the idea, at about the 5th century B.C., from the Greeks on the shores of the Black Sea. However, as we have the example from the Shang tombs near Anyang, which is of a much earlier date, it is probable that mirrors may have been invented independently in China at an early date, and the Greco/Steppe idea only acted as an additional stimulus.

Most of the bronzes that have been buried and recovered from excavations are enhanced by beautiful patinas of green and blue, which are greatly valued by collectors and add to the value of the bronzes. However, Chinese connoisseurs had different tastes, and many bronzes that have been in Chinese collections have been covered with oil and brushed in an effort to produce a black shiny surface.

As the price of ritual bronzes is very high, a number of copies and forgeries exist. The collector must beware of the Chinese forger, for he often produced works in all mediums, using the same techniques and materials as the originals. Fake bronzes are often embellished with a false patina, added by soaking the object in acids, burying in soil for a year or more or other such methods. A more detailed description of the bronze forger, and the methods of detecting his work, will be given at the end of the chapter.

Bronze figure of a man, an example of Steppe nomad influence. Ordos region. China, Han dynasty. *British Museum*.

However, before we leave the subject of ritual bronzes we should mention the difficulties in identifying them. This can be very difficult indeed, and experts often disagree amongst themselves. Experience gained through actually handling objects is invaluable, and the collector should take every opportunity to see and handle as many as possible in collections and sale rooms.

The following story, which illustrates how difficult it is to be sure about bronzes, recently appeared in the *Sunday Times*.

A collector, who had read a few books on Chinese art, spotted a bronze in a junk shop. Thinking it was a bargain at £45, and probably genuine, he bought it. He then took the bronze on a round of the experts. The Oriental Department at the Victoria and Albert Museum, were not impressed. The British Museum were more interested, took photographs, and asked what price the collector expected for it. Sotheby's valued it at not over £50, while a very well known dealer in oriental works of art priced it at £25,000 and agreed to sell it at this for a commission. However, not satisfied, the collector

contacted other experts. The Metropolitan Museum, New York, is reported to have offered him £1,248, on the strength of photographs which he had sent to them, while in Britain one expert said he would not be unduly worried if it was dropped from the top of the Post Office Tower in London. Finally another expert renewed the valuation of £50 . . . and so on. Be warned!

The emphasis on the bronze art of China entirely changed at the beginning of the 3rd century A.D. The break up of the Han dynasty brought with it unsettled times, with chaos and poverty. People clung eagerly to the new religion, Buddhism, by which they hoped to regain peace and stability. During the Six Dynasties it became the popular religion, offering a totally new outlet for the bronze caster. Buddhist images were commissioned for both personal worship and for installing in temples.

To understand much of this later bronze work the collector should seek to obtain a working knowledge of the history of Buddhism in China, and an understanding of the various sects and the images which they favoured. There are a number of excellent books on the subject, a few of which are listed in the bibliography.

BUDDHIST BRONZES

Gilt bronze figure of Buddha Maitreya. Early 6th century A.D. China, Northern Wei period. *Freer Gallery of Art, Washington D.C.*

Buddhism is an Indian religion and to understand it and its effect on art we must look to the sub-continent. In the early days of Buddhism, the Buddha himself was not portrayed, but only suggested by symbols such as the Bodhi Tree, footprints, wheel, and parasol. Early bronzes of the Buddha are extremely rare during the early centuries A.D., but literary sources assure us they were produced, and it is probable that bronzes of this period from the Gandhara region of N.W. India, and those from Central Asia acted as models for the first images produced in China. It is highly unlikely that stucco or stone sculptures would be brought over such a long journey. Most of the early Gandhara examples of Buddhist bronzes and the early Chinese Buddhist bronze figures are small in size, and this has led some scholars to believe that only small figures were produced. This is most unlikely and the answer probably lies in the fact that the smaller the figure, the more likely it is to survive. It is less likely to attract attention to itself at times of Buddhist persecution, and less attractive as a source of metal for smelting down to make new images. Large images were easy prey, and few have survived, though we have records to show that they did exist.

There is an early text that relates that the Chinese traveller and pilgrim, Hsuan Tsang, who travelled in India between the years A.D. 399–414, brought back with him four metal images, one of silver and three of gilded bronze ('golden').

The earliest dated bronze known to us is a gilt bronze seated figure of the Buddha, dated A.D. 338. It is now in the Avery Brundage Collection in the M. H. de Young Memorial Museum, San Francisco. The stylistic elements of this bronze are very similar to Central Asian prototypes, on which it seems to have been modelled.

The early Buddhist bronzes of China were strongly influenced by the iconographic styles of the Gandhara region of N.W. India and of Central Asia. Buddhist iconographic canons were adopted in China and all images that were made had to conform to the specifications laid down for their particular type.

To standardise representation of abstract forms, specifications were laid down for the proportions of the figure, each relative to each other. In this way an artist who had never seen an image of the Buddha should by using the specifications laid down produce an acceptable representation. The first anthropomorphic representations of the Buddha were made by the Indian Gandhara artists.

With all these specifications it might be thought that Buddhist images are the same throughout the Buddhist world, but this is not so. The Buddhist bronzes of China, although strongly influenced by Indian and Central Asian images in the early days, soon established a style of their own, geographically and within the stylistic tendencies of each period. It is these differences that will help the collector to date and place later bronzes.

A problem that will face the collector is one of identifying the subject. The early Buddhist bronzes were mainly of the historical Buddha, Sakyamuni, in either a standing or sitting position. Later, however, when the religion

developed other images of Mahayana Buddhism (the Great Vehicle) were introduced, such as Bodhisattvas, the past and future Buddhas and so on. Later still Tantric Buddhism was introduced, and this necessitated the production of images of the numerous deities popular within the sect. Later too, Lamaism was introduced into certain areas of China from Tibet. Lamaistic images are closely related to other Tantric images, but although basically the same have been somewhat modified in Tibet.

Apart from the numerous gods and goddesses portrayed, there were also different positions of the hands and legs, (*mudras*, *hastas* and *asanas*). It will be seen from this that the collector will have to acquaint himself with the more common forms, and rely on reference books (see bibliography) for the others.

As stated, both large and small images were produced, but with some notable exceptions only the smaller bronzes have survived, examples of which can be seen in collections and museums throughout the world. The bronzes brought back from India by the traveller Hsuan Tsang in the 5th century are recorded as being between three feet three inches and three feet five inches high.

Gilt bronze figure of Buddha, A.D. 451 China, Six Dynasties period. *Freer Gallery of Art, Washington D.C.*

Some of the larger images that were made must have been gigantic. Literary accounts give instances of figures of over 40 feet high being cast. The largest image that survives today is the massive figure of Kuan Yin at Lung Hsing Temple at Cheng Ting. It was made in the 10th century and is approximately 46 feet high.

To cast figures as large as this requires great technical ability, and there are accounts existing which describe some of the difficulties involved. Although life-size and even larger figures could be cast at a time, some of the larger figures were cast in sections. It would have taken many tons of bronze to cast some of them.

One of the largest bronze figures of Buddha, in India, is the Gupta period (4th-6th century A.D.) image found at Sultangunj. It measures seven and a half feet high. The figure was cast in copper in two layers on to a core composed of a mixture of clay, sand, charcoal and rice husks. The first layer was moulded directly to the core and was held together by iron bands. The outer surface was then probably cast over the first layer by the *cire perdue* method. The whole image appears to have been made in different sections. This seems to be different to the method described in literary accounts of Chinese techniques. There is one text which describes the casting of a large bronze figure in the 6th century A.D. The figure, of Amitayus, was 18 feet high, and is said to have been formed in a single cast.

The majority of bronze figures were formed by the *cire perdue* method. The smaller bronzes were modelled in wax and cast solid, while the larger figures were modelled in wax on to a core, and cast hollow. Another method employed was repoussé, the construction of images in beaten sheet metal, hammered into shape from the reverse side.

As already stated, the early Chinese Buddhist images were stylistically related to Gandharan and Central Asian prototypes. When seated they are usually in the lotus position with hands in the dhyana mudra (position of meditation, hands lie in lap, palms upwards). The figures are clothed in monk's robes, which cling in U-shaped folds in the Gandharan style. The hair is arranged in waves, and they have an usnisa, and an urna on the forehead. The figures are seated on a lion throne and sometimes have a halo or flame aureole attached.

It is an interesting thought that in an indirect way the artistic traditions of Greece and Rome influenced the early Buddhist bronzes of China. The Gandharan style itself was the result of Hellenistic influence, which after many years reached Gandhara by way of Iran, reinforced by Roman influence from the eastern centres of the Roman Empire. In this way the art is more Romano-Buddhist.

Apart from the seated figures mentioned earlier, standing figures of the Buddha were made in the Udyana style, strongly Gandharan in appearance. A fine figure of the Buddha Maitreya in this style dated A.D. 477, is in the Metropolitan Museum of Art, New York. There is also a superb bronze figure of the Bodhisattva Avalokitesvara, in the Gandharan style, in the Fuji Museum, Kyoto.

The Chinese modified the Indian and Central Asian styles, to produce a distinctive style of their own. The round smooth features of the Gandhara images give way to the sharper, more angular lines more typical of the indigenous Chinese style.

In the early part of the 6th century, during the Northern Wei Dynasty, the body and head of the figure became thinner and more elongated. The 'table'

68

Gilt bronze Buddhist Trinity, Buddha Amitabha with Bodhisattvas Avalokitesvara and Mahasthamaprapta, dated 597. China, Sui dynasty. *Freer Gallery of Art, Washington D.C.*

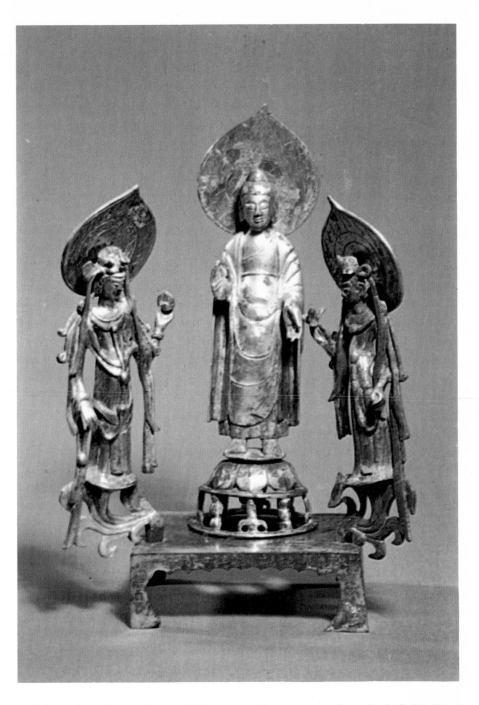

Gilt bronze Buddha Sakyamuni with Buddha Prabhutaratna, dated 609. China, Sui dynasty. *Freer Gallery of Art, Washington D.C.*

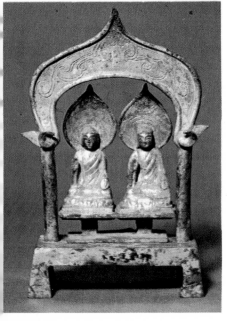

and lotus base is popular and flame aureoles are sometimes included behind the figure. Hair styles vary and may be either with tight curls or with no curls or waves at all. There seems to have been an emphasis on robes which became even more stylised, flowing outwards in layers like a Christmas tree. Jewellery also figures prominently.

Various deities were portrayed including the Buddha Sakyamuni, Maitreya, Prabhutaratna, Bodhisattvas and even Arhats.

During the Northern Chi (A.D. 550–577) and Northern Chou (A.D. 557–581) Dynasties, the style becomes more clear-cut. The Buddha images have pendulous ears, sculptured linear arms, and the hair is simply shaped, not waved. The flowering lotus base is also seen.

There was a complete change at the end of the Wei dynasty, and the style becomes more linear and plastic, as a result of renewed influence from India. During the Sui dynasty the figures are more symmetrical and the face rounder. Images of the Buddha usually have a coiffure of tight curls.

Figures of the T'ang dynasty (A.D. 618–907) have a distinctive style, dissimilar to those of earlier periods. Although the style is influenced by Indian iconographic ideals, and this can be seen clearly, bronzes of this period have the typical Chinese look of the T'ang style, reminiscent of the pottery tomb figures. The images are somewhat more formal with roundish faces, thick lips, slit curved almond-shaped eyes, sometimes with heavy lids, and bow-shaped

69

brows, sometimes shaped with the line of the nose. The hair of Buddha images is usually in tight curls, and the usnisa is large, although some T'ang figures have hair without curls or waves. The diaphanous flowing robes have Indian overtones, the edges and ends often touching each other, forming an openwork effect. Aureoles too, when present, are often openwork, as are the bases. The overall effect of the images is one of spiritual serenity.

The figures are modelled in various positions, both standing and seated. Deities seated in the bhadrasana, both legs pendant in the European manner, and in lalitasana, one leg bent in the position of dhyanasana (meditation), the other pendant, were popular during this period, but were also made at earlier times.

During this period a large number of images were made, including figures of the Buddha Sakyamuni, Vairocana, Maitreya, and Bhaisajyaguru, also minor gods and goddesses, and celestial beings such as apsaras, dvarpalas (guardian deities), and donor figures. Very popular were icons of Amitabha Buddha and Bodhisattva Avalokitesvara, also popular during the previous Sui dynasty. The images of Avalokitesvara appear to give a far more formal iconographic feeling than other subjects.

Bronzes of the Sung dynasty (A.D. 960–1280) are much rarer, probably due to the fact that far greater attention was paid to sculpture in wood than bronze casting.

The anatomy of the figures of this period is much heavier and more solid than in the preceding styles. Like the much larger figures in wood, images are sometimes seated in the maharaja-lilasana, position of royal pleasure, with the right hand raised and the left leg in the position of a Buddha, or pendant. One hand hangs over the knee, the other supports the body which is leaning backwards. The figures have squarish faces with a strong but serene expression. some are fully robed and jewelled. Indian influence can still be seen in some of the images. There is a superb standing figure of Avalokitesvara in the Freer Art Gallery, Washington D.C., which shows strong Gupta influence. It is naked from the waist upwards and wears a tall conical head-dress. Although dated to the Sung dynasty, it may be slightly earlier. There is a similar figure in the Musee Guimet, Paris.

Gilt bronze figure of Bodhisattva Avaloki-
tesvara, showing strong influence of Indian
Gupta artistic ideals. China, 10th century
A.D. *Freer Gallery of Art, Washington D.C.*

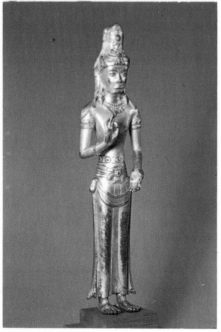 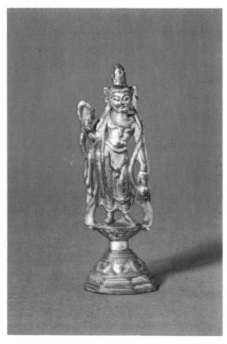

Gilt bronze figure of Bodhisattva Avaloki-
tesvara. China, T'ang dynasty. *Freer Gallery
of Art, Washington, D.C.*

Bronze seated figure of Avolokitesvara on a lotus base. China, Ming dynasty. *Private collection.*

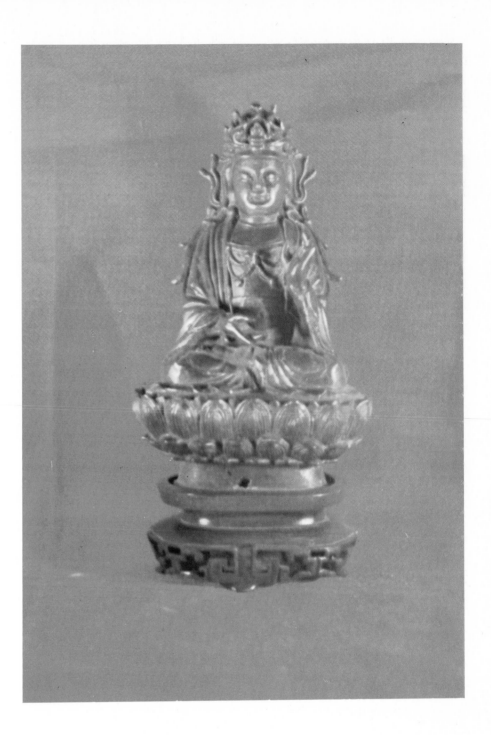

We know from manuscripts that Indian artists worked in China. A Chinese transcription mentions the name Ar-Ni-Ko, a Nepalese artist, painter, sculptor and decorator, who was invited, in the 13th century, to the Court of the Chinese Emperor. He wrote 'A Canon of Proportions' which was translated into Chinese in the 17th century and in 1885 was printed in Japan.

The images of the Ming dynasty are icons in the purest sense of the word. The influence of Tibetan Lamaism and tantric doctrines can be seen clearly in the many-armed and headed figures, a number of which are in museums and private collections.

The bronzes of this period are formal sometimes to the extent of being rigid. The anatomy is full, the robes stiff and sculptural, and sometimes engraved, and the jewellery is arranged symmetrically. The face is squarish, the nose rather wide, the eyes slit, and some figures have a sublime smile.

A number of Lamaist monasteries were established in China, and many of the bronzes made for this sect are difficult to distinguish from the Tibetan. Some of the images in fact bear Tibetan inscriptions. Subjects vary, and include many of the deities from the Tibetan pantheon. Like the Tibetan images, many of the Chinese metal figures were sealed with prayers, grain, precious stones, and sometimes smaller images in clay or metal.

71

Tibetan Lamaism is divided into sects, the Red Caps and Yellow Caps, and there is also a non-Buddhist sect called Pon. Each had its own pantheon of deities. The Yellow Cap sect, (Ge-lug-pa) is supposed to have over 300 divinities, of which there are numerous variations, including over 108 forms of Avalokitesvara. Some of the deities were also worshipped in China and to identify some icons the collector must refer to reference books on Tibetan art or Buddhism (see bibliography).

After the end of the Ming period the art of bronze working declined somewhat. Many of the bronzes of the Ch'ing dynasty were iconomatic, and lacked the inspiration of the Ming and earlier periods, but it would be a mistake to dismiss all the bronzes of this period. Within every era exceptional works of art were produced, within the artistic fashions and restrictions of the day, and the Ch'ing dynasty was no exception.

The images of the 17th and 18th centuries are, for want of a better description, more 'Chinese', the features sharper, the nose more aquiline, and the eyes reduced almost to slits. Apart from Buddhist images, Taoist and other figures were made.

It is extremely difficult to learn to distinguish bronzes of one period from another simply from descriptions in books, and even photographs help only a little. The collector will find, however, that the more bronzes he actually sees and handles, the more he will be able to discover from a piece, and the easier he will find it to make attributions.

Bronzes continued to be made in the 19th century but they are generally of little merit, and somewhat degenerate. However the collector should not be afraid to acquire specimens that please him.

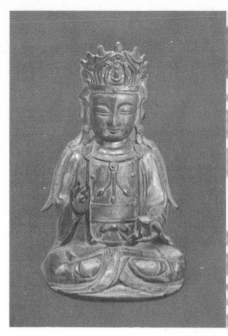

Gilt bronze seated figure of a Bodhisattva. China, Ming dynasty. *Private collection.*

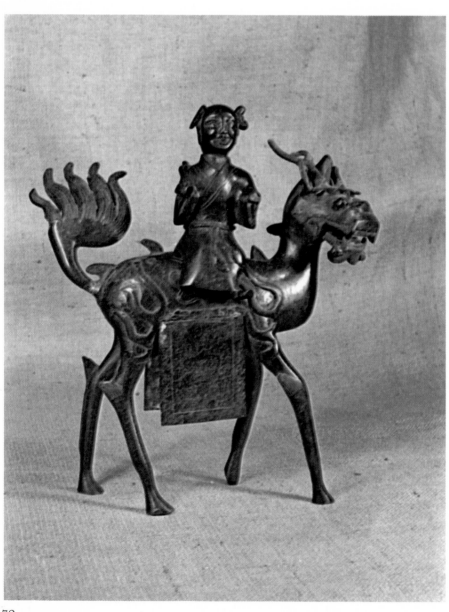

Late bronze figure of a chimerical animal. China, 16/17th century. *Russell-Cotes Art Gallery & Museum, Bournemouth.*

KOREA

As stated earlier, Korean art is strongly allied with that of China, from whence it received its main stimulus and inspiration. At the same time there existed a close association with Japan. In this way Chinese artistic values were diffused through Korea to Japan.

Unfortunately, much less attention has been paid to the art of Korea than to China or Japan, although this is slowly being rectified, and we are gradually learning more and more of the wonderful treasures produced by that country. The Japanese, who in recent times occupied Korea for 35 years, are far better acquainted with its art, and it is to them that we must address our thanks for bringing to light so many of Korea's art treasurers. Some of the finest collections of Korean art were made by Japanese connoisseurs, who not only formed collections in Japan, but were also responsible for much of the collections in Korea's museums. The first chance Western connoisseurs had of appreciating much of this fine heritage was at the Exhibition of the National Art Treasures of Korea, which was held at the Victoria and Albert Museum, London, at the beginning of 1961.

Much of Korean art has been dismissed too easily as provincial Chinese, which, although applicable to some works, simply will not do for all.

We do not as yet have sufficient bronze images and figures of the early periods of Korean art to make the same comparisons and stylistic discussions as we can with Chinese bronzes. We must therefore look to the wooden and stone sculptures to fill in our picture of the stylistic identity of the periods. The reader is advised to read this account in conjunction with the chapter on sculpture.

The early Korean bronze figures were influenced by the style of the Northern Wei bronzes of China, but few exist. Perhaps the most important Korean bronze figure known to us today is a gilt bronze image of Maitreya, dating to the early 7th century (Silla period 57 B.C.–A.D. 668), found near Kyongju. Seated in a pose found in other Korean works, the figure sits on a stool, left leg touching the ground, right leg crossed over the left, with the foot resting on the thigh, and the head and body inclined forward. The right hand is raised, the fingers just touching the cheek, and the left hand rests on the ankle of the right foot. The plasticity of the wax original is clearly seen. A sense of movement is achieved by the subtle change of angle at the waist. The figure is simple, with virtually no jewellery, emphasis being placed on the continuation and smooth flow of the lines and contours. An expression of supreme spiritual calm emanates from the figure.

It is interesting to note that the figure is almost identical to a wooden sculpture of Maitreya in the Koryu-ji Temple, Kyoto. The similarity between the two figures is so striking that is is possible that the bronze may have been inspired by the wooden figure, or that despite the difference in medium they were both the work of a single man or workshop. In any case it seems certain that the one in the Koryu-ji Temple is Korean workmanship (see chapter on sculpture), as we know from records that many Korean artists and craftsmen moved to Japan during the period and worked in the Nara region. The figure shows strong affinities to the Indian Gupta style.

Apart from figures, other works in bronze were produced, such as the famous large temple bells. These bells, decorated with various motifs, are especially fine. One of the most impressive, the large bell at Kyongju, is dated A.D. 770 and is decorated with motifs of apsaras and flowing linear and floral tendrils in relief.

Images of Great Silla (A.D. 668–936), were influenced by current artistic trends in China, but are somehow subtly modified with Korean ideals. Some images have a certain restraint and dignity peculiar to Korea, while others have expressions more typical of Japanese works. Subjects were much the same as in China but there seems to have been a special cult devoted to the worship of Maitreya.

There are few Korean bronzes in existence, and it is extremely unlikely that the collector will have the opportunity to acquire specimens.

JAPAN

In Japan, the first bronzes that are of interest are the mirrors of the Great Tomb period (A.D. 300–700). While a number are Chinese in origin, others are Japanese following the Chinese style. The mirrors are decorated with linear

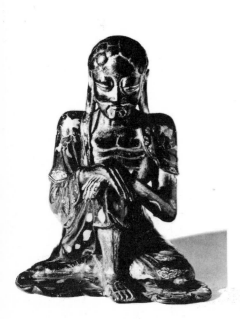

Bronze and lacquered figure of a Lohan, inlaid with mother-of-pearl. China, Ming dynasty. *Sydney L. Moss Ltd., London.*

designs in geometric patterns or with hunting scenes, houses etc. The workman-
ship in general is cruder than the Chinese, but in later times the quality improved
and many fine mirrors were produced. Some of these later mirrors are decorated
with original Japanese innovations.

Contemporary with the mirrors are the dotaku or bronze bells. These
unusual objects range in length from just a few inches to over four feet. There
have been a number of suggestions as to their use. They may well have been a
source of sound, maybe even a primitive musical instrument, but it is more
probable that they had no utilitarian function and were simply regarded as a
symbol of wealth. Some scholars have suggested that they were used as covers
for sacred objects. Apart from their interesting shape, they are decorated with
intriguing linear designs composed of humans and animals such as tortoises,
birds, etc. Some also have patterns of crossed bands and running spirals.

The dotaku have long been claimed as an original Japanese idea, but
excavations in Korea, at Lo-lang, have revealed similar objects, suggesting that
this typical Japanese object may not be so typical after all.

The arrival of Buddhism in the 6th century brought with it a demand for
metal images. The first images appear to have been brought to Japan by the
Buddhist mission from Korea in A.D. 552, although the first representation of
Buddha appears to be on a Chinese bronze mirror, dating to the first half of
the 3rd century, and found near Nara. Other records relate that an artist
versed in the making of images arrived in Japan from Korea in A.D. 557. It will
be evident from this that the first images in Japan reflect Chinese artistic trends,
and were either made by foreign artists or Japanese artists influenced by contact
with Korea.

By A.D. 604 Buddhism had become firmly established and received State
recognition. It was during this period that the famous Horyu-ji Temple was
built at Nara.

The earliest dated bronze of Japanese workmanship is the Buddha in the
Angu-in near Nara, but it is badly damaged and contributes little to our
knowledge of the bronze art of the Asuka period. Another image, the Yakushi
Buddha, at Horyu-ji, gives a far better idea of the bronze imagery of the time.
Dated A.D. 607, it was originally the principal image at the temple. Also at
Horyu-ji is the 'Shaka Triad'. This group is extremely interesting stylistically
as it shows strong affinity with Chinese and Korean prototypes. It bears an
inscription stating that it was made in the year A.D. 623 by Shiba Tori (Tori's
grandfather was a Korean immigrant). The group consists of the central figure
of the Buddha Shaka (Sakyamuni, the historical Buddha), and the two attendant
Bodhisattva figures. The Buddha is seated on a lotus, in the dhyanasana, and
wears monk's robes which fall in symmetrical folds. His hands are in the
abhaya and vara mudras. His face has a subtle smile. His hair is in tight curls
and he has an usnisa and has an urna on his forehead. Behind him is a large
flaming mandala or aureole. The whole effect is abstract, and reflects the
transcendental spiritual aspect of the image. One of the most striking aspects
is the obsession with drapery, which seems to flow everywhere, settling in
tiered folds. The mandala behind the figures matches the flowing lines of the
drapery as floral spirals and flames.

Also of this period, and at Horyu-ji, are the group of bronze images called
the Forty-Eight Buddhas. Other types of bronze work were also carried out,
such as the ban or banner. One made originally for the Horyu-ji Temple, but
now in the National Museum, Tokyo, is gilt bronze some 16 feet in length. The
designs of apsaras, Buddhist deities and honeysuckle scrolls, are beautifully
executed in perforated work and line engraving. The design is very similar to
Korean and Chinese motifs, and recalls the flowing treatment of the figures and
border of the Tamamushi shrine (see chapter on lacquer).

Bronzes made during the Nara period mainly followed the T'ang style and
because of this we often look to Japan to furnish us with illustrations of types
which have disappeared in China. All phases represented in T'ang sculpture
can be seen. There was great artistic contact between China and Japan during
this period.

Although the early works of the period are in bronze, sculpture in mediums
such as clay and dry lacquer became more popular later. It was in this period
that the massive bronze statue of Vairocana Buddha was cast at Todai-ji. The
figure is 53 feet high, and required approximately one million pounds of metal
to cast it, and about 500 pounds of gold to gild it. It was completed, after a
number of failures, in the year A.D. 749. The building in which it is housed is not
the contemporary structure, which was destroyed during the 12th century, but
is two-thirds of the size of the original building, which was 152 feet high, and

74

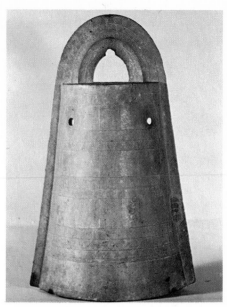

Bronze 'bell', *Dotaku*. Japan, 3rd century
A.D. *British Museum.*

occupied an area of 47,144 square feet. Unfortunately the image has been damaged and rather badly repaired.

In complete contrast is the miniature shrine of Lady Tachibana, in the Kondo at Horyu-ji. The central image of the Amida (Amitabha) Buddha is flanked on either side by attendant Bodhisattvas. All three are on lotus flowers, the Bodhisattvas standing, and the Buddha seated in the dhyanasana, with arms in the vitarka and vara mudras. The beautiful central figure has Indian overtones, coloured by Chinese artistic trends. The hair and the usnisa are in spiral curls and there is an urna on the forehead. The arch of the brows merges with the bridge of the nose, the eyes are half opened, suggesting inner calm, and there is a hint of a smile on the lips. The drapery is superbly executed, with restraint, almost clinging to the body. Behind the central figure is an openwork mandala, consisting of a central lotus surrounded by lattice work and a border of floral scrolls. The three images are backed by a superb screen decorated with apsaras and flowing scarves looping around the figures and merging with floral tendrils.

The whole treatment of the figures is far more sensuous than the figures of the preceding period. During this time physical beauty and spiritual beauty were regarded almost as synonymous.

The finest bronze of this period, and perhaps of the T'ang style, is the Gakko Bosatsu, the Moonlight Bodhisattva, one of the attendant figures of a Trinity,

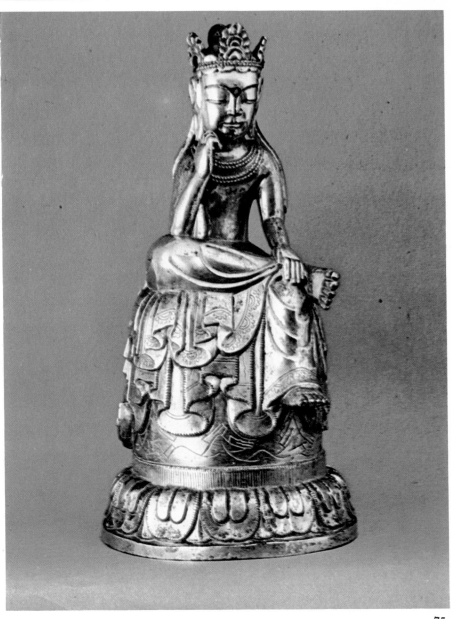

Gilt bronze Buddha, second half of the 7th century. Japan, early Nara period. *British Museum.*

with the centre-piece the Buddha Yakushi. Made about the year A.D. 720, this beautiful large-than-life figures shows all the main points of the T'ang sculpture of the time. The serene facial expression, the sensuous treatment of the body in the tribhanga mudra, the body bent with the gradual curves of the figure 'S'. Originally gilded, the gilding has worn off, revealing the warm tones of the bronze. No comparable statues exist in China.

During the Early Heian period bronzes were rarely made, the principal medium for sculpture being wood. The mystic esoteric forms of Buddhism introduced into Japan caused images to be made in fantastic forms with numerous heads and arms.

Wood continued to be the most popular medium for sculpture during the Heian period, sometimes called the Fujiwara period. Metalwork, however, rose to great heights during this time, rivalling if not surpassing that of China. Castings other than figures were carried out during the Nara period, and the tradition was continued during the Heian period, when the T'ang styles became coloured by Japanese artistic ideals.

Various forms of bronze work were produced, mainly religious such as the ku, or gong, used in religious rites before images, and the keman (wreath of flowers) a kind of bronze floral openwork object. Originally of real flowers it is hung from a nageshi, a horizontal beam in Buddhist temples. The floral work on the keman is Indian in inspiration. A fine example in the Chusenji temple at Hiraizumi is gilt bronze and worked in openwork with floral motifs, and a pair of Karyobinga, half men, half bird figures. Mirrors were also produced during this period.

Images of the time tended to be effeminate, and lacked the force and presence of those of the Nara period. The cult of Amida was popular, but figures were produced of Yakushi Buddha, Bishamon, Guardian of the North, Kannon and Kichijo-ten, originally the Hindu goddess Sri Devi. As stated earlier, they were mainly of wood. The gigantic image of Amida Buddha at the Kotoku-in in Kamakura was cast during the Kamakura period. The most famous work of the period, it was cast in the 13th century and was originally housed in the main hall of the temple, but has remained in the open since the wooden structure was destroyed by a tidal wave in the year A.D. 1495.

This fantastic figure is a masterpiece not only of contemporary bronze technology but also of artistic skill, for despite its huge size it is modelled with vigour and yet the details are tasteful and as delicate as on a smaller sculpture. The proportion and balance of the image is superb. Approximately 42 feet high, it is cast in several sections. To a certain degree some stylistic associations can be seen with contemporary works in China.

The Ashikaga period, also called the Muromachi period, saw a general decline in sculpture, including bronze. Figures of this period tend to be rather stiff and iconomatic and are similar in some respects to the Chinese bronzes of the Ming dynasty.

Bronze sculptures of the Momoyama period continued to be rather rigid and iconomatic, but they are few in number. The decline in the production of Buddhist bronzes is related to the decline in Buddhism which was taking place at the time.

Bronzes of the Tokugawa period are varied. Buddhist bronzes were still produced but many of them tend to lack the original inspiration so evident in some of the figures of the earlier periods. Chinese influence can still be seen in some of the images, but they are rather hackneyed interpretations of the iconographic style of the Ming period. Sculpture declined and miniature carving, such as netsuke and okimono, became more popular.

However, during the Tokugawa period there was a great demand for ornamental metalwork and the traditional art of the bronze caster was sought after. The increased wealth of the nation produced a market for metalwork for personal and domestic use.

The Japanese artist achieved great dexterity in casting bronze objects as well as figures by the *cire perdue*, or lost wax, method, including such items as koro, or incense burner, bells, vases, mirrors etc.

Mirrors continued to be made in bronze but, unlike the early disc variety, were endowed with handles. The designs were more elaborate and of a pictorial nature. Some of the mirrors of this period bear the signature of the bronze worker with the boast, 'first under Heaven!' A favourite shape for the koro was a war drum surmounted by a cock.

Figures other than Buddhas and Bodhisattvas were made including the Seven Gods of Good Fortune. They are:

1. Fuku-roku-ju, the God of Longevity, always distinguished by an abnormal

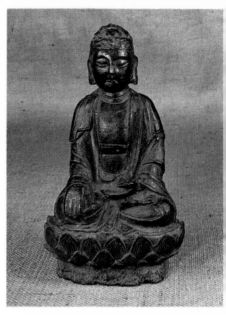

Bronze figure of Buddha on lotus base. 16th century. *Russell-Cotes Art Gallery and Museum, Bournemouth.*

Bronze figure of Kannon, the Chinese *Kuan Yin*. This little figure has a fine sense of movement imparted by the flowing robes. Japan, Tokugawa period. *Russell-Cotes Art Gallery & Museum, Bournemouth.*

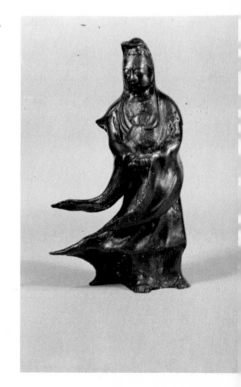

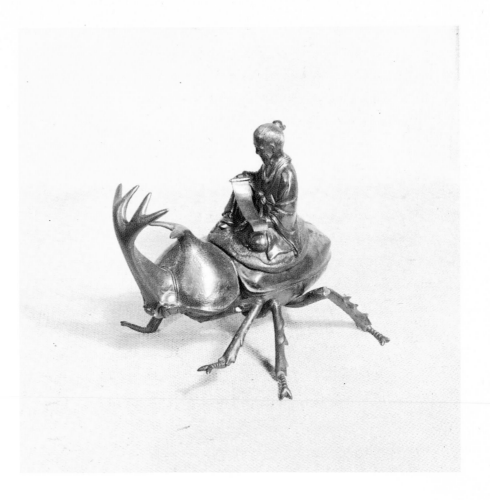

development of the head.

2. Daikoku, the Chinese Ta-shen-wang, God of Wealth and Riches. Although he can be shown in several forms, he usually holds a miner's hammer in his right hand and a sword in his left. Sometimes he is seated on bales of rice.

3. Ebisu, the God of Daily Food, generally represented as a fisherman.

4. Hotei, the Chinese Putai, God of Contentment, represented as a fat, merry old man, with a broad smile. His stomach is usually exposed.

5. Juro-jin, the God of Learning, depicted as a scholar, with a peach in his hand and rolls of writing on the end of a staff.

6. Bishamon, God of Military Glory or War, one of the guardians of the four corners of the Universe. He is depicted dressed as a warrior, holding a spear and pagoda.

7. Benten, Goddess of Love, Learning, Wealth and Music. Richly dressed, she carries an instrument, koto or biwa, or sometimes a sword or spear.

On the whole, bronzes of the Tokugawa period display less artistic merit and are not as pleasing as those of earlier periods. However, works of artistic merit were occasionally produced and are worth collecting, but the collector must be discriminating as so many mediocre works were produced.

Many of the images, both Chinese and Japanese, were gilded and coloured. Gilding was done in one of two ways – either by the application of gold leaf or, as in the case of most small figures, by mercury gilding. In the latter, the gold is applied with the aid of mercury and then the figure is heated, driving off the mercury, leaving only a coating of gold. Some figures were further embellished with painted facial features and hair, etc. Indeed, like Greek sculpture, which was also painted, some of the figures would not be as appealing to us in their original, sometimes garish, colours.

When buying bronzes the collector must always bear in mind two things: One; there are some very good forgeries, and two; there are some good copies and later pieces with stylistic traits of earlier periods. Observation is the collector's best friend, and he must use all his senses to the full.

The collector must not be misled by the seemingly ancient appearance of a piece, which can easily be simulated. False patinas can be added by soaking the bronze in acid for short periods so that the surface will be attacked, and if the

process is handled correctly blue and green patinas can be created, but they should not fool the experienced collector. The secret is to see and handle as many genuine specimens as possible. In this way the false patina will be obvious. There were other ways by which the forger produced false surfaces on fakes. Green paint was sometimes used, mixed with fine sand and earths. In this case the magnifying glass will tell all, sometimes even revealing brush marks and hairs. Another method popular with forgers of the 'better' fakes was to accelerate the natural ageing process. Bronzes were sometimes buried in river beds, with the addition of dung and other 'catalysts' for a period of one or more years. The collector should examine the surface of a potential purchase to see how uniform the colour is, and whether the colour penetrates the cracks and crevices. He should test it gently with his finger nail, preferably on the base or some place that will not be seen, to see if the 'patina' is easily moved. Many collectors are surprised to see the shiny new metal beneath. On genuine bronzes that were once coloured small traces of colouring will remain. The forger sometimes tries to simulate this, but fakes can usually be detected by close examination and using common sense.

Some fakes will give themselves away even before they are handled and examined, when the forger has slipped up, using stylistic fashions and iconographic features of different dates on one piece, or when the bronze is supposed to have been made at an early date, but has later stylistic innovations. Thus it pays to be thoroughly familiar with the different styles and costumes of the various periods. Copies of bronzes of early schools tend to be very stiff.

Recent bronzes tend to be rather sharp, and the edges rough, often with file marks showing on the surface, but occasionally the clever forger has tried to mellow this with acids. Older bronzes, usually mellowed with age, have smooth edges and are pleasant to handle.

A word about gilding. Some bronzes that were gilded, lacquered or coloured, have a rough surface which acted as a key, holding the medium to the figure. The collector will however be able to distinguish this from modern filemarks if he examines the piece carefully.

There are basically two kinds of forgeries. The first is the bronze that has been cast from a mould taken from a genuine piece, and the second is the outright 'original', usually made in the same manner as the genuine bronze, by the *cire perdue* process. A third type may be added to this, although it is not strictly a fake – that is when a genuine bronze of one period has been made to belong to another period, usually by the addition of a false date and/or an inscription. In some cases the bronze has been shown to be even earlier than the period in which the inscription would have placed it.

Bronzes that have been cast from moulds taken from authentic ancient pieces are more difficult to detect but if carefully examined often give themselves away, for in places where they are supposed to be worn the surface may feel quite fresh, showing in fact that the 'wear' has been cast on.

One of the commonest mistakes the novice makes when starting to collect bronzes is that he is misled by the seemingly ancient appearance of the piece. In the case of small figures this can be very misleading, for a late bronze which has been handled and worshipped may be worn while a larger piece which has been buried in the ground or kept in a temple may have a fresh appearance in comparison.

Bronzes of all kinds are well worth collecting and make a most rewarding hobby and good investments. The larger pieces usually fetch higher prices as they show better in museums than the smaller pieces. The collector who is intending to start a collection or who has already started will be well advised to subscribe to the catalogues and price lists issued by the leading salerooms such as Sotheby's, Christie's and Parke Bernet in New York. In this way he will be able to keep himself informed of the latest values and gain useful information. He need not, however, buy at the salerooms, although there are bargains to be found there occasionally. Many beautiful and even rare figures can be had from local auctions and antique shops for just a few pounds or dollars. The collector must be cautious at the start and not pay too high a price for any bronze until he has some idea what he is buying. Remember the story told earlier in the chapter! A little time spent in looking at collections in museums, handling figures in salerooms and antique shops and generally taking every opportunity to see and handle as many pieces as possible will prove most rewarding.

Finally a word or two about cleaning bronzes – DON'T! Unfortunately this advice does not seem to have been available to some owners of bronzes in the past and many pieces have suffered from being cleaned with household metal polishes, which although admirable products for cleaning modern brass and

copper have removed all the surface tone and patina. Although it may have pleased the cleaner, figures that have been cleaned have lost a great deal of their value and charm. The collector should bear this in mind when buying. If he is offered a bronze that has been cleaned, he need not necessarily pass it by, if it is at a suitably low price or if it is reasonably rare. It is possible to tone the surface down using a metal-darkening agent sold by Cannings of Birmingham, manufacturers of electroplating equipment, but if the bronze is very rare he should consult a qualified restorer.

Gilt bronze figure of Buddha. Japan 18th century. Tokugawa period.

Sculpture

Unlike painting, sculpture was never highly regarded in China. It was generally considered a lesser art and few names of sculptors have been recorded. With the exception of some marbles excavated at Anyang in 1934–5, the earliest sculptures which have come to our notice are the highly stylised wooden figures that were recovered from tombs in Ch'ang Sha, dating to the 3rd century B.C. These figures were probably intended as attendants to accompany the deceased, but their exact significance is not known.

Sculpture, as far as our discussion is concerned, starts in the Han dynasty. The sculpture of this period can be divided into two groups – bas-reliefs and figures in the round.

Han bas-reliefs are extremely interesting as they help to give us a pictorial idea of the everyday life of the time. The subjects are invariably mythological or historical, but are depicted in contemporary settings. A large number of reliefs were found in the Wu Liang tombs, in Shantung. The general style of Han reliefs suggests that they are renderings on stone of contemporary paintings or similar medium, and this provides us with ideas of the appearance of paintings that have long since disappeared (see chapter on painting).

Sculpture of the Eleven-headed Avalokitesvara, from Ch'ang-an, Shensi. China. 8th century A.D.

Two techniques were used in the production of these reliefs. The first, low relief carving, and the second, in which the ground is left rough and the figures smoothed and polished with outlines and details engraved.

There are, in addition to the reliefs, a few sculptures in the round. Early examples are the large statues of horses, dating to about the 2nd century B.C., carved from boulders at the tomb of General Ho Ch'u-ping in the valley of the Wei River in Shensi. The carving is rather rough, but indicates that Han artists were quite capable of monumental sculpture in the round, but that it was probably not fashionable. Other animal sculptures are known both from this site and elsewhere. In general, sculptures of animals were of a very high quality, and were carved both in the round and in high relief, as on the pillars of Ch'en at Chu hsien in Szechuan. Here the animal subjects and hunting scenes have a dual role of decoration combined with architecture.

Further sculptures, animal as well as human, in high relief were discovered in 1950, at Ma-hao, in Szechuan Province. These figures are interesting as they suggest Indian influence. There is one relief, depicting nude lovers embracing, that reminds one of Indian prototypes. One scholar has suggested that Szechuan was independent of the central government and had its own commercial links with India, hence direct influence cannot be ruled out.

In our discussion of Chinese sculpture we must, however, separate these early forms from the later, which is principally a religious art based on Buddhism.

When reading this chapter, it will help the reader if he refers to the chapter on bronzes, for bronze sculpture is merely sculpture in another medium, and stylistically is no different from sculpture in stone, wood, clay or lacquer.

As with bronzes the first Buddhist sculpture was strongly influenced by Indian and Central Asian sculptural styles. Many of the works of the Wei period were carved in what is known as the Udyana style.

The origin of the style is given in the King Udyana sutra. The story goes that Sakyamuni had gone to the Tusita Heaven, the home of the Buddha Maitreya (the Buddhist Messiah), to preach to his mother. As time went by the King of Kausambi grew worried that Sakyamuni would not return to earth, so he sought the help of the disciple Maudgalyayana (Chinese: Mu-lien) to send 32 of his craftsmen, together with sandalwood, to the Tusita Heaven, in order that they might make a portrait of Sakyamuni. The miracle was duly performed, and when the image was completed, it was installed in the Jetavana monastery, in the Kingdom of Sravasti, present-day north-west Nepal.

Udyana figure of the Buddha in the Sieryo Temple, Kyoto. Japan.

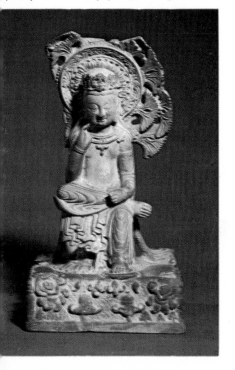

Marble sculpture of Bodhisattva Maitreya or Sakyamuni. China, Northern Ch'i dynasty. *Freer Gallery of Art, Washington DC..*

It seems fairly certain that there was such an image, although not the result of miraculous powers. However, it became famous throughout the Buddhist world and a number of copies were supposed to have been made. There are legendary accounts of how copies and even the original image were brought to China. Although we can place little confidence in these stories, they do reveal one important fact – that it was the practice to import images from India whenever possible. A number of stories bear this out, including the tale of the famous traveller Hsuan Tsang. The importance of this practice on Chinese sculpture is tremendous, for it means that periodically Indian images would have reached China, making it possible for Indian artistic trends to directly influence Chinese sculpture. Thus the superb religious sculptural styles of the Gupta and other periods had a direct bearing on Chinese sculpture. To this we must add the influence from Central Asia (which in its way too was influenced from India), and we shall see that Chinese sculpture is a unique blend of Indian, Central Asian and Chinese indigenous artistic ideals.

To return to the Udyana image, this style embodies elements of Gandharan and Mathuran traditions with slight overtones from Central Asia. A copy of what was supposed to have been the original Udyana image was made in China by a Japanese priest in the year A.D. 987. This image which is still in the Seiryo Temple, Kyoto, displays Central Asian characteristics.

The Gandharan concept of the Buddha is basically Indian, but coloured by Hellenistic and Roman ideas of figurative forms. The first images of the Buddha are thought to have been carved by this school, though some scholars believe that the Buddha image may have been invented at Mathura. Gandhara was the name of the region around Peshawar on the north-west frontier of India. The style spread over a large area including Baluchistan, Afghanistan and even Central Asia.

The Gandharan Buddha image may be described as follows: The figure wears a toga-like robe which reaches below his knees, the folds are well defined, produced by carving parallel and horizontal curves in relief. The limbs are generally thick and even plump. The head is strongly influenced by Greek renderings of the head of Apollo. The features are full, the eyes are half open indicating divine peace; the nose is almost Roman, its line continuing upwards to form stylised brows. There is an urna on the forehead; the lips are well proportioned with strong curved lines; the ears are pendulous. The hair is long and wavy and there is a cranial protuberance or usnisa. The total height of the figure is in the proportion of five heads, as were the figures of the late Roman sculpture.

The Mathura Buddha is truly Indian in concept. The figures have greater contours and well-defined articulation. The usnisa is shown as a spiral and the urna as a raised dot on the centre of the forehead. There is greater sculptural plasticity and emphasis is placed both on the expression of movement and the position of the body. The robe clings to the body giving an impression of anatomical form beneath the garment. For a more detailed description of the origins of the Buddha image and the development of early Buddhist sculpture: the reader is referred to the specialist works listed in the bibliography.

The Chinese took elements of both the Gandharan and the Mathuran styles, sometimes from figures which embodied elements of both with Central Asian colouration, and mixed them with indigenous ideas. The result was unique.

The early Chinese images followed the Gandharan style closely, but as time passed the figure was modified to suit Chinese taste. Broad shoulders became narrow and later sagged, the figure lost its volume and became flat with details carved in relief, while the drapery became stylised geometric patterns. Some of the early dated sculptures are in Yun Kang at Ta-t'ung-fu, in Shansi. These monumental figures are carved out of the living rock face of the gorge.

The work at Yun Kang seems to have begun about the year A.D. 460, and continued till after A.D. 494 when the Northern Wei Emperor moved the capital from Tai (Ta-t'ung) to Lo-yang. The Gandharan style can be seen clearly in the early works at Yun Kang, but the later ones are in the mature Northern Wei style. Many of the figures are dated by inscriptions. Further sculptures were carved in cliffs at Lung-men, after the Court had moved to Lo-yang. The caves at Lung-men have sculptures dating from the late 5th century to the mid-8th century.

The Wei style is marked by its obsession with robes, which are elaborate and fall in tiers with parallel folds. The bodies of the figures are elongated and angular, but more attention is paid to the robes than the form beneath them. The face is squarish, set on a long neck, the eyes are mere slits with no pupils, and there is an enigmatic smile on the lips.

Monumental, non-anthropomorphic sculpture was occasionally produced, probably the most impressive examples of which stand in front of the Royal Tombs outside Nanking. These monumental figures, dating to the Liang dynasty (A.D. 502-557) are full of vitality despite their huge size. The subjects, winged lions, with bulging chests and tongues hanging from their mouths, remind one of the monumental sculpture of earlier epochs in the Near-East.

The sculptural style of the Sui dynasty was a prelude to the sensuous style of the T'ang period. The Sui figures are fuller and more symmetrical than those of the preceding period.

During the T'ang dynasty, the art of the Chinese sculptor reached its zenith. Renewed influence from India had a marked effect on the style. There is, however, one important difference between Indian and Chinese sculpture, both of this and other periods. Indian sculptures were made as an integral part of temple architecture. The exterior of Indian temples combined numerous sculptures into an architectural entity. The techniques and forms, therefore, are closely connected with architecture and masonry. This is worth bearing in mind when one sees Indian sculpture shown in museums as separate works. Chinese sculpture, on the other hand, although influenced by Indian architectural sculptural ideas, was never used architecturally in the same way as the Indian, although cliff temples are carved with sculptures, out of the living rock. The stele was popular during the Wei and Sui dynasties, but although produced during the T'ang dynasty was not so fashionable.

The Indian Gupta style affected the development of T'ang art, but the Chinese indigenous style is the dominant factor.

The figures are less rigid than those of the preceding period and although they conform to iconographic canons there appears to be more individuality which reflects the sculptor's ability to work within strict iconographic dictates. It is possible to see differences between the early and late T'ang styles. During the early style, for instance, a change from the preceding method of depicting drapery can be discerned, the robes falling around the limbs, following the contours of the body, while during the latter part of the period more attention is paid to anatomy itself. This attention to the form of the body rather than the contrived decorative designs of the drapery is the result of Indian Gupta influence. The effect is more sensuous. The lofty aspirations of the T'ang sculptors produced works endowed with physical attributions of great beauty, in an effort to create works of art which enable the onlooker to have an aesthetic experience as a way of achieving spiritual harmony. Spiritual beauty in fact was expressed in physical terms.

Sculpture continued in the caves at Lung-men. One of the most notable is the superb figure of the Buddha in the Ping-yang grotto. The figure is shown seated cross-legged, with attendant figures by his side. An air of spiritual peace and divine being emanates from the sculpture, despite its huge size. It is 50 feet high, and is dated by an inscription to about A.D. 675.

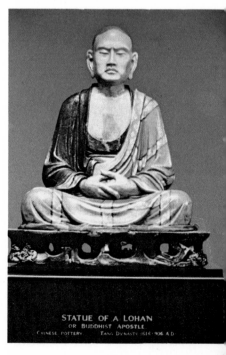

Glazed pottery sculpture of a Lohan (one of eighteen Buddhist Saints). 10th-11th century A.D. China, Sung dynasty. *British Museum.*

When discussing sculpture of the cave temples we must call to mind the famous caves at Tun Huang, which not only house the superb paintings mentioned in the chapter on painting, but also a superb group of sculptures which date from the Northern Wei period to the Sung dynasty. The rock here was unsuitable for carving, and the majority of the figures are modelled from clay and painted. The change in medium resulted in the figures here having greater plasticity then those in other cave temples. Also at Tun Huang are examples of portraiture which although rare in China became an important art form in Japan.

The T'ang sculptors were equally at home with sculpting animals as they were with Buddhist figurative work. In style they are essentially realistic. The individuality of each animal is well depicted whether domestic or wild and the characteristics of the animal superbly portrayed. A variety of animal sculptures exist, in the round, and in relief, both small and monumental. The horse is perhaps best portrayed in T'ang art, both in clay as tomb figures and in sculpture. The spirit of the horse, with all its restlessness and power, is expressed with superb skill. These qualities can be seen in the magnificent. monumental 7th-century sculpture of a winged horse, with head tossed back and flowing mane, made for the tomb of Kao Tsung at Ch'ien Chou, and the life-size relief panels of horses from the tomb of the T'ang Emperor, T'ai Tsung. The sculptures, which date to A.D. 637, are in deep relief, and depict the Emperor's favourite chargers. Smaller pieces of animal sculpture can be seen in various museums throughout the world.

When discussing Chinese Buddhist sculpture, we must bear in mind that it

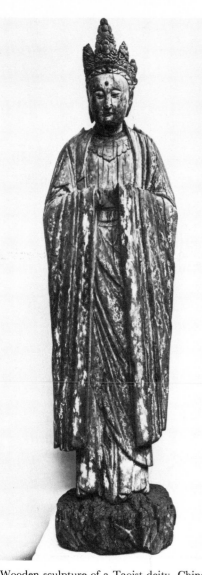

Wooden sculpture of a Taoist deity. China, Sung dynasty. *British Museum.*

was strongly affected by religious fashions, as well as the politics of the various periods, and the reader is strongly advised to read a political history of China in order to fill in the background of the artistic history described in these pages.

Political changes sometimes had a drastic effect on sculpture. The most obvious were the persecutions of Buddhists which occurred at various times. Although Buddhism had suffered setbacks at earlier periods, perhaps the greatest persecution took place under the Emperor Wu Tsung in A.D. 845. Over 45,000 temples were destroyed, and about 275,000 priests and nuns were obliged to leave the priesthood.

Change in fashion of Buddhist doctrines also forced changes in artistic trends. Ch'an Buddhism (Zen) with its emphasis on meditation and instant Enlightenment caused a decline in the demand for images and an increased demand for painting.

During the Sung dynasty there was a change in preference of medium from stone to wood and dry lacquer.

The figures of the Sung period are naturalistic and fleshy, and more pictorial. Figures of Kuan Yin are popular, and a number of large-size figures are known, some life-size, many of which are in museums. The modelling is powerful, contrasting with the drapery which falls in graceful folds, and jewellery is elaborate. The facial characteristics are a development of the T'ang style. The Bodhisattva Kuan Yin (Avalokitesvara), has by this time been transformed into a female deity, 'The Goddess of Mercy'.

During the Yuan dynasty, Buddhism received a new impetus, when it was made the official religion. This is reflected in the sculpture. Images were made in Lamaistic forms, influenced by Tibetan and Nepalese types, a practice that was to continue into the Ming dynasty.

By the Ming period sculpture had declined. Although sculptural works continued to be produced they had lost much of their earlier vitality. Monumental works were produced, but they had none of the quality and spirit of previous periods. In fact, a change occurred, carvings became smaller, stone and wood being discarded in favour of ivory and similar material. However it would be unwise to assume that sculpture ceased to be produced from the Ming period. Works were produced, but they were no longer of the same quality as earlier pieces. Some outstanding carvings exist in ivory, but they are smaller, and should be considered separately.

In Korea, sculpture was strongly influenced by Chinese artistic traditions. The ruins of Pulguk-sa Monastery and the cave temple of Sokkul nearby housed some of the finest specimens of Korean Buddhist art. The sensuous treatment of the sculptured figures shows strong influence from T'ang China. The figures of Bodhisattvas, Buddhas and saints are in the typical T'ang style, like those at Lung-men in China.

JAPAN

In Japan, apart from the earlier pottery Haniwa figures, the first sculptures of merit are the Buddhist images of the Asuka period (A.D. 552–645). Buddhism arrived in Japan in the 6th century A.D. by way of Korea. The first images, therefore, are in the Chinese style with Korean overtones, in fact, a number of the early sculptures in Japan were made by Korean artists. One of the finest wooden sculptures of the period is the large standing image of Kannon, (Chinese—Kuan Yin) the Bodhisattva of Mercy. The figure is extremely elongated. No similar sculptures have been found either in China or Korea, although the figure is generally considered to be a Korean import or the work of a Korean artist resident in Japan.

Perhaps the greatest work of the period is the superb image of Miroku or Maitreya at the Koryu-ji Temple, Kyoto. This wonderful figure is very similar to a metal image of Miroku found at Kyongjuin, Korea, and has been considered like the image above to be of Korean work (see chapter on bronzes, page 73). The figure is made from a single piece of pine wood, and was probably once covered with lacquer. The carving is extremely simple; there is no jewellery and the figure is naked from the waist upwards. The clear-cut lines of the facial features are emphasised by the grain of the wood. The figure invokes an air of transcendental mysticism. There is another similar image in the Chugu-ji in Nara, but there are minor differences. Both figures are in a position often found in Korean works, seated on a stool, one leg crossed over the other, the body bent forward and the right hand raised with the fingers barely touching the cheek.

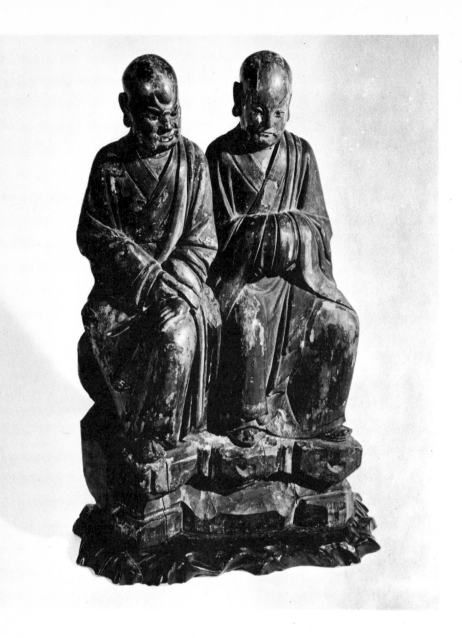

An example of late Chinese sculpture. Wood, 16/17th century. *Sydney L. Moss Ltd.,* London.

During the Nara period, the sculpture reflected the full-bodied T'ang style. Bronze sculpture was popular during the earlier part of the era, but later works of clay, lacquer and wood were more popular. There are more master-pieces of the T'ang sculptural style in Japan than in China.

Clay sculptures, because of their medium, are more plastic than their stone or wood counterparts, but they are extremely fragile. Few Chinese examples have survived and the finest examples we know are in Japan. The technique is basically a more elaborate version of the method used for constructing the Hindu images in India, for the annual Pujas. A framework of wood is covered with straw and straw mixed with clay, and then covered with layers of fine clay. The figure was then coloured and gilded in parts with gold leaf.

Probably the finest of these early images is the Nikko Bosatsu or 'Sunlight Bodhisattva', in the Todai-ji Temple at Nara. This superb figure is of the late Nara period and reflects the true majesty of the T'ang style. An air of spirituality emanates from the figure, which is standing with hands in the namaskara mudra.

Dry lacquer sculptures were lighter and easier to transport and use in processions but were difficult to make. Hemp was impregnated with lacquer and stretched on a framework of wood. The rough shape thus formed was then built up with layers of lacquer, the features then being modelled on the surface layers. The process allowed fine modelling with a smoothness that evoked an air of naturalism. Thus it was the natural medium for portraits. This can be seen in the superb portrait of the Chinese monk Ganjin, in the Toshodai-ji, Nara. The face of this figure is a masterpiece of expressive art. The features are modelled in soft contours, and the eyes cleverly formed in half-closed narrow fish-shaped slits, giving the impression of blindness, for Ganjin was blind. The robes fall softly around the figure which is seated in the dhyana mudra.

Wooden Gigaku mask. Japan, 729–748 A.D. *British Museum.*

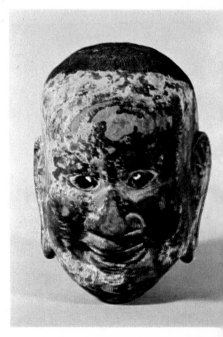

84

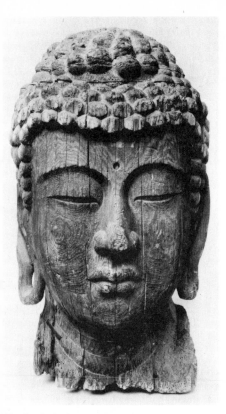

Head of Amida Buddha, wood, formerly painted. Japan, late 12th century. *British Museum.*

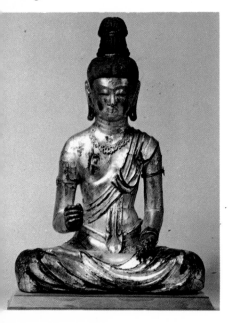

Lacquer sculpture of Buddha. 10th century. Japan, Heian period. *Freer Gallery of Art, Washington D.C.*

The whole feeling is one of spiritual calm. It is the oldest portrait statue in Japan.

Another superb sculpture in lacquer is the many-armed and faced figure of Asura Deva, originally in the Golden Hall at Kofuku-ji. It is now in the Nara Museum. The arms and hands are interesting as they are like bent pipes, with no attempt at articulation. The true sensuous treatment of the Nara style is reflected in this piece.

During the Nara period the idea of portraying spiritual beauty as physical beauty, as in T'ang China and Gupta India, can be seen clearly. To gain a complete picture of the style of the period the reader should refer to the chapter on bronzes, which should be read in conjunction with this chapter.

In Japan, as in China, sculpture served a different purpose to that in India, where it was primarily an adjunct of architecture.

The Early Heian period saw a change in the art of sculpture, with clay and lacquer falling out of fashion as suitable mediums. Most works of this period were executed in wood. This may be due to the popularity of Shingon Buddhism, with its complicated and many-armed deities, which may have been more economical to produce in wood than in lacquer or bronze. It has been suggested by some scholars that clay was not suitable for the production of the elaborate figures of the esoteric sects, but this seems an unlikely explanation, as clay is used most successfully in India for figures with more than 20 arms.

The style of the Early Heian figure is a development of the earlier Nara style, but is rather heavier, fuller and more naturalistic. Greater attention is paid to the drapery, almost to the exclusion of the anatomical form beneath. The lines of the folds became important decorative features in themselves. The Hompashiki or rolling wave style developed from a series of parallel curves. The treatment is still sensuous, and reflects Indian influence. Many of the figures have a peculiar expression, quite unlike the earlier smile of the Nara figures. In general, in comparison with the sculptures of the Nara period, the Early Heian images are overpowering and iconographic, and although naturalistic bear little relation to reality.

Although the style is different from the preceding style of the Nara period, it is impressive, and must be viewed for what it is, an awesome and grand art medium for transmitting the divine plan to the faithful.

The Heian or Fujiwara period saw a number of changes in sculpture. Techniques and inspiration changed. The sect of Amida became fashionable and the demand for Shingon and Tendai images declined. A new technique was introduced during this period. The old practice of using a solid wooden block to carve was superseded by building up a shape from a number of pieces of wood, and then carving the details when joined together. This enabled the sculptors to produce works lighter in weight and more intricate than before.

A return to the earlier and milder forms of the Nara period suited the execution of images of Amida Buddha.

A superb work of the period which illustrates these points is the large gilded wooden image of Amida by the sculptor Jocho. The image is in the Byodo-in, Uji, near Kyoto. Seated in the position of dhyana mudra or meditation, the carving is extremely simple, contrasting with the elaborate flame aureole behind. It became the model for a number of later images.

The return to the earlier warmth and sensuousness of the Nara period can be seen in the figure of Kichijo-ten in the Joruri-ji Temple, Kyoto.

Unlike China, the prestige of sculptors in Japan was high, and they were considered artists and men of importance. They obtained positions in society which enabled them to introduce new stylistic traits, like the great innovations of Chinese painting. Thus we can ascribe a number of Japanese works to the hands of particular sculptors. The new technique allowed the shapes of the figures to be formed in the workshop from the master's design by the apprentices and assistants, the details and finishing touches being added by the sculptor.

The greatest sculptors of the Kamakura period were Kokei, his son Unkei and his pupil Kaikei, the most important being Unkei. The sculpture of this period was the last that can truly be described as great. Clay and lacquer were again used, but never regained the importance they held during the Nara period.

The style is vigorous and realistic and contrasts with that of the previous period. The inspirations continued to be mainly Buddhist, but in addition to iconographic works portraits were produced, both of priests living and dead, and of laymen. A fine example of the latter is a portrait of Uesugi Shigefusa. The sculpture, in wood, is interesting, for although the robes are arranged in

stylised geometric forms, pyramidically, the face is naturalistic.

The violence of some of the figures is startling and extremely convincing. The superb figure of Kongo Rikishi, one of the Guardians of the Faith, by Jokei, in the Kofuku-ji Temple, Nara, almost explodes with vitality. The plastic modelling is in the round, and emphasises the muscles and anatomy of the figure which is stretched taut with violent movement. The face is expressive, drawn into a violent mask, and the loin cloth is swept back by the force of action. Parallels of this kind of figure can be found in China. Chinese ideals of the Sung period also influenced other sculptural forms.

With the passing of the Kamakura period the great era of Japanese sculpture ended. During the Ashikaga period, sculpture declined, as it did in contemporary China. This was probably due to a number of reasons, but the decline of the iconographic sects and the popularity of Zen Buddhism, with its reliance on meditation rather than icons, played an important part. However, although Zen Buddhism did not use images portraits of Zen priests were made.

From this period onwards, and throughout the Tokugawa epoch, sculpture tended to become smaller, with Japanese carvers concentrating on miniature works such as netsuke. Images continued to be made, but they had lost all their earlier vitality and had become on the whole mere icons. Wood and and lacquer were both used, but the size was usually small. Many of the smaller wooden images were gilded. Most were hollow, and some contained inscriptions, recording the date they were made, the donor or patron and the artist.

In the early 17th century, in an effort to suppress Christianity, the second Shogun, Hidetada issued an Edict, instructing each household to have a Buddhist image. Thus a number of images date to this period.

Styles were rather formal, in the styles of earlier periods, often modelled on some of the great masterpieces.

It would be a mistake to assume, however, that all works produced during these later periods, were hackneyed versions of earlier works, and not worth our attention, for as with the art of any period there are bound to be exceptions, and it is these exceptions that the collector must look for. It is probably fair to say that on the whole the true spirit of the Japanese sculptor can be seen only in the minute works in ivory.

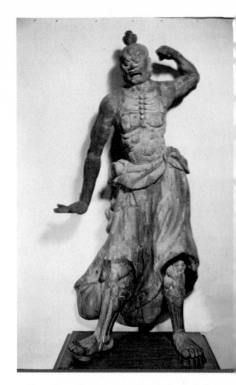

Guardian Figure, wooden sculpture. Japan, Kamakura period. *Freer Gallery of Art, Washington D.C.*

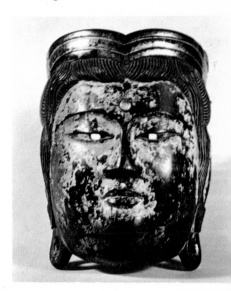

Bosatsu mask. Japan, late 12th century. *British Museum.*

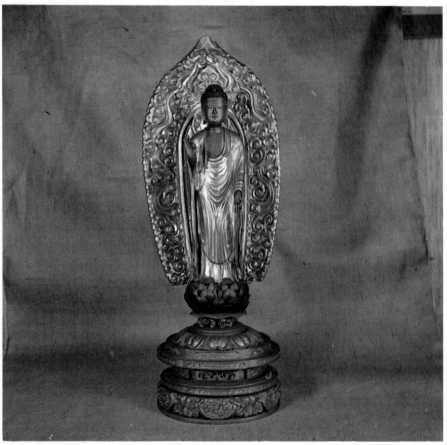

Painted and gilded wooden sculpture of Buddha. An example of late work 18/19th century. Japan, Tokugawa period. *Russell-Cotes Art Gallery & Museum, Bournemouth.*

A superb silver and jewelled elephant, inlaid with gold and jewelled with amethyst, coral, agate, yellow jade, malachite and chicken bloodstone. The howdah is surmounted by a crystal sphere. The work of Komai, it is a fine example of late metal sculpture. Japan, Tokugawa period. *Russell-Cotes Art Gallery & Museum, Bournemouth.*

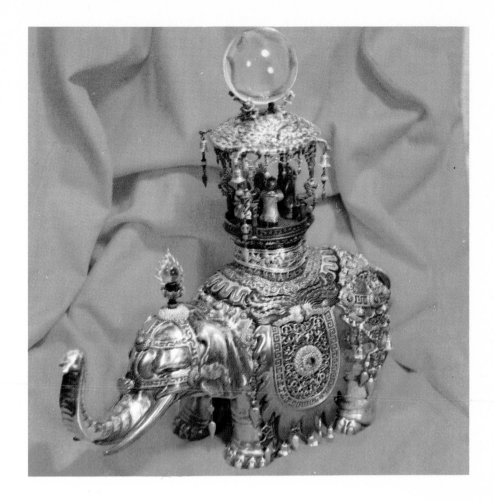

On the whole the collector will stand more chance of obtaining Chinese works of good quality than Japanese.

Both Chinese and Japanese sculpture may be purchased from antique shops and salerooms, but there is little chance of obtaining Korean works. As with other branches of Far Eastern Art, the collector is advised to subscribe to the catalogues of the major salerooms to obtain a guide to current values. He is also advised to see and handle (if size allows!) as many pieces as possible. A number of museums in Britain, America and Europe have fine collections and the collector will be well advised to be acquainted with collections accessible to him. On the whole he will find that he is able to acquire more small than large pieces, as the latter are in demand for museums. Small wooden and lacquer figures are sometimes of great artistic merit. Stone steles and heads of images may also come on to the market, but the larger figures will be rare.

As with most forms of Oriental art, the collector must guard against forgeries, for even in sculpture they occur. Copies, of course, were made in the original material, but more recently casts have been produced from the original works with powdered stone and resin, or some cement compound, and collectors are often misled by the seemingly-worn appearance and air of authenticity. Lacquer works have been simulated with resin and gilded, while clay and stucco figures were copied by casting with liquid clay on a framework, or in the case of stucco with plaster of Paris.

Pottery Sculpture

In addition to the larger sculptures in stone, wood and similar materials, there exists a large body of extremely delightful smaller works in pottery. These charming works have great plasticity, and could perhaps be described as masterpieces of ceramic art. Principally made for use as tomb furniture, they help to illustrate the everyday life of the time. Human figures, animals, houses etc. are all reproduced superbly.

The practice of human sacrifice as part of burial rites is vividly illustrated by the excavations of the Shang tombs at Wu-kuan-t'sun, near Anyang, where the burials of the Shang royal family produced numerous skeletons of attendants sacrificed during the burial ceremony. This barbaric custom changed later and only substitutes were buried. Among the earliest of these figures are the highly stylised wooden sculptures from Ch'ang Sha in the Yangtze valley, Hunan.

During the Han dynasty the practice of placing pottery models and figures in tombs became fashionable. They were not simply rigid figures, but extremely plastic, and modelled in various groups or singly, showing some of the pursuits and pleasures of life which the deceased had enjoyed on earth. Subjects were varied and included musical scenes, games, dancing etc. Animal figures and models of houses, estates, and domestic equipment were also made. Although most were naturalistic, some of the buildings were highly stylised, sometimes to the point of being ornamental. All were intended to accompany the deceased for his use in the next world. There is a superb green glazed pottery model of a pleasure pavilion, complete with figures, in the British Museum. Other examples of figures and models can be seen in museums and private collections throughout the world.

Unlike most other forms of Chinese art, these fascinating figures and models show a sense of humour more typical of Japanese works.

The superb models of horses of this and the later Wei and T'ang periods are among the masterpieces of Chinese art, and rival Greek renditions in the mastery of spirit and movement.

Some of the models and figures are covered with a green glaze, while others are simply painted with unfired pigments over the dark grey body. Some are shaped in moulds. Tomb figures of the Han period are smaller than those of the T'ang dynasty. The quality varies according to whether it was placed in a rich or poor man's tomb. As well as the tomb figures in the round there are also reliefs on clay bricks that were used for the walls of tombs. These reliefs are similar in style to the stone reliefs of the period. Some of these bricks were ornamented with stamped designs.

Tomb figures continued to be produced in increasing numbers from the end of the Han period, and we have some fine figures of horses dating to this time. The human figures tend to be stylised, similar to the style of the stone sculpture of the time, but with greater plasticity. The animal figures of this intermediate period show a greater degree of naturalism, heralding the realistic treatment of the T'ang period.

The figures of the T'ang dynasty are dynamic, naturalistic and extremely plastic. T'ang artists were masters of ceramic sculpture, and their skill and artistry is clearly seen in the figures which seem endowed with a sense of life and movement.

The cosmopolitan attitude of T'ang China can be seen clearly in these figures, some of which depict foreigners from the Near and Middle East and Central Asia. Subjects were many and varied; animals such as horses, camels, bullocks; human figures such as dancing girls, musicians, servants, dwarfs and guards. All were accurately portrayed by the T'ang artists. The realistic non-iconographic treatment of these figures is in complete contrast with the formal religious sculpture of the period. One reflects the everyday life of the

Horse with Rider. Painted pottery tomb figure. China, Six Dynasties period. *Victoria & Albert Museum, London.*

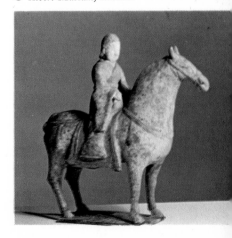

88

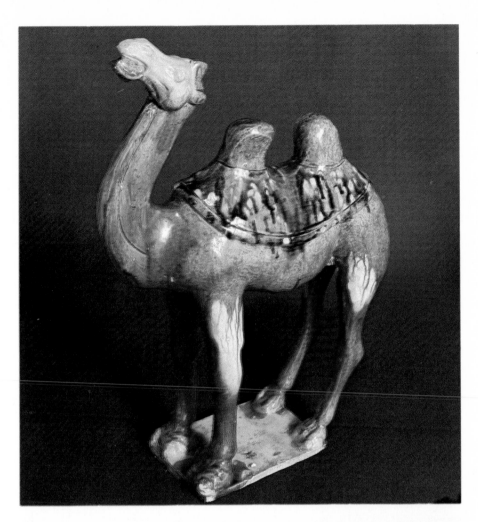

Camel. Glazed pottery tomb figure. China,
T'ang dynasty. *John Sparks Ltd., London.*

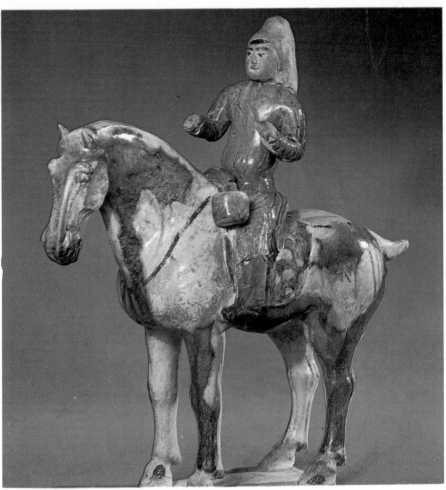

Horse with Rider. Glazed pottery tomb
figure. China, T'ang dynasty. *Sydney L.
Moss Ltd., London.*

period, and the other the high spiritual and abstract ideals of contemporary philosophy. Mythological figures were also made such as the God of Death, the Judge of Hell, and tomb guardians.

The advances in pottery technology were used to great effect by the ceramic sculptors. Most of the figures are covered with delightful glazes of green, brown, cream and yellow, often merging with each other, other times mottled. The pottery body was lightly fired and can usually be marked with a finger nail. Unglazed figures were painted with unfired pigments, such as white, red, green and black. Most figures are hollow cast. The art of ceramic tomb sculpture declined with the end of the T'ang dynasty.

In Japan the only comparable sculptures are the haniwa figures of the Old Tomb period. The earlier highly stylised pottery figurines of the Jomon period are probably fertility symbols and are extremely primitive. It is, however, the haniwa figures that command our attention.

These figures developed from the practice of placing pottery cylinders filled with earth around the great mounds of earth of the tombs. The cylinders were set closely together as a sort of buttress, to hold up the soil around the edges of the mound. As time passed, efforts were made to ornament the cylinders, and, inspired perhaps by the tomb figures of Han and Six Dynasties China, the cylinders took the form of animals and humans. They are, however, completely different from the Chinese figures, and are quite abstract and sophisticated, very pleasing to the modern eye. Inanimate objects were also modelled on the cylinders, with subjects such as armour, weapons, thrones etc. predominating.

As sculpture they are extremely interesting, as the stiff and rigid lower part of the cylinder contrasts strongly with the animated plastic forms which have been modelled on the top.

There are a number of stories relating to their origin. According to a sacred book of the 8th century A.D., the Nihon Shoki, they were made as substitutes for human sacrifices at burial rites, like the Chinese tomb figures. This seems most unlikely as they were placed outside the tomb, and also as it is possible to trace the haniwa back to simple pottery cylinders. No evidence of sacrifices such as seen in the Shang tombs of China has been found in Japan. It seems probable

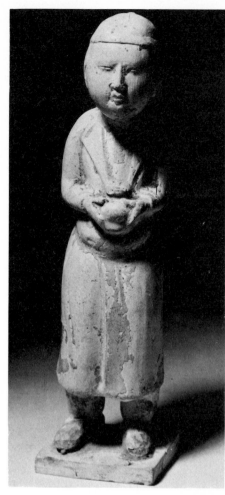

Beggar. Pottery tomb figure painted with cold pigments. China, T'ang dynasty. *Sydney L. Moss Ltd., London.*

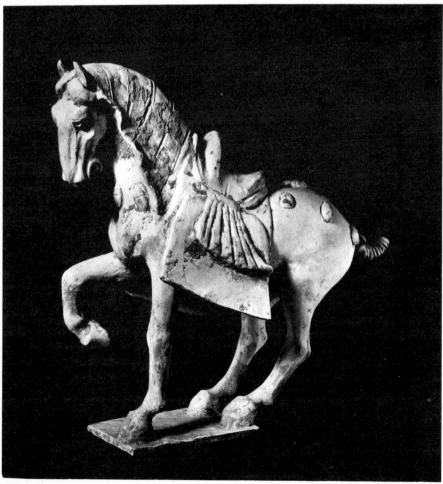

Horse. Pottery tomb figure. China, T'ang dynasty.

90

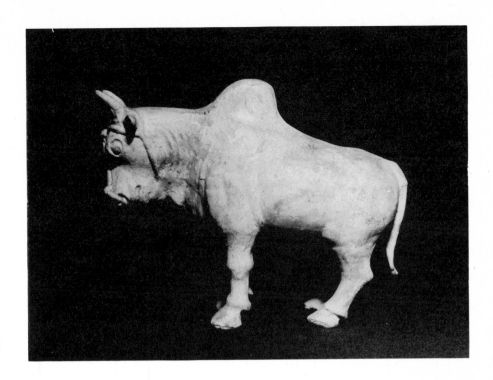

Zebu ox. Pottery tomb figure. China, T'ang dynasty. *Sydney L. Moss Ltd., London.*

Pottery Haniwa figure. Japan, 6th century A.D. *British Museum.*

that the legend of the origin of haniwa figures may have been started by the very appearance of the figures, half-buried as they were around the mound.

Large numbers were made in an infinite variety of subjects. The tomb of the Emperor Nintoku in Izumo Province had over 11,280.

The basic form of the haniwa allowed extremely abstract and geometrical treatment of subjects. Facial features such as noses and ears were modelled and attached, while eyes and mouth were cut out of the clay, creating a mask-like effect, like a creature out of science fiction. Although stylised, the figures are a valuable source of information on contemporary costume and material culture. Men and women in various occupations, warriors, in armour, animals, inanimate objects, all were the subject of the haniwa artist. Some of the horses and other animals are masterpieces of what could be termed 'folk art'. They make interesting comparisons with recent cylindrical pottery figures of horses and other animals made in the villages of Eastern India.

The early tombs had simple arrangements of vertical cylinders around the mound. In the 5th century, the Middle Tomb period, the cylinders began to be decorated with inanimate objects. During the Late Tomb period figures of humans and animals replaced inanimate objects in popularity.

The size varies from 2 to 3 feet high and averages about 10 inches in diameter. They are therefore technical as well as artistic achievements, and it is possible that some artistic effects such as cutting holes for the eyes and mouth may have been introduced to prevent the figures cracking when fired, acting in a similar way to the holes on the back of the Greek Tanagra terracotta tomb figures.

Large numbers of tomb and haniwa figures were produced, but in spite of this there are a number of fakes on the market. The collector will, however, be able to acquire genuine examples of less important and smaller pieces at reasonable prices, but the finer figures are rare and expensive. It is the latter type of figure that the forger loves to copy.

During the first part of this century a large number of tomb figures were recovered from tombs in China when the Lung Hai railway cut right through a cemetery. Many of the figures in museums and private collections throughout the world were found at this time. During the early 1920's, allowing for the difference in the value of money, tomb figures were fetching extremely high prices, even more than today, but prices soon hit an all-time low, due to a glut on the market. Figures were sold in a London auction room in lots of ten or more 'ex SS Fushimi Mara'. A T'ang camel could be bought for £1·50. However with prices so low it was soon common knowledge that after the supply of the genuine figures had ceased figures continued to reach the market but this time they were the products of a fake factory. The presence of these fakes effected the prices for some time. Prices today are high for the better pieces, but the collector should remember that fakes still abound.

It is unfortunate that tomb figures are comparatively easy to fake. They can be produced either from moulds of genuine pieces or modelled afresh. Most fakes are unglazed, as it is much more difficult to fake aged glaze. The body of T'ang figures is usually buff or red/brown, while that of Wei figures is usually grey. The clever forger copied both these characteristics. Painted figures were aged by first applying the paint then brushing some of it off, and then applying a coat of liquid mud. Some fakes, if examined closely, have brush marks in the mud coating. Many of the genuine glazed figures have iridescence.

Science today is coming to the collector's aid. A method of dating pottery by thermoluminescence, originally developed as an aid to archaeologists, is now being used to date tomb figures. Some salerooms and dealers are selling pieces with a certificate of dating. Tests in Britain are carried out by the Research Laboratory for Archaeology and the History of Art, Oxford.

The collector should be extremely cautious when buying ceramic sculpture and seek advice whenever possible. If purchasing in an ordinary antique shop, he should treat any potential purchase as modern, until proved genuine. Of course there are occasions when one can find a genuine piece at a bargain price, but they are rare indeed. The collector should always be able to buy from specialist dealers with confidence, as most have many years of experience and some are authorities in their subject.

Tomb guardian. Glazed pottery tomb figure. China, T'ang dynasty. *S. Marchant and Son. London.*

Miniature Sculpture and Carving

Jade ritual ornament. China, Shang dynasty. *British Museum*.

JADE

Ivory, jade and other materials were also used for sculpture but mainly for smaller figures and miniature works. Jade was carved in China as far back as Neolithic times. It has always been greatly treasured, and often figured as tribute to the Emperor from the outlying barbarian lands. The term 'jade' is used to describe a number of substances, but genuine jade, the classical nephrite, is calcium magnesium silicate with a hardness of $6\frac{1}{2}$ degrees on the Mohs Scale. The Chinese called it Chen Yu. Other minerals are sometimes included under the heading jade, such as Chinese serpentine. In the 18th century, jadeite (sodium aluminium silicate) began to be imported into China from Burma, though there are accounts suggesting that it was used at earlier times, when in colours such as brilliant red, and emerald green it is immediately distinguishable from nephrite.

Nephritic jade was found as pebbles in river beds as well as extracted from rock, mainly in Turkestan. It is improbable that any was found in China. The name jade comes from the Portuguese 'pedra-de-mijada', so called because it was supposed to prevent kidney and urinary diseases.

A number of colours are known, caused by the presence of various silicate or oxides. The colour can range from white, when almost pure, pink, purple, blue to nearly black/green. The Chinese call the white jade 'Mutton Fat', but 'Cabbage' Jade, light green/grey, is the most common.

Subjects over the years have varied from personal items of jewellery such as pendants, bangles, belt buckles and figures, both human and animal, vessels, panels, seals, sceptres and ritual objects.

In the Book of Rites, written towards the end of the Chou dynasty, six ritual objects are mentioned. They are the Pi, the Ts'ung, the Kuei, the Chang, the Hu and the Huang. Out of these the Pi is worth describing, as it was made from earliest times until the present day. It is a small disc pierced in the centre, sometimes plain, other times decorated. In the Shang tombs at Anyang, Pi are found decorated with symbols similar to those seen on ritual bronzes of the Shang and Chou periods. Other jade objects were decorated with mystical t'ao t'ieh masks and kuei. (see chapter on bronzes). The Pi, thought by some to be a representation of the sun, symbolises Heaven.

Another ritual object also made during the T'ang and Sung periods is the Ts'ung. Basically it is a cylindrical tube within a rectangular brick formed by four vertical triangular prisms. A large number exist, both carved and plain. Their exact use is not known but they may have been connected with some earth or fertility cult.

The shapes and decorative motifs peculiar to various periods depend a great deal on the technology of jade working current at the time. Jade is a very hard substance, and to work it harder materials must be used.

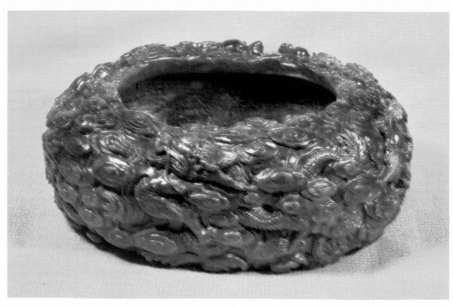

Fine carved jade Dragon Bowl. 18th century. China, Ch'ing dynasty. *Sydney L. Moss Ltd., London.*

In Neolithic times jade was worked by rubbing the surface with an abrasive, probably made from crushed garnets mixed with grease, using a bone or bamboo stylus. Holes were made with bow drills and similar abrasives. Later, with the introduction of metal, bronze or iron tools took the place of bone and wood, but the method was still basically the same. The diamond tip is thought by some scholars to have been introduced into China during the first millennium B.C., but it seems more likely that it was the corundum tip. The technique of embedding a rough 'diamond' tip in a metal tool fell out of fashion during the first centuries of the Christian era, due to the high cost, although it was used on occasions, especially during the 18th century, for engraving texts on objects.

Jade blocks were cut with a rotating iron disc and abrasives. Crushed garnets continued to be used through the centuries, but in the 13th century the jade-worker was helped by the discovery of a new abrasive, 'black sand' or crushed corundum. During the Ch'ing dynasty further deposits of corundum were discovered in China and the technique of manufacture and use of abrasive was refined and perfected. Instead of grease, a new method of using a mixture of fine clay, corundum, and other abrasives was introduced. This had a revolutionary effect on jade working, allowing many new processes to be evolved.

Jade figure sculpture is not common before the Sung dynasty. There is an interesting stylised figure of a man in the British Museum which dates to the late Chou or early Han period (4th–2nd century B.C.), but otherwise human figures are noticeable by their absence. This is probably due to the popularity of other mediums, especially pottery. Animals, however, were carved, usually mythological and highly stylised. An exception is the fine Han sculpture of the head and chest of a horse in bright green jade, now in the Victoria and Albert Museum, London. This dynamic figure bears all the stylistic traits of sculpture in other mediums of the period. It probably dates to the 2nd century A.D. Most of the animal sculpture, however, right up to late Sung times, tends to be stylised.

During the Yuan period, massive works in jade were carried out, an echo of which can perhaps be seen in the large sculpture of a tortoise in the British Museum. The sculpture, which is in grey/green nephrite, is two feet long and unlike sculpture of earlier periods it is delightfully naturalistic.

Carved jade vase. 18th century. China, Ch'ing dynasty. *Victoria & Albert Museum, London.*

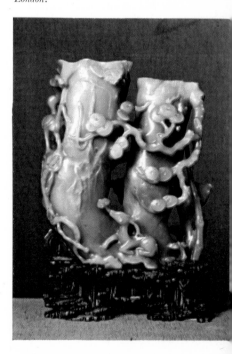

Human figures were carved during the Ming period and in later times. Subjects were varied but generally were Buddhist or Taoist, and included deities such as Kuan Yin, Manjusri, Sakyamuni, and the Taoist Lao Tzu, and the Eight Immortals.

Vessels were made at various periods, but were less fashionable during the Ming dynasty. The Sung period saw a revival of archaic styles and shapes, and it is often difficult to distinguish archaic jades from those of this period. Some vessels which have been dated to the 4th–3rd century B.C., by one authority have been placed in the 17th century A.D. by another.

The golden age of jade is generally agreed to have been the Ch'ing dynasty, and there are many wonderful objects in museums and private collections all over the world to illustrate this. The Emperor Ch'ien Lung was fond of jade and commissioned a number of works. Most interesting, perhaps, are the jade mountains, made of large blocks. These pieces, usually in the form of mountain

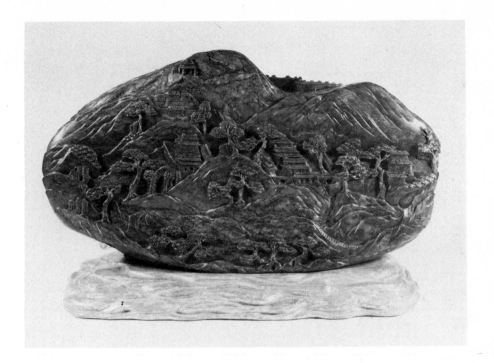

landscapes, are embellished with poems by the Emperor. Jade from Siberia began to be imported into China during this period.

When buying jade the collector must take precautions to ensure that the object of his interest is in fact jade and not soapstone, alabaster or marble. A simple test is to see if it will scratch with a metal point, on some hidden part. Jade is hard and will not scratch. Chinese craftsmen copied works of earlier periods, and it is often difficult to distinguish between the genuine and the fake. The collector should take note of the materials and techniques that were used at different periods. Jade is a subject on which there are few authoritative works, one of the earliest being Laufer's *Jade – A Study in Chinese Archaeology and Religion*, Chicago, 1912. Others are listed in the bibliography, and the collector is advised to study them and see and handle as many pieces of jade as possible.

When buried, the surface of jade tends to change due to oxygenation and carbonisation. This causes stains to appear which sometimes penetrate quite deeply. The process takes a considerable time, usually more than one thousand years before it begins to show, depending on the conditions etc. Such stains very often enhance the beauty of the object. Many collectors take it as an indication of age, but fakes have been produced with an imitation surface achieved by heating the jade in high temperature ovens.

The collector should bear in mind that jade figures and objects are still carved in Hong Kong, Taiwan and China and many of these pieces are imported into Europe. After seeing and handling genuine pieces the collector should have no difficulty in distinguishing between modern and old works. If unsure the collector should never pay more than he would for a modern piece.

IVORY

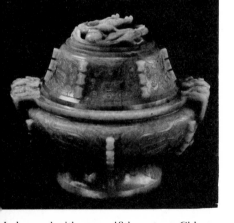

Ivory, bone and horn were also used in China, ivory especially, during the Ming dynasty. Perhaps the most effective use of ivory can be seen in netsuke and similar objects of Japan.

As mentioned in the chapter on sculpture, during and after the Ashikaga period sculpture as an art became miniaturised. The larger religious works gave way to small carvings for daily use. The Japanese artist excelled at producing masterpieces in miniature, fitting his composition into a confined space. It is not surprising then that netsuke should provide a challenge that the Japanese artisan could hardly resist.

The netsuke is part of the elaborate costume accessory known as sagemono. The sagemono could consist of a number of items, seal or medicine boxes, inro, tobacco pouches, tonkotsu, money pouches, writing materials, snuff bottles, etc., suspended on cord from a sash, obi, which held the kimono closed. The netsuke or toggle, was intended to prevent the assembly slipping through the obi.

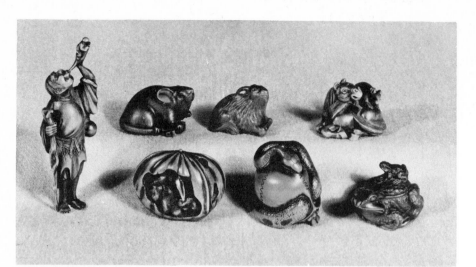

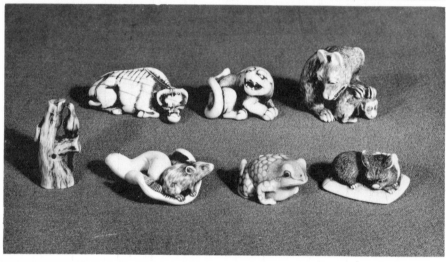

A number of materials were used to make netsuke including metal, porcelain, antler and bone, but the most common was wood and ivory. Many different kinds of wood were used including ebony, boxwood, cherry, yew, sandalwood etc. The forms are varied and wonderful, the creative imagination of the Japanese carver knowing no bounds.

The earliest examples date from the 16th century, but the majority date from the 18-19th centuries. It is possible that a form of netsuke was used during the Ashikaga period for suspending keys from the sash. There are a number of forms and an infinite variety of subjects. The bun or manju usually do not date earlier than the mid-19th century. They are flat, round, sometimes square or quadrilateral and although some are solid they are usually hollow, in two halves, with room to carry charms or similar articles. They can also be quite large. A variation was the ryusa, which had deeper carving.

Kagamibuta (mirror-lid) were similar to the lower half of the manju, but had the opening closed with a highly decorated convex metal disc. They were hollow and may have been used to carry amulets or similar items. Other forms were the ichiraku, woven or plaited netsuke, and the long netsuke, sashi.

There was an infinite variety of subjects, drawn from nature, everyday life and mythology. Religious subjects included arhats, the Bodhisattva Kannon, and the Seven Gods of Good Fortune (see bronzes). Mythological subjects included ghosts, oni or evil spirits, usually depicted as grotesque creatures; mythological animals such as dragons, the kirin or unicorn, phoenix, the minogame, a supernatural tortoise with tail, and tengu, an aerial monster with the body of a man, wings of a bird, claws and a beak. No matter what the subject it was impossible for the artist to suppress his glorious sense of humour. The netsuke is one of the most delightful of Japanese arts, and one which can provide the collector with innumerable hours of pleasure.

The subject can often help to date a netsuke. Early pieces were often simple, gradually getting more elaborate as time progressed. Subjects such as the signs of the zodiac, the Seven Gods of Good Fortune, oni and demons, historical events, legends, poets and foreigners were popular in the 18th century. In

Netsuke carved from wood. Japan, Tokugawa period. *Russell-Cotes Art Gallery & Museum, Bournemouth.*

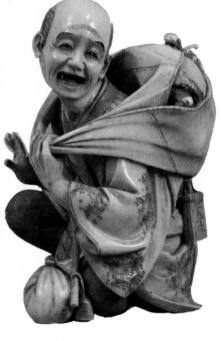

Okimono in ivory depicting a man with an animal peeping out of a sack. Japan, Tokugawa period. *Russell-Cotes Art Gallery and Museum, Bournemouth.*

Group of wooden netsuke. The elephant being washed is by Minkoku and the *Tengu* emerging from an egg is by Shumin. Japan, Tokugawa period. *Russell-Cotes Art Gallery and Museum, Bournemouth.*

contrast subjects of everyday life and birds, animals, fruit and vegetables etc., were popular in the 19th century. This of course is only a rough guide, there are numerous exceptions.

Many of the finer netsuke were signed but there are also a number of fine works that are unsigned. This is because most of the better artists and craftsmen worked for their patron or lord, and this work was generally unsigned, unlike the work which the artist did in his own time, which was usually signed. The collector should examine pieces carefully and with the aid of a book such as *Netsuke* by F. M. Jonas, now reprinted by Tuttle, he will be able to identify the artists and obtain interesting biographical information. This book is a classic, and no intending collector of netsuke should be without it.

The netsuke artist sometimes turned his hand to carving okimono, ornaments, which were an extension of the art of netsuke. Larger than the netsuke, they embody the same wonderful sense of composition, but were made purely for their ornamental quality.

Okimono were more highly praised in the West than in Japan, and because of this many were made purely for export. The quality of these was not usually as good as those meant for the indigenous market.

Subjects are varied and include figures, animals and large compositions similar to netsuke.

When buying netsuke the collector must be on guard for copies and forgeries, for unfortunately they abound. Common are small okimono or fragments of ivory statuary which have been embellished with cord holes. These can usually be spotted by the fact that the composition is usually too big or unbalanced, and usually the forger has forgotten to create 'wear' on the edges of the cord holes. Some pieces have also been made to appear old by the addition of stain, and cracks were added occasionally by heating the object, and stain would then be rubbed in. Sometimes pieces have been embellished with false inscriptions or signatures. Modern fakes are usually produced by one of two methods. Firstly, by casting in resin with ivory powder, and, secondly, by carving block perspex with a special machine, which reproduces the exact contours of the original. The piece is then finished by hand, buffed and stained. Observation is the collector's friend. If he bears the above in mind and gains experience in handling specimens he will soon be able to tell fake from genuine, good from bad.

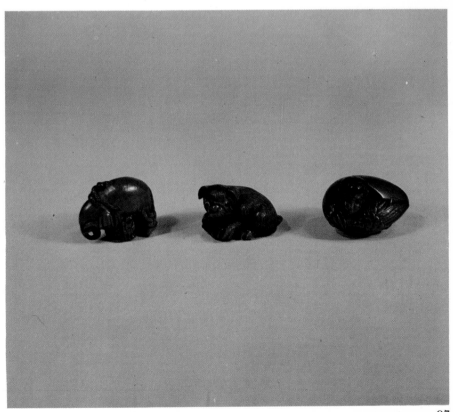

Chronology

NOTE ON CHRONOLOGIES
There is some variation in chronology according to which interpretation or system is used.

PRINCIPAL PERIODS OF CHINESE ART

Shang Dynasty (Yin)	*c.* 1523–1027 B.C.
Chou Dynasty	1027– 221 B.C.
Warring States Period	481– 221 B.C.
Ch'in Dynasty	221– 206 B.C.
Han Dynasty	206 B.C.–A.D. 220
Three Kingdoms	A.D. 220–A.D. 280
Six Dynasties Period	A.D. 280–A.D. 589
Northern Wei	A.D. 385–A.D. 535
Eastern Wei	A.D. 535–A.D. 550
Western Wei	A.D. 535–A.D. 557
Northern Ch'i	A.D. 550–A.D. 577
Northern Chou	A.D. 557–A.D. 581
Liu Sung (South)	A.D. 420–A.D. 478
Southern Ch'i	A.D. 479–A.D. 501
Liang	A.D. 502–A.D. 557
Ch'en	A.D. 557–A.D. 588
Sui Dynasty	A.D. 589–A.D. 618
T'ang	A.D. 618–A.D. 906
Five Dynasties	A.D. 907–A.D. 959
Sung Dynasty	A.D. 960–A.D. 1280
Yuan Dynasty	A.D. 1280–A.D. 1368
Ming Dynasty	A.D. 1368–A.D. 1643
Ch'ing Dynasty	A.D. 1644–A.D. 1912

CHINESE EMPERORS MING AND CH'ING PERIODS

MING 1368–1644

Hung Wy	1368–1398	Hung-Chih	1488–1505
Chien Wen	1399–1402	Cheng Te	1506–1521
Yung Lo	1403–1424	Chia Ching	1522–1566
Hung Hsi	1425	Lung Ch'ing	1567–1572
Hsuan Te	1426–1435	Wan Li	1573–1619
Cheng T'ung	1436–1449	T'ai Ch'ang	1620
Ching T'ai	1450–1457	T'ien Ch'i	1621–1627
T'ien Shun	1457–1464	Ch'ung Cheng	1628–1643
Ch'eng Hua	1465–1487		

CH'ING 1644–1912

Shung Chih	1644–1661	Tao Kuang	1821–1850
K'ang Hsi	1662–1722	Hsien Feng	1851–1861
Yung Cheng	1723–1735	T'ung Chih	1862–1873
Ch'ieng Lung	1736–1795	Kuang Hsu	1874–1908
Chia Ch'ing	1796–1820	Hsuan T'ung	1909–1912

KOREAN CHRONOLOGY

Lo Lang	106 B.C.–A.D. 313
Paekche	18 B.C.–A.D. 663
Koguryo	37 B.C.–A.D. 668
Silla	57 B.C.–A.D. 668
Great Silla	A.D. 668–936
Koryo	A.D. 918–1392
Yi	A.D. 1392–1910

JAPANESE CHRONOLOGY

Jomon period	1000 B.C.–200 B.C.
Yayoi period	200 B.C.–A.D. 500
Tumulus or Great Tomb period	A.D. 300–A.D. 700
Asuka period	A.D. 552–A.D. 645
Early Nara period	A.D. 645–A.D. 710
Nara period	A.D. 710–A.D. 794
Early Heian period	A.D. 794–A.D. 897
Heian or Fujiwara period	A.D. 897–A.D. 1185
Kamakura period	A.D. 1185–A.D. 1392
Ashikaga or Muromachi period	A.D. 1392–A.D. 1573
Momoyama period	A.D. 1573–A.D. 1615
Tokugawa period	A.D. 1615–A.D. 1868

NOTE ON SPELLING AND PRONUNCIATION

All Japanese, Chinese, Korean and Sanskrit words have been written in their simplest form phonetically. Accents and pronunciation marks have been omitted. Chinese proper names of Emperors and places etc. have been written as two words, e.g. Hsuan Te rather than hyphenated as Hsuan-te.

Glossary of names and words used in text

Ajanta – A group of caves in India famous for their Buddhist paintings.

Ami – The family name of a group of Japanese painters from the 14th to 16th centuries.

Amida Buddha – The Japanese name for Amitabha, Lord of Boundless Light.

Amida Raigo – A form of painting depicting Amida Buddha surrounded by his attendants descending from heaven to receive his followers. There are a number of examples dating to the Heian period and the Kamakura period.

Amitabha – Lord of Boundless Light.

Amitayus – A Dhyanibuddha of Infinite Life.

Angu-in – Temple near Nara, Japan.

Anyang – Site in China famous for its Shang tombs.

Apsaras – Celestial nymphs.

Arhats – Saints (Chinese Lohan).

Ar-Ni-Ko – Nepalese artist, painter, sculptor and decorator who was invited in the 13th century to the court of the Chinese Emperor. Author of *A Canon of Proportions*.

Atisa – Hindu priest founder of the Ka-dam-pa sect in Tibet.

Attiret – Jesuit priest, painter in the court of the Emperor Ch'ien Lung.

Avalokitesvara – Bodhisattva, in China known as Kuan Yin, a female deity, in Japan Kannon.

Awa – Province in Japan.

Benten – Japanese Goddess of Love, Learning, Wealth and Music.

Bhaisajyaguru – Medicine Buddha, Supreme Physician.

Bishamon – Japanese God of Military Glory.

Bishamonten – See Bishamon.

Biwa – Japanese stringed instrument.

Bodhisattva – One who has forsaken Nirvana in order to intercede on behalf of humans. (Mahayana Buddhism.)

Buddha – Gautama. One who has obtained Nirvana. Enlightened One. Founder of Buddhism. Image has urna, usnisa and long lobed ears.

Bun Jin – Japanese equivalent of Wen Jen, amateur literati style of painting.

Byodo-in – Temple near Kyoto, Japan.

Castiglione – Jesuit priest, protége of the Emperor Ch'ien Lung. Painter in the Chinese style, his Chinese name was Lang Shih-ning.

Ch'an – A form of Buddhism not entailing the use of images but relying on instant enlightenment through meditation. Japanese name Zen.

Chang – Chinese archaic ritual jade.

Ch'ang An – City in China.

Ch'ang Sha – Ancient city in Hunan province, China.

Chao Meng-fu – Chinese painter active 1226–1290.

Che – School of painting during the Ming period taking its name from the province of Chekiang, China.

Chen Yu – Chinese name for jade.

Chia – Chinese archaic ritual bronze vessel.

Chia Ching – Chinese emperor 1522–1566.

Ch'iang-chin – A Chinese technique of lacquerworking, of engraving and gilding.

Chiang Ting-hsi – Chinese painter 1669–1732.

Chien – Chinese archaic ritual bronze vessel.

Ch'ien Hsuan – Chinese painter 1235–1297.

Ch'ien Lung – Chinese emperor 1735–1795.

Chih – Chinese archaic ritual bronze.

Ch'in – Chinese game.

Ching T'ing-piao – Chinese painter who worked using Western techniques in Chinese Style.

Chinso – A form of Japanese portrait painting.

100

Chishaku-in – Temple in Kyoto, Japan.

Ch'iu Ying – Chinese painter 1510—1551.

Chou – Scroll painting.

Chou Ch'en – Chinese painter.

Chou Fang – Chinese painter active A.D. 780–816

Chueh – Chinese archaic ritual bronze.

Chugu-ji – Temple, Nara Japan.

Chung – Chinese bronze bell.

Chuson-ji – Temple at Hiraizumi, Japan.

Chu Ta – Chinese painter *c.* 1625–1700.

Cire perdue – Lost wax process used in bronze casting.

Coromandel – Name of Indian city given to type of lacquerwork.

Corundum – Abrasive used in jade working.

Daien-in – Temple on Mount Koya in Wakayama province, Japan.

Daikoku – Japanese God of Wealth and Riches.

Dainichi Nyorai – The Supreme Buddha. (Japanese).

Daitoku-ji – Temple, Kyoto, Japan.

Dengyo Daishi – Founder of Tendai Buddhism in Japan in A.D. 805.

Dotaku – Bell-shaped bronze object. Japanese.

Dvarpalas – Guardian deities.

Ebisu – One of the Seven Gods of Good Fortune. God of Daily Food. Japan.

Edo – Modern day Tokyo.

Eitoku – See Kano Eitoku.

E-makimono – Long horizontal hand scrolls. Japanese.

Fujiwara Takanobu – Japanese painter 1143–1206.

Fuku-roku-ju – One of the Japanese Gods of Good Fortune. God of Longevity.

Gakko Bosatsu – The Moonlight Bodhisattva. Japan.

Gandhara – Region in North West India responsible for the first images of Buddha.

Ganjin – Chinese monk.

Gei-ami – Japanese painter 1431–1495.

Ge-lug-pa – Tibetan Yellow Cap sect of Lamaism.

Genre Painting – Scenes of everyday life.

Gupta – Period in Indian history.

Guri-lacquer – Multi-coloured layers of lacquer deeply carved like cameo.

Hunan – Province in China.

Hang Chou – City in South China.

Haniwa – Japanese cylindrical terracotta figures placed around tumuli of the Great Tomb period.

Han Kan – Chinese painter A.D. 720–780.

Harunobu, Suzuki – Japanese print artist died 1770.

Hashirakake – 'pillar-hanging' Japanese print.

Heian-kyo – Present day Kyoto, Japan.

Hiaku-ko-kan – Japanese technique of decorating lacquer with fragments of ceramics.

Hideyoshi, Toyotomi – Japanese painter, 1536–1598.

Hidetada – Japanese Shogun who in the early 17th century issued an edict ordering every household to have an image of the Buddha.

Hinayana – Small Vehicle. Orthodox sect of early Buddhism based on doctrine rather than Buddha worship.

Hira-maki-e – Technique of Japanese lacquerwork, the application of gold lacquer on a uniform flat background.

Hiroshige, Ando – Japanese print artist 1797–1858.

Ho – Chinese archaic ritual bronze vessel.

Ho Ch'u-ping – Chinese General. His tomb at Shensi is noted for the fine sculptures of horses.

Hokusai – Japanese print artist 1760–1849.

Hompa-shiki – Rolling wave style of carving. Japanese.

Hosegawa Tohaku – Japanese painter 1539–1610.

Hotei – One of the Japanese Seven Gods of Good Fortune. God of Contentment. Chinese Putai.

Hsia Kuei – Chinese painter active 1180–1230.

Hsieh Ho – Chinese artist, author of *Six Techniques of Painting c.* A.D. 490.

Hseih Shih-ch'en – Chinese painter 1488–1547.

Hsien – Chinese archaic ritual vessel.

Hsuan Te – Chinese emperor 1426–1435.

Hsuan Tsang – Early Chinese traveller and pilgrim. Travelled to India between the years A.D. 399–414.

Hsu Wei – Chinese painter 1521 – 1593.

Hu – Chinese archaic ritual vessel.

Huang – Chinese ritual jade.

Huang Kung-wang – Chinese painter 1269–1354.

I – Chinese ritual vessel.

Ichimai-e – Japanese single sheet print.

Ichiraku – A form of netsuke.

Ike-no-Taiga – Japanese painter 1723–1776.

Inro – Seal or medicine box.

Izuka Toyo – Japanese artist 19th century.

Jadeite – Sodium aluminium silicate.

Jatakas – Legends of the previous lives of the Buddha.

Jetavana – Monastery in North West Nepal where the original Udyana statue of Buddha was supposed to have been housed.

Jocho – Japanese sculptor Heian period.

Jodo – Japanese sect devoted to the worship of Amida Buddha.

Jokei – Sculptor of the Kamakura period, Japan.

Josetsu – Painter active 1405–1430.

Juro-jin – One of the Japanese Seven Gods of Good Fortune. God of Learning.

Kabuki – A form of Japanese theatre whose actors were often portrayed by the masters of the Japanese print.

Kacho-e – Japanese print – nature pictures.

Ka-dam-pa – Tibetan sect of Buddhism founded by Atisa in A.D. 1040.

Kagamibuta – A form of netsuke.

Kaikei – Japanese sculptor of the Kamakura period.

Kakemono – Japanese hanging scroll picture.

Kamakura-bori – A form of lacquerwork where the design is incised before lacquering in red and green.

K'ang Hsi – Chinese Emperor 1662–1722.

Kannon – Bodhisattva of Mercy. Chinese: Kuan Yin.

Kano Eitoku – Japanese painter 1543–1590.

Kano Masanabo – Japanese painter 1434–1530.

Kano Motonobu – Japanese painter 1476–1559.

Kano Naonobu – Japanese painter 1607–1650.

Kano Sanraku – Japanese painter 1559–1635.

Kano Tanyu – Japanese painter 1602–1674.

Kanzan – Chinese Zen priest.

Kao – 14th century Japanese artist.

Kao Ch'i-p'ei – Chinese painter, exponent of finger painting died 1734.

Kao Feng-han – Chinese painter 1683–1743.

Kara-e – Chinese style of Japanese painting. Popular during early Fujiwara period.

Karyobinga – Half-men, half-bird creatures.

Keman – Wreath of flowers – a kind of bronze floral openwork object, hung from the Nageshi, a horizontal beam in Buddhist temples.

Kichijo-ten – Japanese Goddess of Good Fortune.

Kim Duk-sin – Korean painter 1754–1822.

Kim Hong-do – Korean painter *c.* 1760.

Kimono – Japanese robe.

Kiri-kane – A technique used on painting whereby thin lines of gold leaf were applied to the surface.

Kirin – Unicorn. Japanese.

Kisaeng – Korean equivalent of the Japanese geisha.

Kiyonaga – Japanese print artist 1752–1815.

Kobo Daishi – Japanese priest founded Shingon sect of Buddhism A.D. 806–807.

Koetsu – Japanese artist famous for his Raku pottery and lacquerwork.

Kokei – Japanese sculptor of the Kamakura period.

Koma Koryo – Japanese lacquer artist 19th century.

Korin, Ogata – Famous Japanese lacquer artist 18th century.

Koro – Japanese incense burner.

Koryusai – Japanese print artist active 1763–1785.

Kose no Kanaoka – Japanese artist Early Heian period.

Koto – Japanese string instrument.

Ku – Chinese archaic ritual vessel.

Kuang – Chinese archaic ritual vessel.

Kuan Yin – Goddess of Mercy. Chinese.

Kudara no Kawanari – Japanese artist of the Early Heian period.

Kuei – Chinese archaic ritual bronze vessel.

Kuei – Chinese archaic ritual jade.

Kuei – Dragon.

Ku-K'ai-chih – Chinese painter 4th century A.D.

Kung Hsien – Chinese painter *c.* 1617–1689.

Kunisada, Utagawa – Japanese print artist 1786–1864.

Kuniyoshi, Utagawa – Japanese print artist 1797–1861.

Lamaism – Form of Tibetan Buddhism.

Lang Shih-ning – Chinese name for the Jesuit painter Castiglione 1698–1766.

Li – Chinese archaic ritual bronze vessel.

Liang K'ai – Chinese painter Sung dynasty.

Li Chen – Chinese painter T'ang dynasty.

Lie Wen – 'Thunder Pattern' on Chinese ritual bronzes.

Lin Liang – Chinese painter *c.* 1500.

Li Ssu-hsun – Chinese painter A.D. 651–716.

Li/Ting – Chinese archaic ritual bronze vessel.

Lu Chi – Chinese painter *c.* 1500.

Mahayana – The Great Vehicle. Unorthodox sect of Buddhism. Later development of the Lesser Vehicle with emphasis on the worship of Buddhas and Bodhisattvas.

Ma-Hsia – School of Chinese painting.

Maitreya – The Future Buddha.

Make-e – 'Sprinkled picture'. A form of lacquerwork where gold or silver dust is sprinkled over the object after the design has been drawn in lacquer on the surface.

Makimono – Japanese horizontal hand scroll.

Mandala – (Sanskrit) Aureole.

Mandala – (Sanskrit). Magic circle or diagram used in Tantric Buddhism. Imagined shape of the Universe. Japanese Mandara.

Mandara – See Mandala.

Manju – Form of netsuke.

Manjusri – Bodhisattva.

Maruyama Okyo – Japanese painter 1733–1795.

Masanobu, Okumura – Japanese print artist 1686–1764.

Matabei, Iwasa – Early Ukiyo-e artist 1568–1650.

Ma Yuan – Chinese painter 1190–1225.

Mincho – Japanese painter 1352–1431.

Minogame – Japanese mythological tortoise with hairy tail.

Miroku – Japanese name for Maitreya.

Mitsumi-no-Sukune – Legendary Japanese master of lacquer.

Moronobu, Hishikawa – Japanese print artist 1625?–1694.

Motonobu, Kano – Japanese painter 1475–1551.

Mu Ch'i – Chinese painter 1180–1250.

Namban Byobu – Painted screens depicting 'Southern barbarians' or foreigners.

Nageshi – Beam in Buddhist temple used for hanging the Keman.

Neolithic – New stone age.

Nephrite – Calcium magnesium silicate.

Netsuke – Carved toggle used for preventing the Sagemono from slipping through the obi.

Nichiren – Japanese sect of Buddhism founded by the priest Nichiren.

Nikko Bosatsu – Sunlight Bodhisattva. Japanese.

Nirvana – Spiritual liberation. Death of the Buddha. Transmigration.

Nishiki-e – Japanese full colour printing introduced in 1764.

Nishimura Zopiko – Japanese 19th century lacquer artist.

Ni Tsan – Chinese painter 1301–1374.

No – Japanese theatre.

No-ami – Japanese painter 1397–1471.

Nabunaga, Oda – Japanese painter 1534–1582.

Obi – Sash used for holding the kimono closed.

Oda Nobunaga – Japanese painter 1534–1582.

Okimono – Miniature decorative carving in ivory.

Oni – Evil spirit. Japanese.

P'an – Chinese archaic ritual bronze vessel.

Pa-ta Shan-jen – Chinese painter, Chu Ta *c.* 1625–1700.

Pedra-de-mijada – Portuguese name for jade.

Pi – Chinese archaic ritual jade.

Pujus – Indian religious ceremony.

Putai – One of the Seven Gods of Good Fortune. The Chinese God of Contentment.

Pyon Sang-byok – Korean painter. 18th century.

Repoussé – Method of embossing or working metal from the reverse side.

Ritsuo – Japanese lacquer artist 1663–1747.

Ryusa – A form of netsuke.

Sagemono – The assembly of inro, and other accessories held in the obi by the netsuke.

Sakyamuni – The historical Buddha. Gautama Buddha.

Sashi – A form netsuke.

Sesshu – Japanese painter 1420–1506.

Sesson – Japanese painter 1504–1589.

Shaka – Japanese name for Sakyamuni.

Shamanism – Korean philosophy/religion.

Sharaku – Japanese print artist, activity restricted to 1794.

Shen Chou – Chinese painter 1427–1509. Founded the School of Wu.

Shiba Tori – Japanese sculptor Asuka period.

Shih Chung – Chinese painter 1437–1517.

Shingon – A form of mystical esoteric Buddhism.

Shinto – The Japanese indigenous cult of natural forces, ancestors and the State.

Shogun – Overlord

Shoso-in – Large timber building, temple store-house.

Shou Chuan – Chinese hand scroll.

Shubun – Japanese painter active during the first half of the 15th century.

Shunga – Japanese erotic prints.

Shunko – Japanese print artist active 1780–1800.

Shunman – Japanese print artist 1757–1820.

Shunsho – Japanese print artist 1726–1792.

Sim Sa-jong – 18th century Korean painter.

Sin Yun-bok – Korean painter 1758–?

So-ami – Japanese painter 1472–1525.

Son – Korean form of Zen Buddhism.

Sotatsu – Japanese painter active 1596–1623.

Sri Devi – Tibetan female deity. Female defender of the law of Buddhism.

Sumida Shozo – Real name of the Japanese print artist Kunisada.

Surimono – 'Printed things' such as greetings, notices etc.

Sutra – Text.

Tabako-bon – Smoker's box.

Tai Chin – Chinese painter active 1446.

T'ang Yin – Chinese painter 1470–1523.

Tao-chi – Chinese painter *circa* 1630–1714.

T'ao-t'ieh – Stylised geometric mask used on Chinese ritual bronzes etc.

Tendai – Form of Buddhism introduced into Japan by Dengyo Daishi in A.D. 805.

Tengu – Japanese mythological creature with the body of a man and wings, claws and beak of a bird.

Ting – Chinese archaic ritual bronze vessel.

Toba Sojo – Japanese painter, 12th century.

Togidashi-maki-e – A form of Japanese lacquer, maki-e, which has been covered with a thin coat of lacquer and then polished until the gold shows through.

Tokonoma – Quiet corner of Japanese home where kakemono is hung.

Tokugawa Ieyasu – 1542–1616, founder of the Tokugawa period.

Tonkotsu – Japanese tobacco box.

Tosa Mitsunobu – Japanese painter, 1434–1525.

Tosa Yukihiro – Founder of the Tosa School of painting. Japanese.

Tou – Chinese ritual bronze vessel.

Toyohiro, Utagawa – Japanese print artist 1763–1828

Toyokuni, Utagawa – Japanese print artist. 1769–1825.

Toyokuni – Name used by Kunisada, as Toyokuni III.

Tsou I-Kuei – Chinese painter 1686–1722.

Tsun – Chinese archaic ritual bronze vessel.

Ts'ung – Chinese archaic ritual jade.

Udyana – Early style of Buddha image based on Gandharan.

Uki-e – 'Perspective Pictures' a form of Japanese print developed by Masanobu.

Ukiyo-e – 'Pictures of the Fleeting World'. Art style used on Japanese prints.

Unkei – Japanese sculptor, Kamakura Period.

Uragami Gyokudo – Japanese painter 1745–1820.

Utamaro – Japanese print artist 1753–1806.

Vairocana – A Spiritual Son of the Primordial Buddha.

Vajrayana – Buddhist sect. Vehicle of the Thunderbolt.

Wang Chien – Chinese painter 1598–1677.

Wang Hui – Chinese painter 1632–1720.

Wang Meng – Chinese painter *c.* 1309–1385.

Wang Shih-min – Chinese painter 1592–1680.

Wang Wei – Chinese painter A.D. 698–759.

Wang Yuan-chi – Chinese painter 1642–1715.

Wen Cheng-ming – Chinese painter 1470–1559.

Wen Jen Hua – School of painting of the Literati.

Wu Chen – Chinese painter 1280–1354.

Wu Tao-tzu – Chinese painter of the middle T'ang period.

Wu Wei – Chinese painter 1458–1508.

Yakushi – Buddha of Medicine. Japanese.

Yamato-e – Japanese art style.

Yen Li-pen – Chinese painter died A.D. 673.

Yi In-mum – Korean painter 1746–1825.

Yi Sang-chwa – Korean painter *c.* 1550.

Yosa Buson – Japanese painter 1716–1783.

Yoshiwara – Brothel quarter of Edo.

Yu – Chinese archaic ritual bronze vessel.

Yun Shou-p'ing – Chinese painter 1633–1690.

Zen – A Japanese form of Buddhism similar to the Chinese Ch'an. Based on meditation and instant Enlightenment.

Glossary of Mudras, Hastas and Asanas

Mudras and Hastas

Abhaya – Protection. Right arm raised and slightly bent. Open palm held outwards, the fingers extended and directed upwards. Hand is level with shoulders.

Anjali – Salutation. Both arms raised fully upwards above head – palms turned up and fingers extended.

Some authorities disagree over this and equate it with the namaskara mudra.

Bhumisparsa – Witness. The right arm is pendant over right knee. The hand has all fingers stretched downwards, touching lotus throne, palm inward.

Bhutadamara – Awe-inspiring. Wrists crossed in front of chest. No symbols.

Buddhasramana – Salutation. Right hand level with head. Palm upwards, all fingers extended outwards.

Damaru – Similar to the tripataka, but palm faces inwards and is holding a drum.

Dharmachakra (-cakra) – Preaching. 'Wheel of Law'. Hands held against chest, left hand covering right.

Dhyana (Yoga) – Meditation. Hands lie in lap, one on the other, palms upwards and all fingers extended. Figure seated in padmasana or paryanka asana.

Karana – Hand stretched outwards, fingers extended, but with second and third fingers pressing against palm.

Kataka – Hand partly closed with thumb and tip of index finger almost touching, signifying hand holding attributes or stems of flowers.

Ksepana – Hands clasped together, fingers interlocking, except for the two index fingers, which are turned downwards into a kalasa containing amrita (nectar).

Namaskara – Hands held at chest, praying. (See Anjali).

Tarjani – Menacing. Hand clenched as fist but with index finger pointing upwards.

Tarpana – Homage. Arms raised above level of shoulders, with palms turned inwards, fingers pointing towards shoulders.

Uttarbodhi – Similar to Ksepana but with tips of thumbs touching and index fingers pointing upwards.

Vajarahumkara – Similar to bhutadamara but holding Vajra and Ghanta.

Varda (or Vara) – Charity. Palm of the left hand opened outwards, with fingers pointing downwards. Arm pendant.

Vismaya – Astonishment. Forearm folded at elbow, with the palm of the hand facing the image, with fingers pointing upwards.

Vitarka – Arm bent, fingers extended upwards, except index finger, which touches tip of palm, which is turned outwards.

Vyakhyana – Exposition. Hand in similar position to abhaya mudra but with the thumb and forefinger touching. (v.vitarka).

Asanas

Alidhasana – Standing position. Stepping to the left, with right leg straight and left leg bent.

Ardhaparyankasana – Dancing pose.

Bhadrasana (Pralamabapada asana) – Both legs pendant. Figure seated in European style. Pose of Maitreya.

Dhyanasana – Meditation pose of Buddhas, etc. When seated on a lotus throne – padmasana.

Lalitasana – One leg bent in position of dhyanasana, the other pendant. (Same as sukhasana).

Maharaja-lilasana (Rajalilasana) – Position of royal pleasure. Right hand is raised and the left leg in position of a Buddha, or pendant. One hand hangs over knee the other supports the body, which is leaning backwards.

ABHAYA

ANJALI

BHUMISPARSA

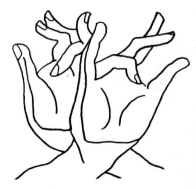

BHUTADAMARA

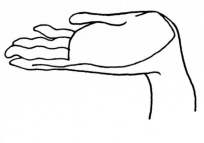

BUDDHASRAMANA

Padmasana – Seated position. Legs crossed, with feet resting on thighs.
Pralamabapada asana – (See *Bhadrasana*)
Pratyalidhasana – Standing position. Stepping to the right, with left leg straight, right leg bent.
Sattvasana – Legs loosely locked. (Position of some Bodhisattvas.)
Sukhasana – Seated pose – one leg folded and resting on plinth, the other pendant.
Yab-yum – Seated or standing position. Union of God with Sakti.
Yogasana – Similar to padmasana but with knees slightly raised, supported by a band called yoga-patta.

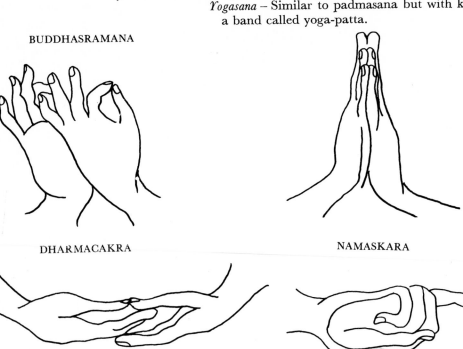

DHARMACAKRA

NAMASKARA

VARADA or VARA

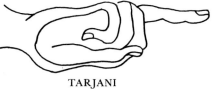

DHYANA or SAMADHI

TARJANI

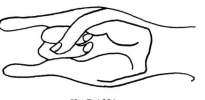

KARANA

VISMAYA

TARPANA

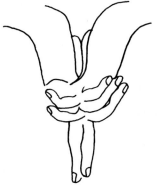

KSEPANA

TRIPATAKA

VITARKA

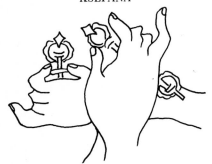

VAJRAHUMKARA

UTTARABODHI

ARDHA-CHANDRA

107

Bibliography

Books for further reading

GENERAL

Ashton, L. & Gray, B. *Chinese Art* London 1951

Catalogue, Exhibition *The National Art Treasures of Korea* London 1961

Forman, Werner *Chinese Art* London

Getty, A. *The Gods of Northern Buddhism* Tokyo 1962

Kim, Chewan & Kim Wan-Yang *The Arts of Korea* London 1966

Munsterberg, H. *A Short History of Chinese Art* East Lansing 1949

Munsterberg, H. *The Arts of Japan* Tokyo 1957

Piggott, Juliet *Japanese Mythology* London 1969

Ridley, M. *The Arts of Japan* Bournemouth 1970

Ridley, M. *Oriental Art* London 1970

Seckel, Dietrich *The Art of Buddhism* London 1964

Swann, Peter *The Art of China, Korea & Japan* London 1963

Swann, Peter *Japan* London 1966

Willetts, W. *Chinese Art* London 1958

PERIODICALS

Arts of Asia Hong Kong Bi-monthly
Oriental Art London Quarterly

PAINTING

Binyon, R. L. *Painting in the Far East* London 1960

Cohn, William *Chinese Painting* London 1948

Fenollosa, E. F. *Epochs of Chinese & Japanese Art* 1912

Gray, Basil *Japanese Screen Painting* London 1955

Hett-Kuntze, H. *Far Eastern Art* London 1969

Munsterberg, H. *Landscape Painting in China and Japan* Tokyo 1956

Pageant of Japanese Art Tokyo 1952

Seckel, D. *E-Makimono* London 1959

Shenfield, M. *Korean Painting* London 1964

Siren, O. *Chinese Painting: Leading Masters & Principles* London 1956

Toda, Kenji *Japanese Scroll Painting* Chicago 1935

Yutang, Lin *The Theory of Chinese Art* London 1967

JAPANESE PRINTS

Binyon, L. & Sexton, J. J. O'Brien *Japanese Colour Prints* London 1960

Hillier, J. *Japanese Colour Prints* London

Hillier, J. *The Japanese Print: A New Approach* Tokyo 1960

Lane, Richard *Masters of the Japanese Print* London 1962

Meissner, Kurt *Surimono* London

Turk, Frank A. *Prints of Japan* ·London 1966

LACQUER

Luzzato-Bilitz, O. *Oriental Lacquer* London 1969

Koizumi, G. *Lacquer Work* London 1923

Catalogue of the Exhibition of Gilt Bronze Statues in Japan Tokyo Museum. Tokyo 1959

Gordon, A. K. *The Iconography of Tibetan Lamaism* Tokyo 1960

Munsterberg, H. *Chinese Buddhist Bronzes* Tokyo 1967

Watson, William *Ancient Chinese Bronzes* London 1962

Watson, William *Handbook to the Collections of Early Chinese Antiquities in the British Museum* London 1963

SCULPTURE

Ashton, L. *An Introduction to the Study of Chinese Sculpture* London 1924

Kidder, J. E. *Masterpieces of Japanese Sculpture* Rutland 1961

Kidder, J. E. *Early Japanese Art* London 1964

Kuro, T. *A Guide to Japanese Sculpture* Tokyo 1963

JADE

Laufer *Jade – A Study in Chinese Archaeology and Religion* Chicago 1912

Luzzatto-Bilitz, O. *Antique Jade* London 1969

NETSUKE ETC.

Jonas, F. M. *Netsuke* Tokyo 1960

Meinertzhagen, F. *The Art of the Netsuke Carver* London 1956

Index

Page numbers in italics relate to illustrations.